CROSSING BOUNDARIES

CROSSING

ELLSWORTH KELLY

ERIC FISCHL 1970–2000

james rosenquist

The Pisces Collection ahead of the 21st ce

Jasper Johns The Museum of Modern Art, New York

Olafur Eliasson

lisa yuskavage

BOUNDARIES

A GLOBAL VISION OF DESIGN

WORDS AND PHOTOGRAPHS BY

VICENTE WOLF

WRITTEN WITH

CHRISTINE PITTEL

THE MONACELLI PRESS

TO MY MOTHER,
WHO SHOWED ME THE WAY

AND TO CATHY WHITWORTH,
WHO MADE IT POSSIBLE FOR ME
TO GET THERE

First published in the United States of America
in 2006 by
The Monacelli Press, Inc.
611 Broadway, New York, New York 10012

Printed and bound in Italy

Designed by Beverly Joel

Library of Congress Cataloging-in-Publication Data
Wolf, Vicente.
Crossing boundaries : a global vision of design /
words and photographs by Vicente Wolf ; written
with Christine Pittel.
p. cm.
ISBN 1-58093-181-2
1. Interior decoration—Themes, motives. 2. Asia—
Description and travel. 3. Africa—Description and
travel. I. Pittel, Christine. II. Title.
NK2113.W57 2006
747.09—dc22 2006015733

CONTENTS

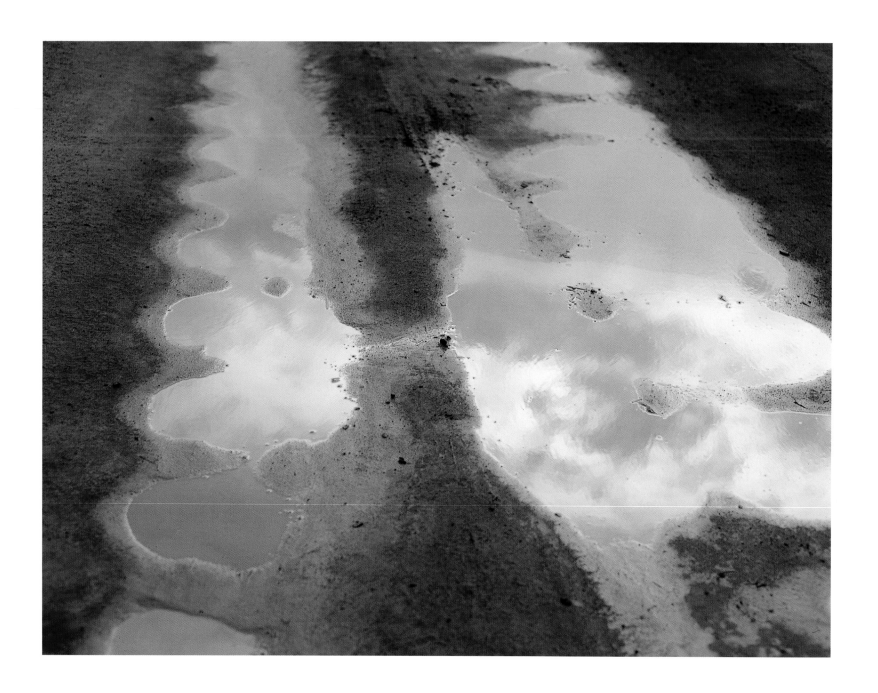

TAKING FLIGHT

I'VE BEEN BITTEN BY THE TRAVEL BUG EVER SINCE THAT DAY IN HAVANA in the 1950s when I watched my mother board a Super Constellation airplane bound for Europe. The liquid lines of the plane, the welcoming stewardess at the top of the stairs, and that last turn to wave goodbye will be with me for the rest of my life. I wanted to be on that plane.

Fast forward to a drawerful of old passports and a career as a designer in New York City. My education didn't come from school but from experience. Travel is my medium, the world is my classroom, and the passport— stamped in countries by the score—is my diploma. Every stamp triggers a picture—galloping through the Brazilian savannah in a thunderstorm, floating down a river in the jungles of Borneo, or standing atop a mountain in Bhutan at sunset.

When I'm in New York, I see through New York eyes. My range of vision is narrow: I focus on my clients, my employees, my responsibilities. But once I land in a new country, everything changes. It's like that moment in the eye doctor's office when new lenses click into the phoropter. Suddenly everything is sharp and clear. When I am on a windswept plateau in Madagascar, I see how clouds are reflected in a puddle of rainwater— something I wouldn't even notice in Manhattan.

Once, when I was on a small plane in the Himalayas, a gray-haired, sparrowlike woman sat down in the next seat. We started to talk, and I felt an immediate connection, as if we had known each other for years. She said, "That's because you, like me, have a traveling soul. We're kindred spirits, and we keep bumping into each other in our various lives."

I believe we can draw to ourselves the things we want. What I want is to go beyond the familiar. Travel is the brass ring I've always grabbed.

ETHIOPIACOMPOSITION

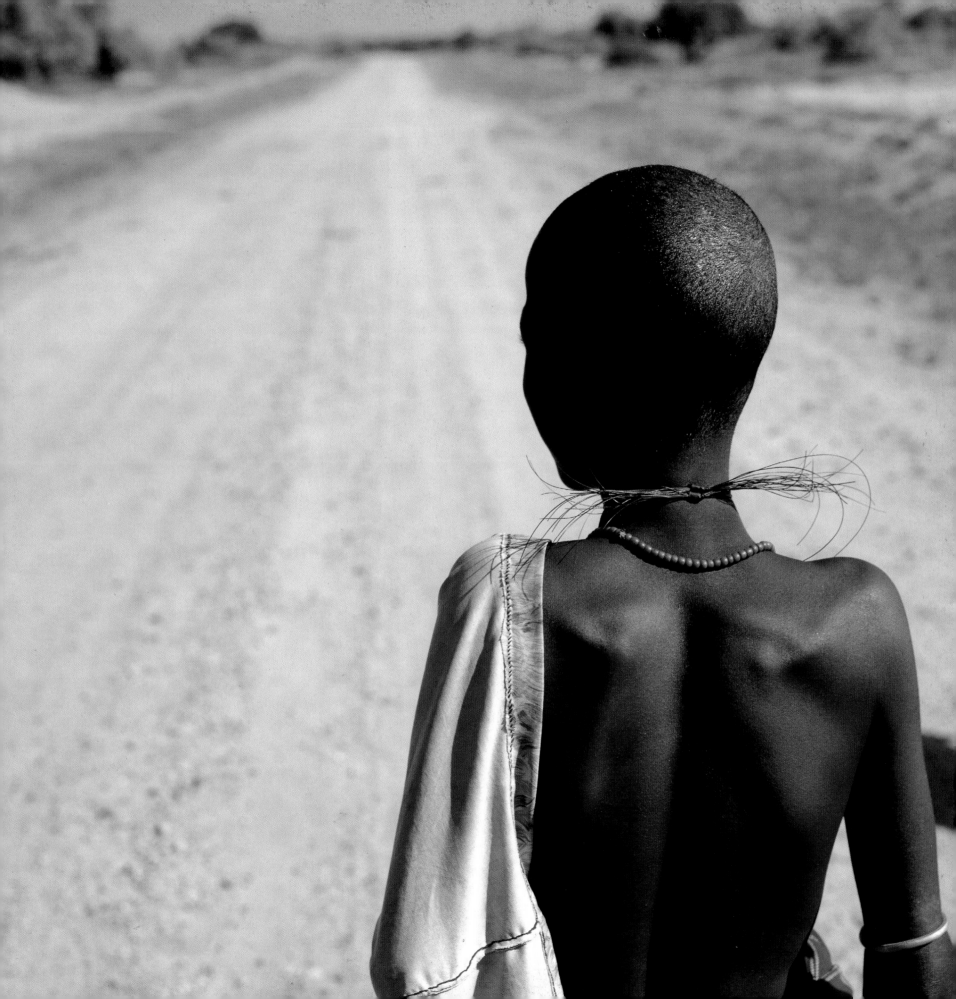

THE FIRST THING THAT ATTRACTS ME TO A PLACE IS THE ROMANCE OF THE NAME. ETHIOPIA CONJURES UP IMAGES OF SMOKE AND INCENSE. I'M ALREADY IMAGINING THE TREASURES I CAN BUY. AS A DESIGNER AND COLLECTOR, I'M ALWAYS SEARCHING FOR THAT CERTAIN SOMETHING I'VE NEVER SEEN BEFORE. IF YOU WANT TO CREATE AN INTRIGUING INTERIOR THAT DOESN'T FEEL AS IF IT WERE STAMPED FROM A COOKIE CUTTER, THE OBJECTS HAVE TO LOOK AS THOUGH YOU DUG THEM UP. YOU DON'T WANT THINGS THAT HAVE BEEN HOMOGENIZED.

IT'S NIGHT WHEN WE LAND IN ADDIS ABABA, WHICH IS RIGHT IN THE CENTER OF THE COUNTRY, AND I CAN'T SEE MUCH UNTIL MORNING. IT'S A NEW CAPITAL, VERY DUSTY, AN INCREDIBLE MIX OF PAST AND PRESENT, WITH TRADITIONAL MUD-AND-STICK SHACKS IN THE MIDST OF HIGH-RISES. YOU SEE PEOPLE PUSHING CARTS BRIMMING WITH CABBAGES RIGHT NEXT TO OTHERS CARRYING BRIEFCASES AND HURRYING TO WORK.

I usually don't like to stay in capitals. After years of canvassing foreign countries for unusual objects, I've learned that it's much better to head for the countryside, see what you can find there (usually at a cheaper price), and then fill in the blanks at the end of the trip when you go back to the capital to fly home. From all the reading I've done, I know that the road north of Addis Ababa is the historic route of kings, linking the ancient cities they built. In the south, the country is less rocky and more lush, dotted with tribal villages. I'm heading north.

The first day's drive with my guide, Brook, from Addis Ababa toward Lalibela, the fabled capital of a medieval dynasty, takes us through harvested fields of wheat and millet all stacked in neat domes. This is where I first see the colors of the country—the vivid contrast of the golden wheat against the deep blue sky. The major roads are being reconstructed all across the country, so we're stuck on temporary side roads where the dust fills every crevice of your face and clothing. Now I know how a James Bond martini feels—shaken not stirred.

We break for the night in Kembolcha, and the next morning, the sun is just beginning to warm things up by the time we're back on the road. The countryside is rocky and mountainous, not very green at all. I can't identify the trees because they're so oddly shaped. Brook explains that the people here constantly hack off branches for firewood or for fences or houses. They're careful not to cut down the tree, but they will prune it practically down to the trunk, then go on to the next tree. A year later, the process will start all over again. It creates a surreal form of topiary.

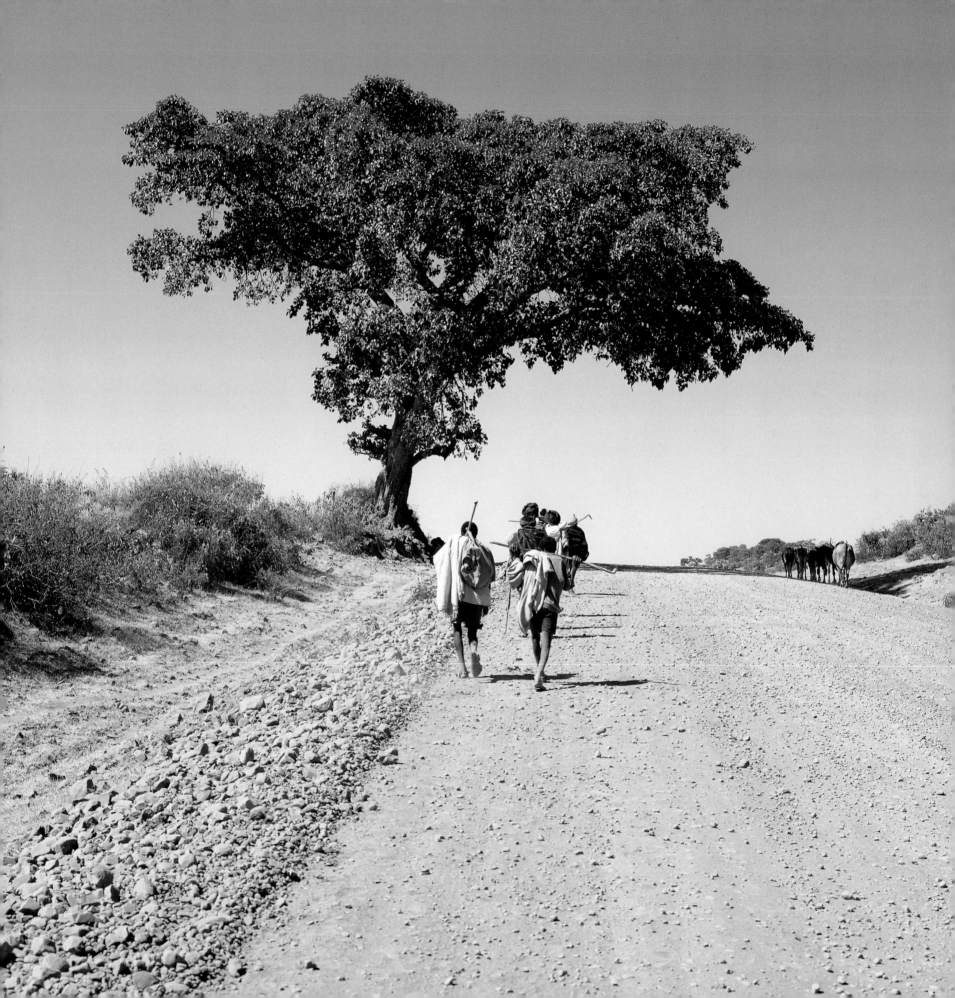

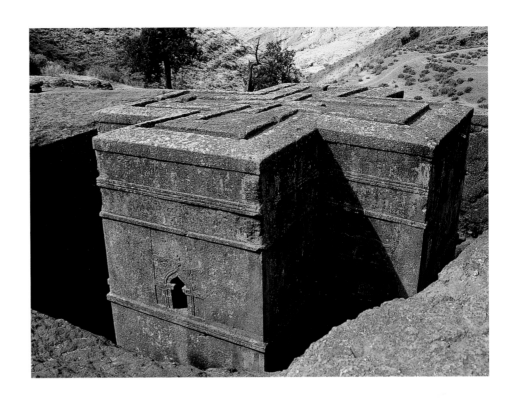

Vehicles are not alone on this road. I now know why Ethiopia has produced so many champion runners. Everybody runs or walks from town to town. The road is the bloodline. At times, the line of people stretches as far as the eye can see. I really know that I have left New York when I start waving at kids from the car.

We're heading up into the Lasta Mountains. It's a very strange sensation, being on a plateau. You see the sky differently; the clouds are closer. Lalibela, an ancient city built in the twelfth century, turns out to be a very small town, a shadow of its former glory. I keep looking for the famous churches, hewn out of rock, that make Lalibela the "eighth wonder of the world," but I can't see them until we're practically on top of them. Carved from the soft volcanic rock, they're almost totally hidden in deep trenches or sheltered by

caves. The Ethiopians are not very clear on how these churches were created. There's a legend that King Lalibela's brother tried to poison him, and when the monarch woke from his stupor, God told him to carve these churches out of the rock.

You begin the tour at ground level, walk down twenty-five feet of rock-hewn steps, and enter the churches through ten-foot-tall solid wood doors. Sometimes the only way in is through a tall, narrow tunnel with the musty smell of time. It's amazing to think that all these windows, columns, and arches were chiseled out of solid rock. The passageways inside are very narrow and lead to a rabbit warren of rooms with straw mats on the floors. Sometimes human skeletons are stretched out in a niche as if they had just lay down and died.

The walls of the churches are painted with early Christian frescoes that look

almost Byzantine. All the faces have enormous dark eyes, which is typically Ethiopian. Some frescoes portray the stories of the saints. One holy man walking through the desert found a bird dying of thirst, and he let the bird drink from his eye. When the colors start to fade, the Ethiopians just paint them over, so 90 percent of the surface is very modern, with intense greens and yellows. The figures are flat and one-dimensional.

Each church is tended by a priest dressed in golden robes patched with mismatched fabric. When you come in, he will bring out a holy crown and put it on for you. The crowns were great, and I wished I could have one. When I am looking at such things, I can't help taking them out of context and imagining them displayed in a room.

To visit the monastery of Na'akuto La'ab, which has been compared to Native American cliff dwellings, we drive to the outskirts of town, leave the car, and head down a path through a field filled with farmers busy at their work. All of a sudden we come to the edge of a precipice and see a church miraculously perched inside a cave, right in the face of the cliff. All the stalactites on the roof of the cave are dripping. Long ago someone took large rocks and carved out rough bowls in the tops to catch the water. People walk up to each one, dip their fingers in what is considered holy water, and bless themselves. There are birds' nests tucked into the nooks and crannies, so all you can hear is the chirping of birds. From the hot, bright sun, you come into this cool, shady realm of peace and tranquillity. The straw mats on the floor are strewn with fresh-cut grass, and there are a few rugs. The priests who live here sleep in hand-fashioned wooden cots. Their primitive chairs are made of wood with woven-leather backs and seats. One chair has one leg shorter than the other, and someone has gently mounded the earth underneath it to compensate. I wandered through a series of dark rooms, lit only by candles. In the flickering light, I could just make out the portraits of the saints. I had the sense that I was entering an ancient tomb.

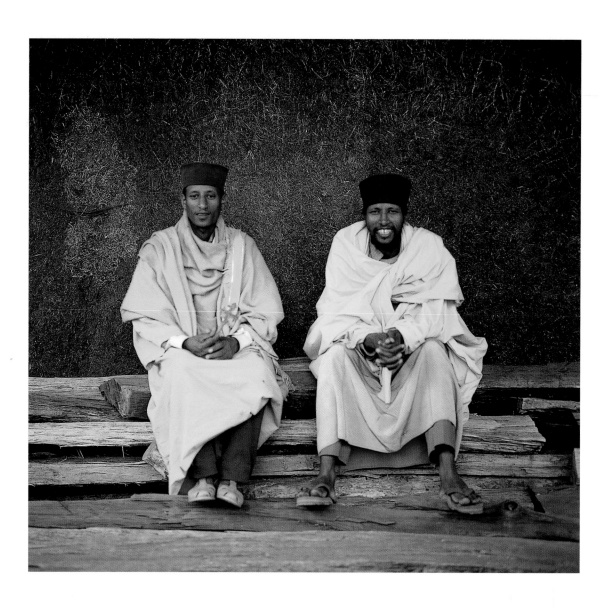

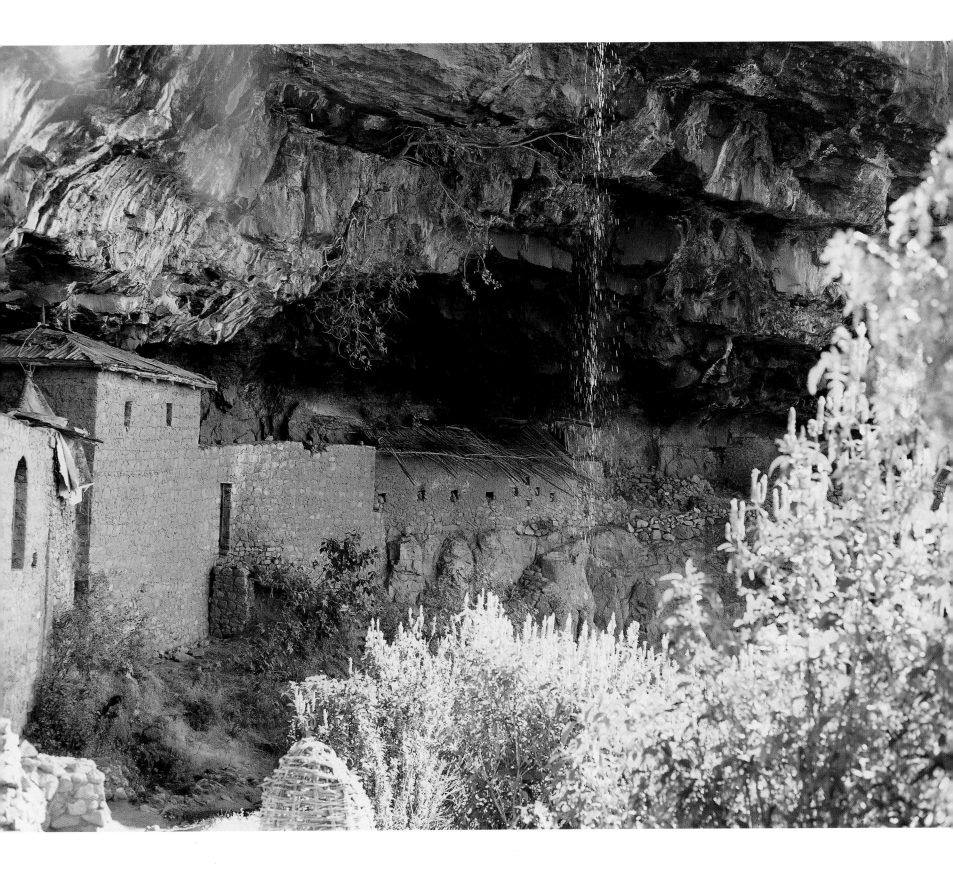

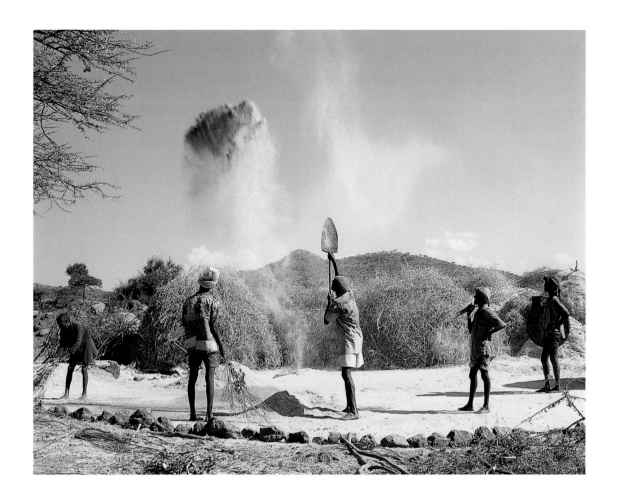

People think of Ethiopia as a parched land, but it's actually known as the water jug of Africa. On our way to the lake country, we stop for a cup of coffee at a roadside stand. The waitress brings a little clay contraption with coal inside. She puts green coffee beans in a metal dish on top and roasts them right in front of us. Then she grinds them to make a dark, strong coffee, thick as mud. It's delicious, and part of the fun is knowing we're drinking coffee the way natives do. Ethiopians are very proud of their coffee, which is not surprising, since this is supposedly where coffee originated. Everyone seems to have a coffee bush behind his house.

The trip to Lake Tana, the largest lake in Ethiopia and the source of the Blue Nile, takes approximately seven hours on a bumpy road, but the scenery is stupendous. We're traveling along the ridge of a mountain range. The amount of cultivated land is enormous—we keep passing farmers on their way to and from markets where the recently harvested grains are bought and sold. The wheat is separated from the chaff by having oxen walk in circles over the grains. Then it's put into flat baskets and thrown up into the air and the husk is fanned away. As we're driving over an outcropping of rocks, I see what appears to be a puff of smoke. It turns out to be the wheat tossed up by the farmers.

From Bahir Dar, a town with wide, palm-lined boulevards on the southern shore of Lake Tana, you can take an excursion boat out onto the lake. The island we're going to, Daga Istafanos, is inhabited by monks, and only men are allowed to visit. It's a twenty-five-minute hike up to the church, with its glass coffins containing the mummified remains of five former emperors of Ethiopia, starting with Yekuno Amlak in the thirteenth century. The other attractions are the beautiful wall paintings of the Madonna—the first that really look old to me. It's a pleasure to be in a boat after so many days in the Land Rover. I'm happy to sit back in the sun and just watch all the life on the lake.

Before leaving for Gondar the next morning, I check out the local market and hit a bonanza. A boy, eager to help, brings me to a man who drags out three burlap sacks filled with cups made out of horn. I sit on the ground and go through them, pulling out the ones I want. With all the different shades of horn, they look attractive even scattered in the dirt and will work very well as containers for flowers or other things. I also find goblets made out of bone and ebony candlesticks.

Then we're back on the road again. One of the things I love about traveling is losing control. My life in New York is all about control—constantly overseeing my projects, making sure they come out the way I envision. I get into a taxi and immediately start to take control, telling the driver which way to go. But once I step onto a plane for one of my trips, I leave all that behind. After planning my basic itinerary, I let circumstances take over. What I think will be one way turns out to be another. The people I meet, what I buy—everything is left up to fate and luck. To me, this is one of the great gifts of travel. The fact is, we are really not in control of anything, and when we let go, our joy increases. There is great pleasure in the unknown.

The main attraction in Gondar is the royal enclosure—a walled compound of castles dating from the seventeenth to the nineteenth centuries. In their design and construction, there are traces of Portuguese and Indian influences. Iyasu's castle, one of the largest, was once decorated with ivory, gold leaf, and precious stones but it's now in ruins, damaged by an earthquake in 1704 and bombs during World War II. To come so far to see a European-style castle is rather disappointing.

The next morning we leave at 7 A.M. for the ten-hour drive to Aksum (my advice—take a plane). But the scenery is a breathtaking roller-coaster of gorges up and down the Simyen mountain range. The Simyen Mountains National Park is nearby, and we dodge families of baboons crossing the road. Usually the only type of bird I like is fried, but even I have to admit that the birds here are amazing. As you drive along, they'll zoom in front of you—an iridescent flash of red and blue.

Aksum is the oldest city in Ethiopia and the center of one of the most important and technologically advanced civilizations of its time—dating back to the first century A.D. The Aksumites created Ethiopia's first written language, Ge'ez, and embraced Christianity early on. In fact, the Ark of the Covenant is supposedly kept locked away in a special sanctuary of the Maryam Tsion Cathedral, but no one except the official guardian is allowed to see it.

Luckily, you don't need special dispensation to see the ancient stone monoliths that have made Aksum famous. The stele field is right in the center of town, and it seems so incongruous, as if these slabs had suddenly dropped down from outer space. The tallest, carved from a single piece of granite, stands seventy-five feet high, and the remains of others lie scattered on the ground. The gray stone is a sharp contrast to the blue, blue sky, and the whole place feels very powerful.

Just outside of town are the ruins of what is said to be the Queen of Sheba's palace. A huge water reservoir hewn out of rock is known locally as her swimming pool. We pass it on the way to the tomb of King Kaleb. The walls of his palace have long since crumbled, but the underground burial vaults and treasury chambers, walled and roofed with thick slabs of stone weighing thousands of pounds each, are still accessible. It's dark and small and empty down there, except for a large colony of bats in one room. A group of Japanese tourists arrive with their cameras and camcorders, and before we can warn them, they focus their lights on the ceiling. The bats explode out, quickly followed by the terrified tourists. For every action, there is an equal reaction.

As the sun is setting, we hike up the side of a cliff, very barren, with spiky trees, toward the Pentaleon monastery. I feel like I'm climbing Calvary. One ancient priest runs the compound with his apprentices, and some are just kids, eight to fourteen years old. When a few of the boys start to joke with us, the priest comes out with a stick and gives one a whack. No fooling around. They're cooking their evening meal in an oven made out of rock. Each of the boys takes a turn as the chef. One is kneading bread dough. He flattens it out on a large smooth stone and then shoves it into the oven, next to a simmering pot of stew. When the bread is done, he takes it out of the oven and rests it on the branches of a tree to cool.

The church was built on the very top of the hill in the sixth century by Abba (Father) Pentaleon, who is said to be one of the nine saints who brought Christianity to Ethiopia. As he has done in every church we have visited, Brook asks for some of the sacred ashes from the incense that is being burned. He's collecting them for his mother. As soon as I head back outside, I almost get blown away by the wind. I stand for a while, watching the light fade throughout the valley below.

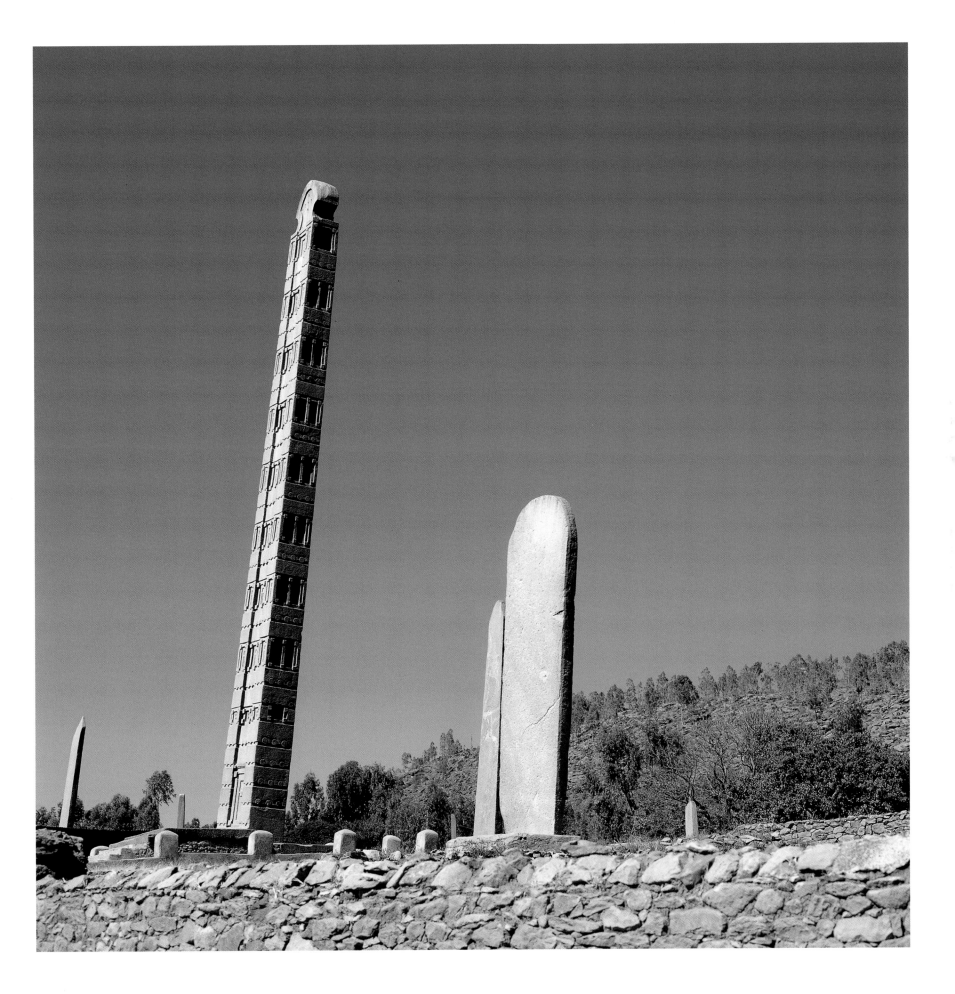

The next morning I fly back to Addis Ababa for one day before heading south, so I just have time to check out a few of the shops selling traditional furniture. I pull aside a chieftain's chair made of black ebony wood and a few hand-carved stools. It's better to put everything you want together, then start negotiating. If you ask about each piece singly, you'll pay a much higher price. But everything I've chosen still costs enough that I'm reluctant to buy right away. Now that the owner knows what I like, he promises to have even more to show me when I return in a week. I always try not to buy things the moment I arrive in a country. Once you get the lay of the land, you have a better idea of the going rate. And something that seems unique in the first store you visit can turn out to be commonplace.

I leave the furniture behind for now and go off to investigate the gold market, concentrated on one street, with shop after shop selling jewelry. Very pretty, especially the intricate gold earrings. Prices are higher than in the north but the selection is much better. I find it best to offer 50 percent of the quoted price and then go a little higher, but not much more.

The next morning we're off to the other half of the country—the land of primitive tribes and more shopping possibilities. As soon as you head south from Addis Ababa, you start to see another Ethiopia— lush and fertile instead of rocky and arid. There's a marked contrast in the people, too; they seem more exuberant than the reserved, religious northerners. We pass farmers selling watermelon and papaya for fifteen cents each, a bargain anywhere, and we stock up for the ride. Kereyu warriors with their scarified faces are herding camels along the roadside. Whenever I'm traveling, I break for flea markets. Today I see dozens of people haggling around a large pen filled with livestock. One stall sells sandals made out of car tires. People here know how to improvise. Women are selling homemade beer, as well as another liquor made from fermented honey. I walk past racks and racks of used clothing—everything from Laura Ashley–like floral prints to Nike nylon sports shirts.

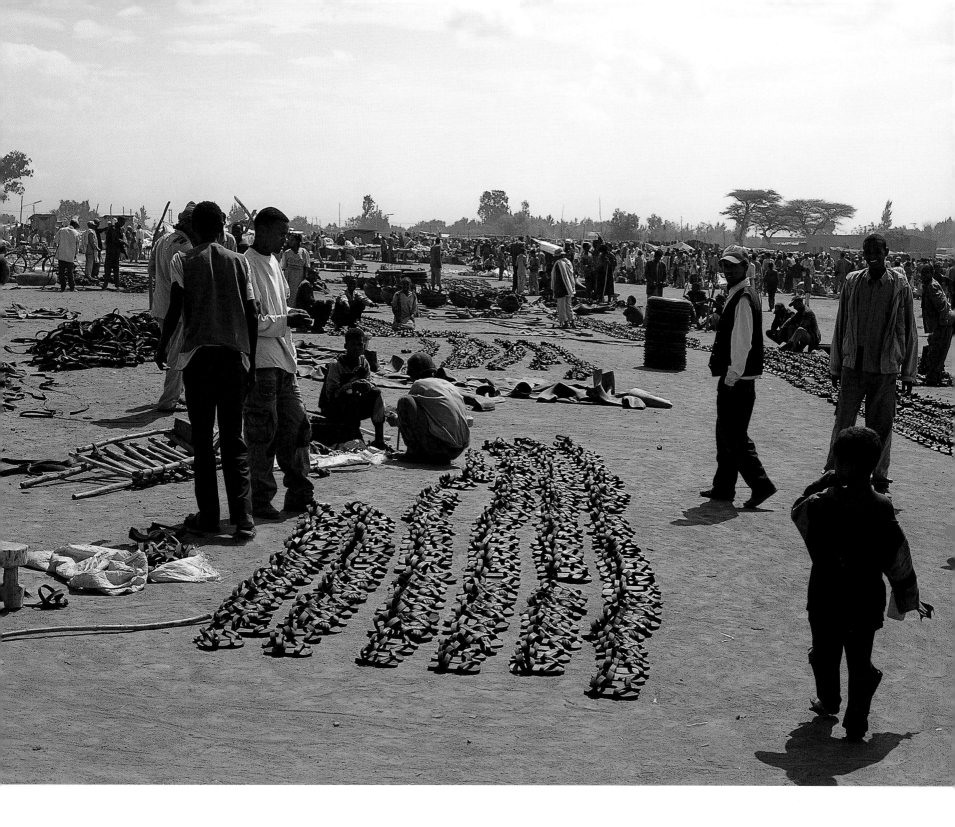

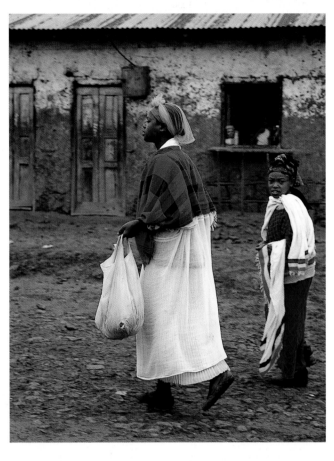

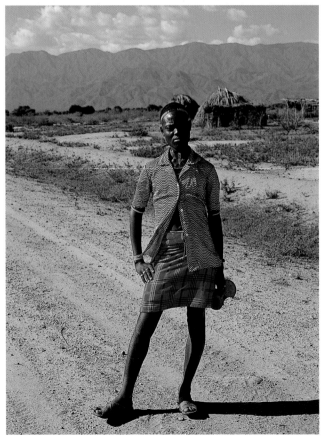

Ethiopia is the final resting place for a lot of secondhand clothes, tossed off by one society and picked up by another. That's what makes people-watching here so interesting. Women who have never seen a fashion magazine put things together in such incredible ways. I see one girl in a pleated skirt with a sheer skirt over it and another sporting a satin nightgown as daywear. Some people are wearing ten different patterns at once, no problem. They could have come off a Jean Paul Gaultier runway, and they've got just as much attitude. When I pull out my camera, the girls strike a pose.

When we get to Awasa, the capital of the south, I go to the morning fish market, held on the shores of Lake Abaya. The fishermen sell catfish, tilapia, and barbus right out of their boats. Giant Marabou storks mingle with the crowd, and pelicans rest their beaks on the edge of the stern, waiting for scraps as the fishermen gut the fish for their customers. Horse-drawn buggies stand waiting to take people back to town. At a nearby café, merchants and shoppers gather for their morning coffee or the local concoction—a refreshing avocado drink, made in a blender with sugar and lime juice. It's so thick you have to eat it with a spoon.

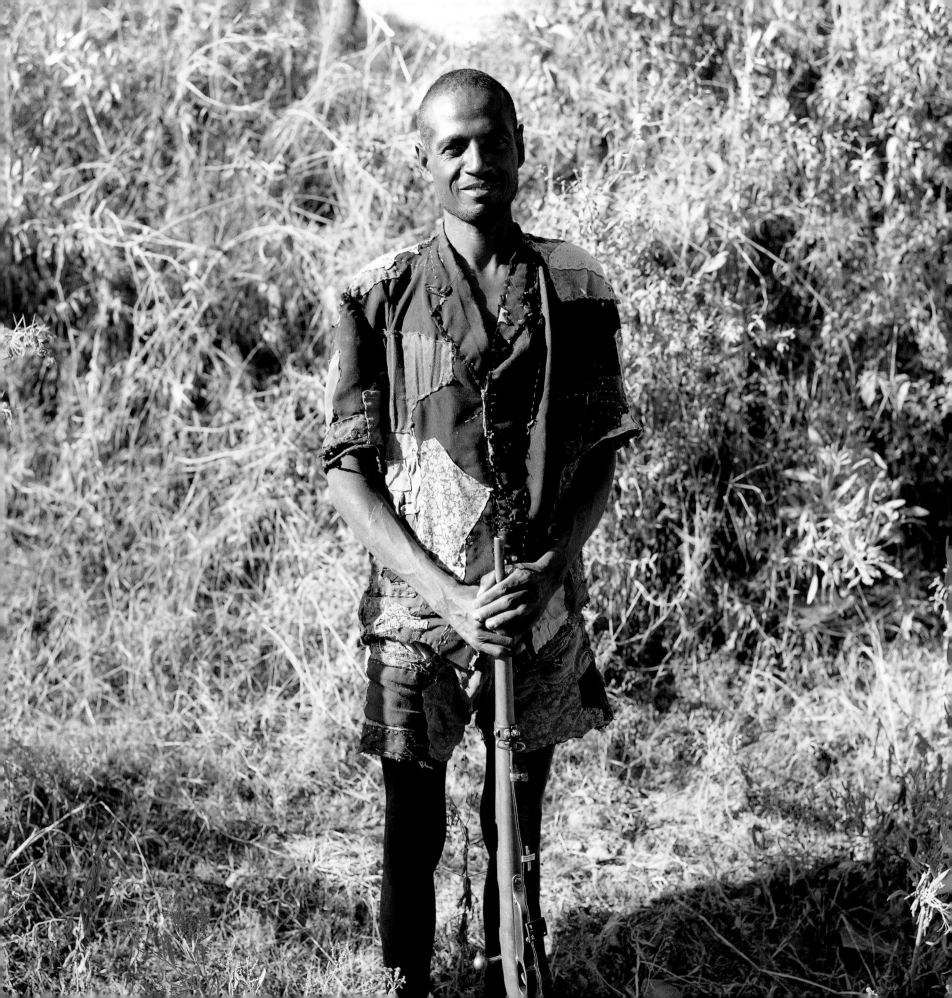

This particular stretch of the country is marked by a chain of lakes, and we stop for the night in the town of Arba Minch on the western edge of the Rift Valley. Our hotel, the Bekele Mola, couldn't have a more spectacular setting—on the edge of a cliff overlooking the strip of land between Lake Abaya and Lake Chamo, which is called the Bridge of Heaven. It's dark when we arrive and I can't see much, but the next morning I get up early and go to breakfast on the veranda. It's still misty over the lakes, and when I walk to the rail at the edge of the cliff, I feel as if my feet have left the ground. The distance is so enormous it fools the eye. Everyone sitting here is calm and quiet, just looking. There's none of that usual breakfast chatter. The vista is so imposing—the two vast lakes, the plains beyond stretching all the way to the eastern wall of the Rift Valley. It's easy to feel awestruck.

I've been intrigued by the guidebook's pictures of the Dorze people, who have lived in Chencha, their village high in the Guge hills, for at least five hundred years. Formerly warriors, they're now famous for their weaving. On the way up the winding road to the village, we pass one stand after another selling small woven caps, brightly colored togalike robes called *shamas*, and gauzy scarves, one more vibrant than the next. Each stand, and each weaver, has an individual style. But even if the Dorze people didn't know a warp from a weft, their village would be worth a detour because they live in the most remarkable dwellings I have ever seen. Their tall, beehive-shaped huts—some almost two stories high—are woven of grass and leaves over a bamboo scaffold. I tried to peer discreetly inside a few. They're dark and simple, with pounded-earth floors and a stool or two for furniture. Very primitive, yet at the same time somehow modern. The looms stand in an open thatched-roof area where the men, not the women, do the weaving. These people are instinctive architects. The walkway to the hut area is lined with angular, thorny-looking fences made of tree trunks and branches all interlaced together.

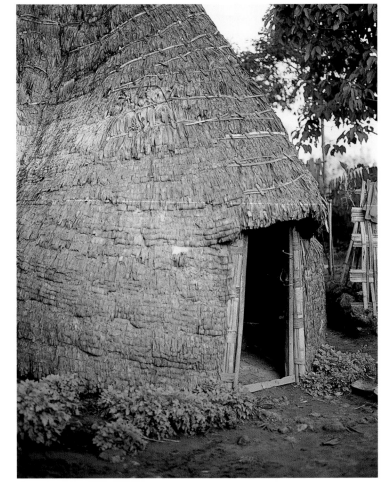

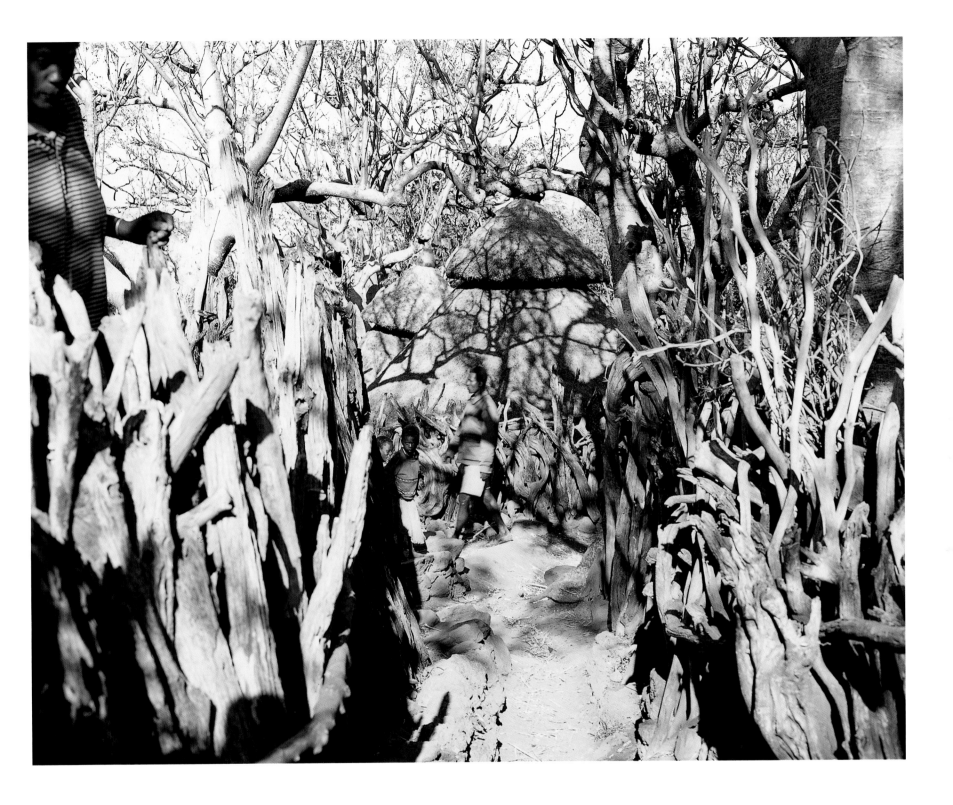

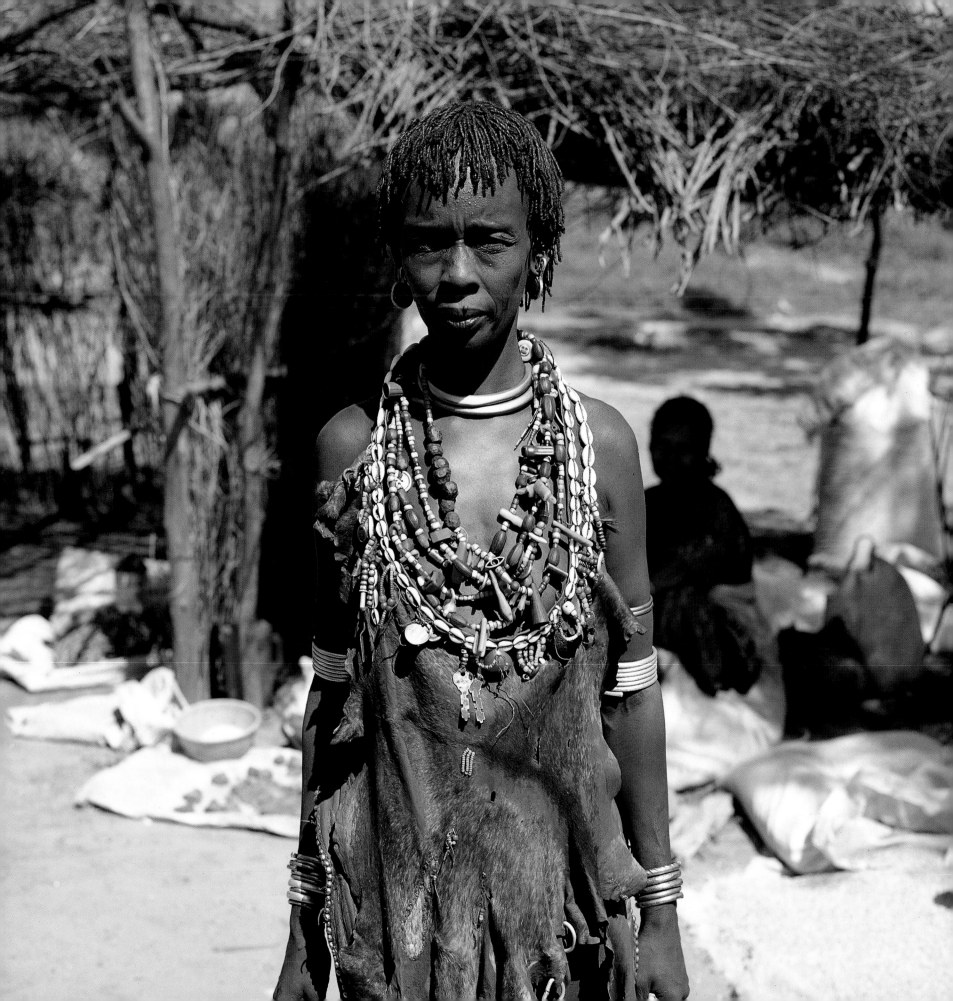

On the way back down the hill, I go into shopping overdrive. I can't resist the hats, with their dazzling combinations of pattern and color. Some have cryptic words or dates worked into the design. They are so tightly woven they look like fine needlepoint. Each is a little work of art.

Let me take this opportunity to explain a fundamental principle of acquisition: one object is chance, two are tchotchkes, and three is a collection. Therefore, it makes perfect sense to buy every hat I like, especially since they cost only a few dollars each. How often do you get to buy as much as you want of anything? One seller doesn't have any change, so I add to my pile a cloth woven in the green, yellow, and red of the Ethiopian flag.

The next morning, we aim for the Hamer market in Jinka. The Hamer women smear their hair with butter and red mud and wear it in tight little braids that look a bit like the bullion fringe on a piece of upholstery. Their leather skirts are ornamented with cowrie shells, and married women wear thick bands of copper round their necks. I'm a dedicated flea marketer from way back, and I'm determined to get there early. Too early, as it turns out. When we arrive, the clearing is utterly empty. "Are we in the right place?" I ask Brook, and he says, "Just wait."

First come the older people, who sit down around the perimeter of the clearing and start chatting. Then come the children running around. Next the women appear with sacks on their backs and set out vegetables. Someone arranges sacks of spices, another woman spreads out fabrics.

Before I know it, the market is alive. About fifty sellers, I'd guess. After all these years as a designer, I have a technique for doing a market. First, I scan the whole place, walking quickly through the stalls. Usually I see it, or I don't. If your eye is trained, you can pick up anything good on that first scan. Most of what's there is what the natives are selling to the few tourists who show up, the very generic, souvenir-of-Africa sort of things that doesn't interest me. Since I know almost immediately that I will not be rushing to grab some long-lost treasure before someone else spots it, I can relax and enjoy myself. Instead of concentrating on the merchandise, I begin to focus on what people are wearing. Then it starts to click. I see a girl with a button dangling from her ear. Strung through it are all sorts of beads. "How much do you want for your earrings?" I ask. She hangs back, a little shy, then happily asks for the equivalent of fifty cents. So I buy the earrings, and then my attention is caught by one woman arguing with another. All of a sudden my eye jumps from the furious woman's face to her neck. She's wearing a necklace made from the caps of ballpoint pens, keys, screws, buttons, a piece of intravenous tubing—all strung together with bits of pebbles and glass. It's folk art, the kind of thing you rarely find in a shop. "How much for your necklace?" I ask. She can't believe that I would want her necklace.

She made it herself, out of found objects—part of that universal human impulse for adornment. What is special to her is commonplace to me, and vice versa. I must pick up a ballpoint pen at least ten times a day, but I don't even bother to look at it. Now it's as if I'm focusing on it for the first time. What I love about travel is that moment when you suddenly see something through someone else's eyes. I want those ballpoint pen caps. And then I take a closer look at the top she has on— just a piece of leather rather like a bib. But along the neckline she has sewn all sorts of objects, centered on a big pink plastic heart. I realize the leather is actually a goatskin, with the two legs tied around her neck. I can already visualize it mounted on a stand, in one of my houses. It could be a very strong piece. I buy her top and she takes it off. So I go to the van to pull out the cloth I bought in the Dorze village. When I give it to her, she beams. She thinks that this is a great deal—the money and the cloth. She's so excited that I wonder if I missed something here. Is there something precious about the cloth? By now people have gathered to watch this transaction, and they're all looking at me with curiosity. I head off with the goatskin top.

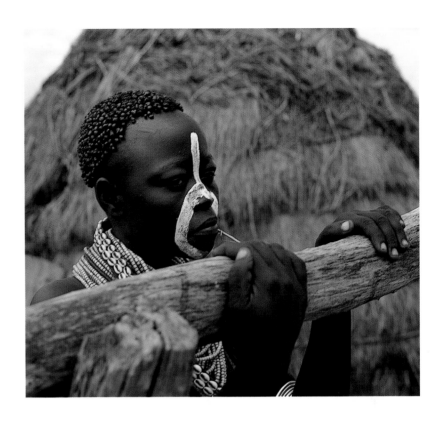

We're camping in Jinka because there are no hotels around. I do not pretend to be the most rugged of travelers, but I have learned to make do. When we arrive at the campground, I immediately start to design my new home, picking out our spot and setting up the tents. We can see children leading cows down to the river a few feet away. In the morning, I line up with the only other tourists, a group of Italians, for a shower from a metal tank that the camp manager keeps filling with buckets of river water. (I quickly figure out that it's better to shower at the end of the day, after the water has had a chance to warm up in the sun.) It's New Year's Eve, so I get everyone together and arrange to buy a goat and have it roasted so we can all celebrate later.

Brook and I head to another market, and now I'm primed for the hunt. The moment I walk in and see all these girls wearing rows and rows of beads that glow on their dark, slim bodies, I can visualize the necklaces on stands at my shop. I jump right in and buy string after string of round red beads and chunky glass stones. I pick up cylindrical beads from Mauritania that look like hard candies. I buy clothing right off people's backs. The tribes are such an anachronism, a living, breathing throwback to another era. Each has its own distinctive style of hairdo and jewelry and dress—except now you see a zipper worn as a headband or a metal watchband turned into a pendant. As a designer, it's interesting for me to see how an object taken out of context acquires a whole new meaning.

The people of the Hamer tribe look so sophisticated they could be walking down the streets of Manhattan, yet at the same time they're standing here naked as if it were the most natural thing in the world. Those guys over there are jiving each other, just like the guys on my street corner.

The more I travel, the more common denominators I find, and that translates into my interiors. Back in Addis Ababa, I head straight for the furniture shops. Now that I know what's available, I know exactly what I want. I buy chieftain's chairs carved from a solid block of wood, the slatted backs inset with coins. I buy wooden hour-glass-shaped stools and low tables, trays and wooden platters incised on the bottom with designs. I buy children's chairs and canes and small ebony spoons. I buy funeral totems made by the Konso people, with teeth made out of seashells and bone.

Somehow the objects are all inter-connected and so are we, living in one big global village. I went to Ethiopia expecting the people to be primitive, but it's very hard to see them in those terms, which just shows how sophisticated the primitive can be. Or is it how primitive we are?

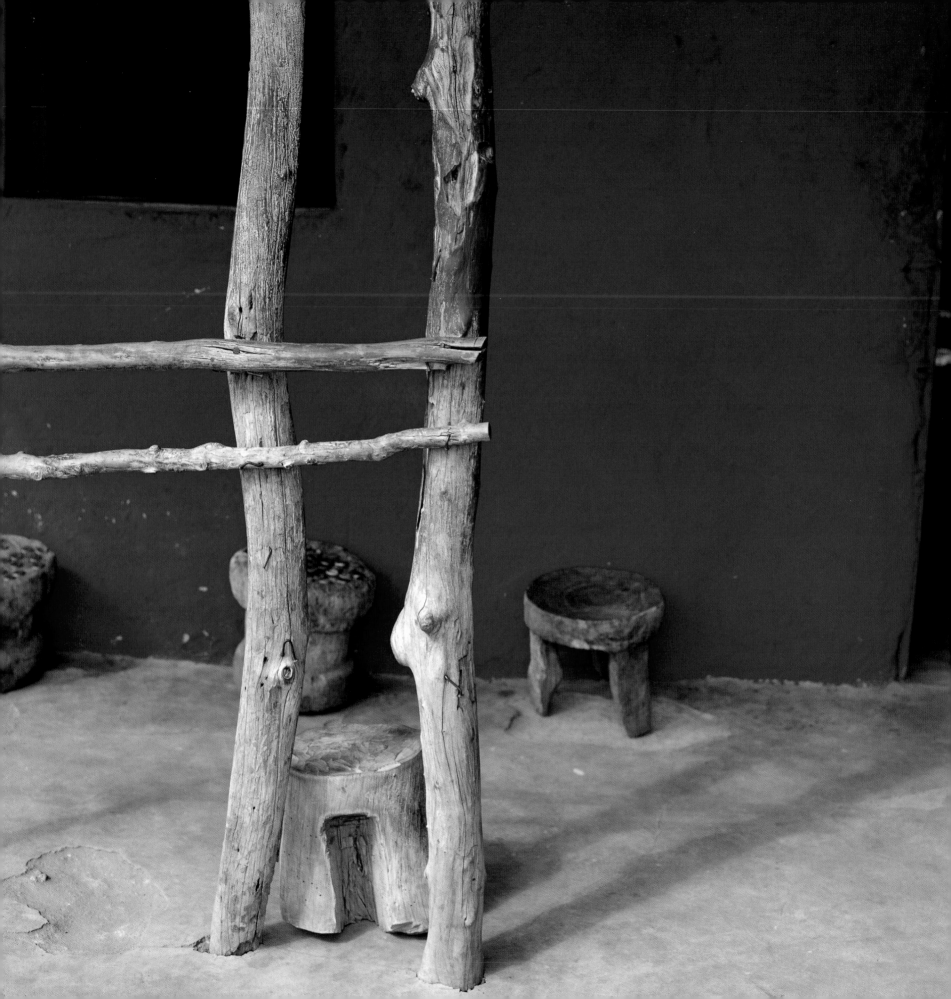

ETHIOPIA COMPOSITION

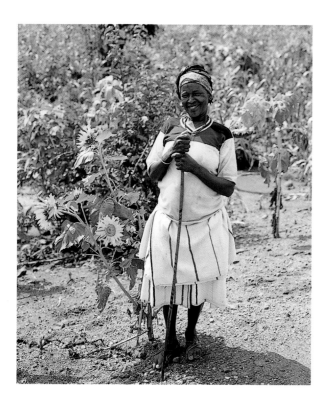

WHEN I LOOK AT A PHOTOGRAPH MONTHS AFTER I'VE TAKEN IT, I SEE IT IN A WHOLE NEW WAY. It's no longer simply the memory of a moment, but an object in itself. Once the experience is more distant, I "read" the photo almost like a book. When I picked up my camera, I saw one thing, a woman standing in a field of sunflowers. Now when I look at the picture, I see it more abstractly. My eye starts to isolate each element, noticing the color of the earth, the different greens of the leaves, the shade of her skin. All of a sudden I start to analyze the photo as a play of tonalities, a composition of forms. It's the yellow that stands out and captures attention, which reminds me of how important an accent color can be in a room.

And it only takes a small amount to make a big impact. This is very reassuring for someone like myself who believes that maintaining a certain sense of neutrality increases the longevity of a space. You can bring in a bit of yellow or pink or green, whatever appeals to you at the moment, and then you can take it out when you get tired of it. That kind of flexibility allows a room to travel longer through time. When you get bored, all you have to do is add new pillows or a rug to refresh it.

In this living room, part of a turn-of-the-century beach house on Long Island, the cool, clear neutrals—dashed with yellow—bring in a light, bright contemporary point of view. At first it may seem to have little in common with the field of sunflowers in Ethiopia, but look more closely. I'm working with the same tonalities—the sunny pillows, the sandlike sisal. When I took the photograph, I was struck by the contrast of the lush sunflowers and the dry earth. The woman, who so naturally incorporated the colors of her environment into her clothing, reminded me of one of my basic principles of decorating: when you're stumped for a color or can't decide on a particular palette, just take a closer look at the world around you and you'll come up with a wealth of ideas.

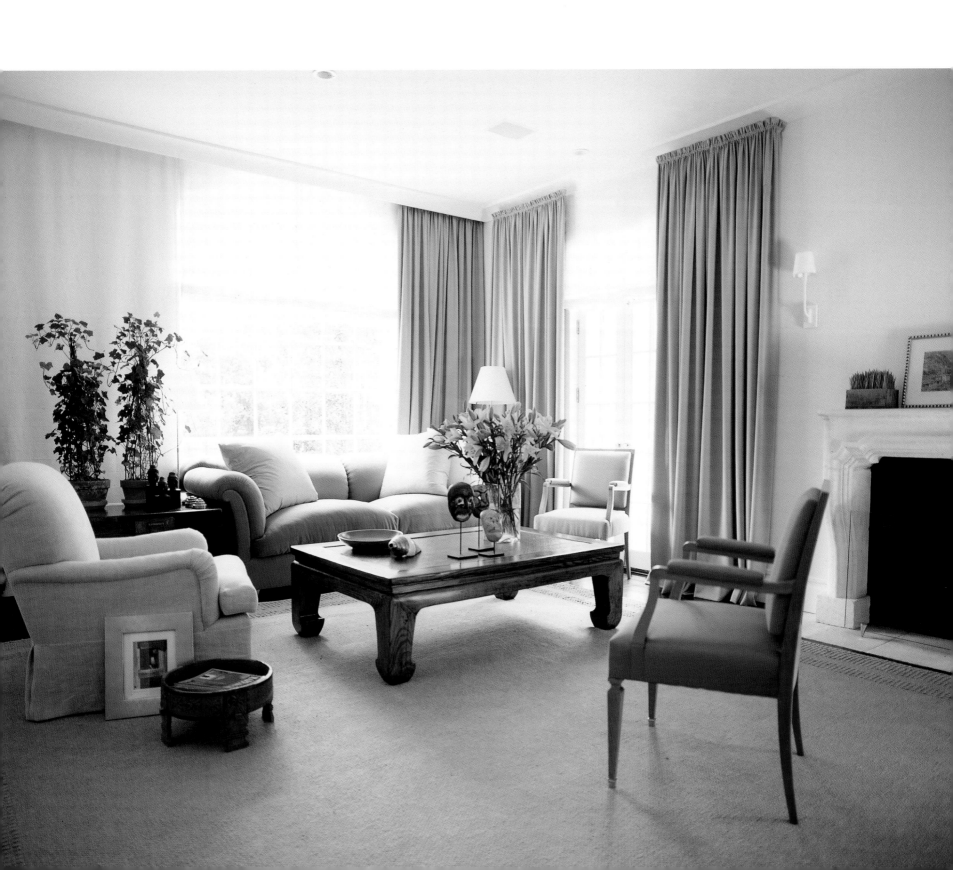

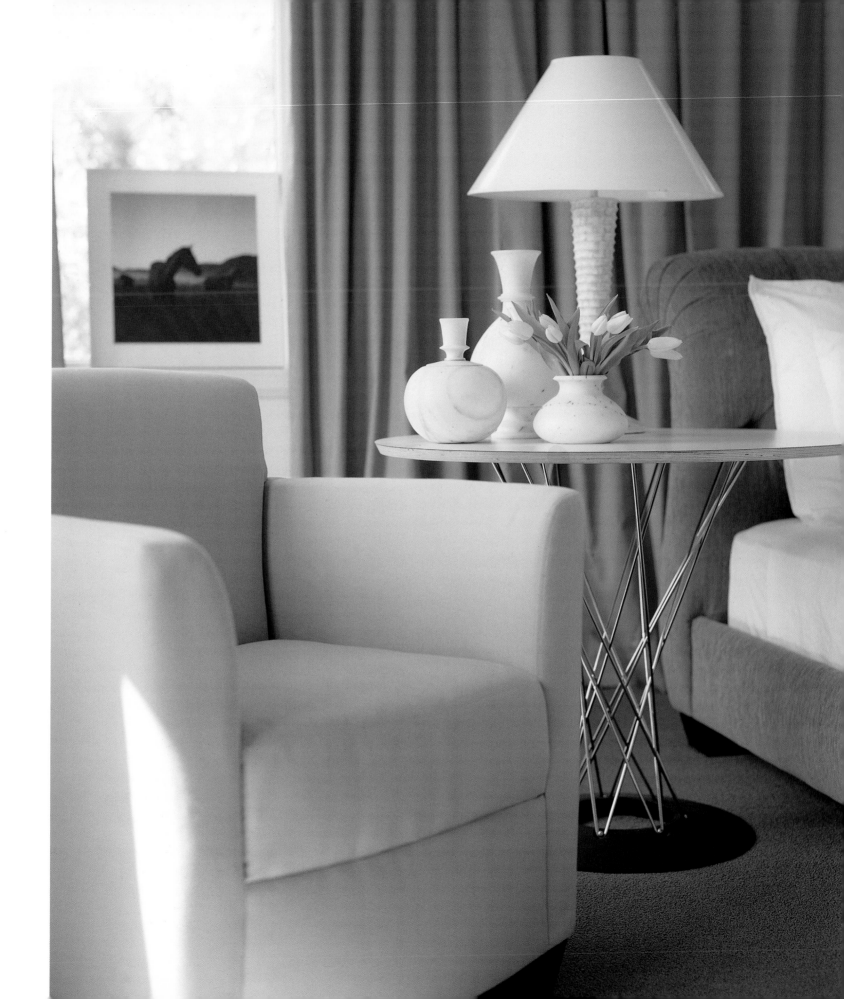

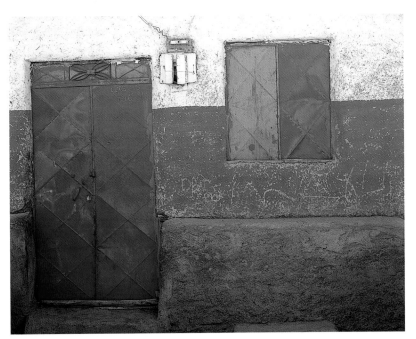

BENJAMIN MOORE
WHITE CHRISTMAS
872

BENJAMIN MOORE
BLUE NOVA
825

BENJAMIN MOORE
STRATFORD BLUE
831

BENJAMIN MOORE
806

While driving through a small town, I suddenly said, "Stop the car!" I wanted to get a closer look at this wall, painted a dazzling blue. But not just one blue. It was almost as if the painter had run out of paint a third of the way through and simply stirred up a new batch without necessarily trying to match the first. And then stirred up another.

I used to think a room looked best when everything in it matched. I would try diligently to find upholstery and curtains and a rug in the exact same shade. But that ends up looking very static. I finally realized that what you really want is a mixture of shades and tonalities in a space, even if you're working with only one color. The variation in tone gives a room depth and makes any color look so much richer. It's the variation in blues that makes that wall so beautiful.

One color is great, but something even better happens when you put several colors together. Look how that band of white sets off the blue, which then merges into the dark earthen stucco. The horizontal stripes are echoed by the vertical stripe of the two shutters, creating a powerful graphic image. If the whole wall had been painted a uniform blue, it would not have had the same impact.

I did my own variations on the theme of blue in this guest room in an upstate New York house. Here the blues range from pale to deep, from purply blue periwinkle to azure. To set off the blue, I too chose white for the sheets and the accessories—a white lamp, white marble containers from India, and a white Noguchi table.

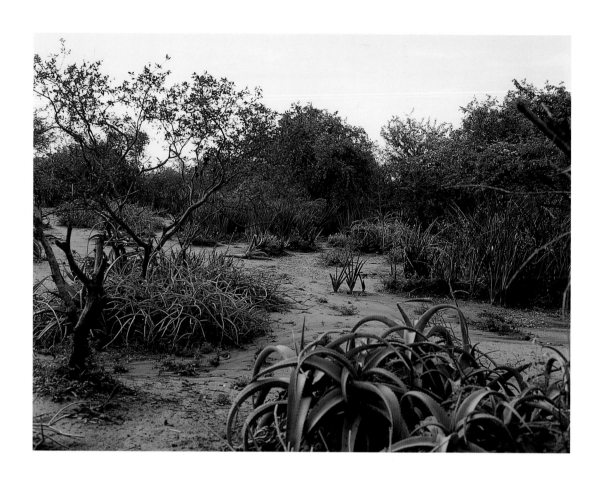

BENJAMIN MOORE
ATMOSPHERIC
AF-500

BENJAMIN MOORE
EXHALE
AF-515

BENJAMIN MOORE
CONSTELLATION
AF-540

BENJAMIN MOORE
VALLEY FORGE
BROWN
HC-74

I WAS FASCINATED WITH THIS DRY RIVERBED SPROUTING WITH VEGETATION. There were all sorts of succulents, each with its own individual shade of silvery grayish green. Everything had an iridescent quality. In a country where most of the colors are true greens or browns, these plants were something different. I got out my Benjamin Moore paint chips and started trying to match the colors of the plants and the earth. All those spikes surrounding me gave the place a slightly surreal quality. I was excited because I love those kinds of indeterminable, elusive colors, those greens that blur into grays or blues and back again.

I tried to play with the same shades in this master bedroom, decorating the space with gray-blues and gray-greens, searching out a wonderful Italian silk damask for the headboard that combined those colors with earth tones. One thing all the fabrics shared was that magical iridescence, which meant no color stayed the same. They seemed to be constantly shifting and changing in tone, looking like different shades in different lights, so the room seemed to vibrate with color.

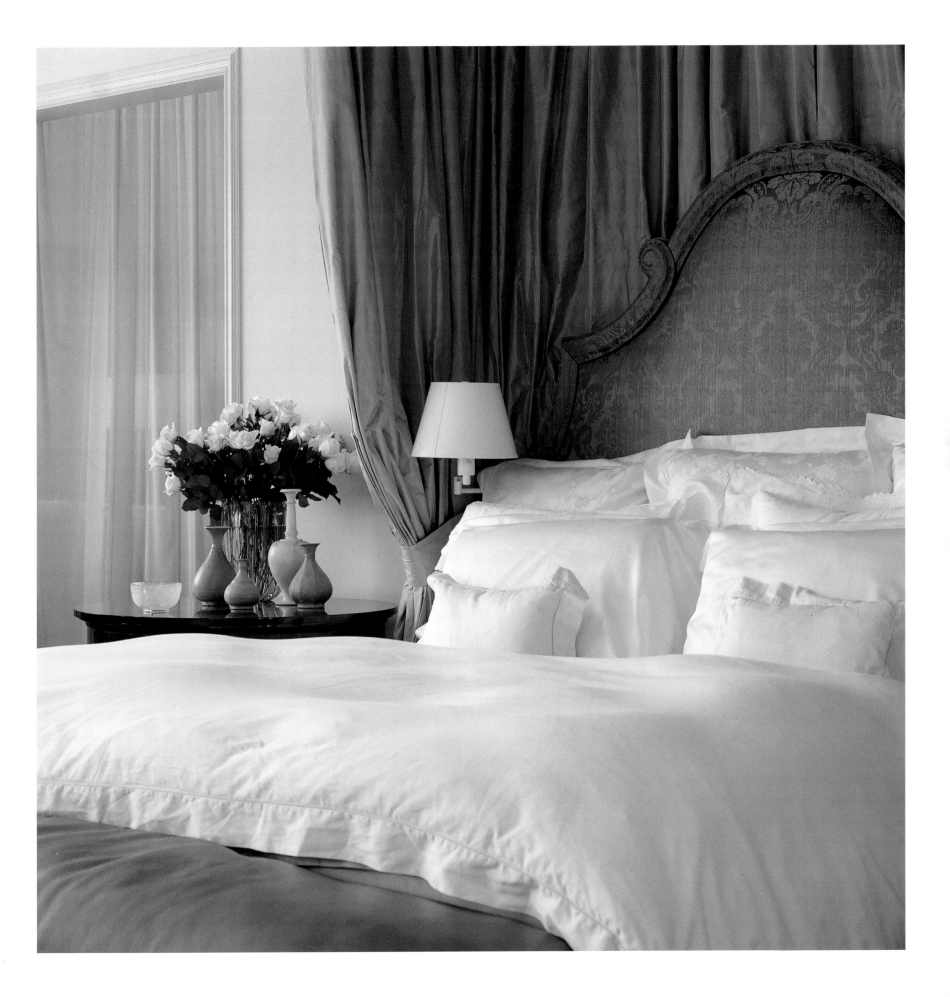

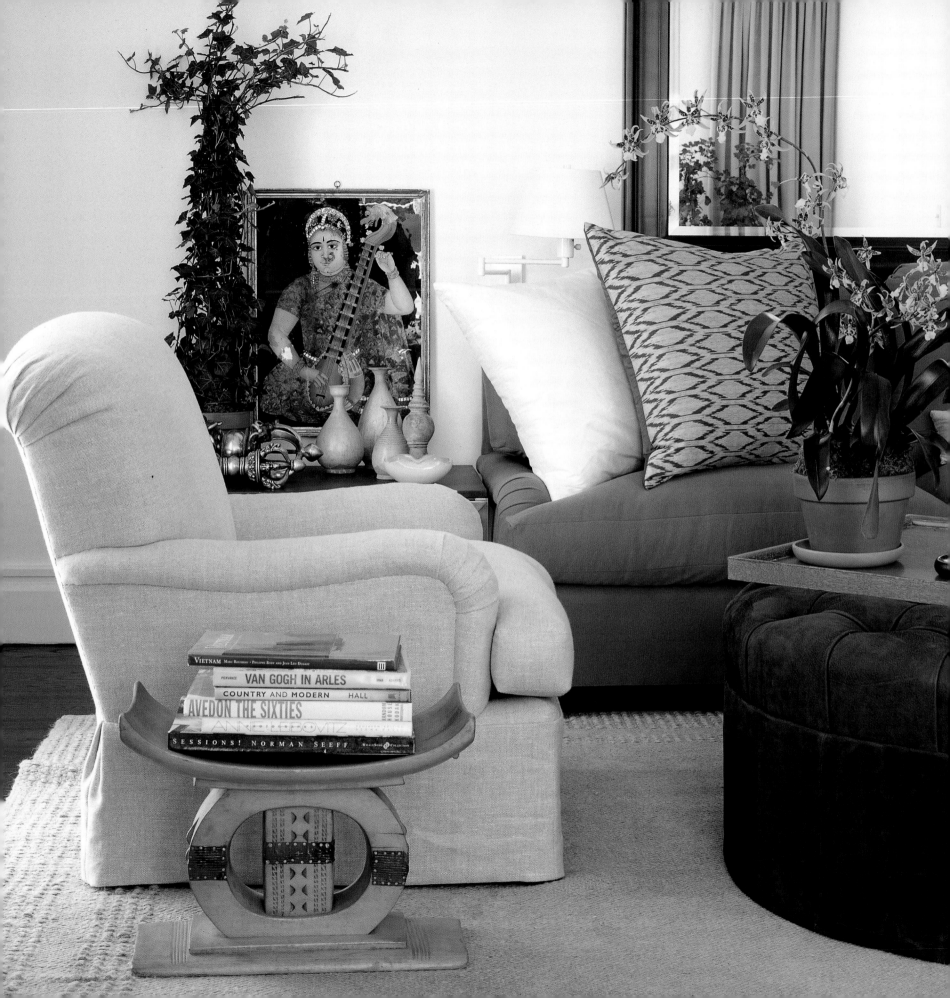

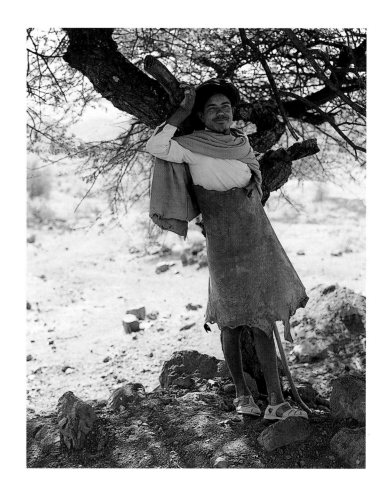

I SPOTTED THIS SHEPHERD HIDING FROM THE MIDDAY SUN in northern Ethiopia and thought he had such panache, just leaning there against the tree, wearing a turban, a white cotton shirt, a length of wool casually wrapped around his neck, and a leather hide around his waist. All these elements seemed to come straight out of the earth. The soft colors and the various textures worked so well together.

I used the same earthy colors and textures in a Long Island living room, thinking of this image when I chose the leather for the ottoman, the fabric for the sofa, and the shade of the curtains (which could have been made of the same soft wool as the shepherd's throw). It's fascinating how the eye will pick up something in a faraway place and use it later. What I'm attracted to when I travel is actually the same thing that I find interesting about interior design. It's the play of color, shape, and texture. The textures in this space range from the rough linen of the handwoven rug to the softer linen on the club chair to the smooth billiard cloth on the sofa to the sueded buffalo on the ottoman. I've used natural materials in nature's colors, and that's what makes the room feel alive.

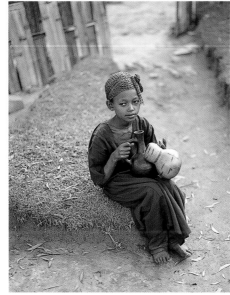

It's interesting to see some of the things I bought in Ethiopia come together in the outdoor shower at my own house in Montauk. The gourds I bought from children in the Dorze village become the perfect receptacle for flowers, and a chair I found in a small roadside shop in Addis Ababa now holds towels. I'm always attracted to children's chairs or stools because of their charm—look at the legs on this one. I might use a stool as a small table to hold books or as an extra pull-up chair by the fire. Part of what's wonderful about a primitive object like this, besides the touch of the craftsman's hand, is the evidence of the wear and tear, the layers of dirt and mud and oil that give it such a warm patina.

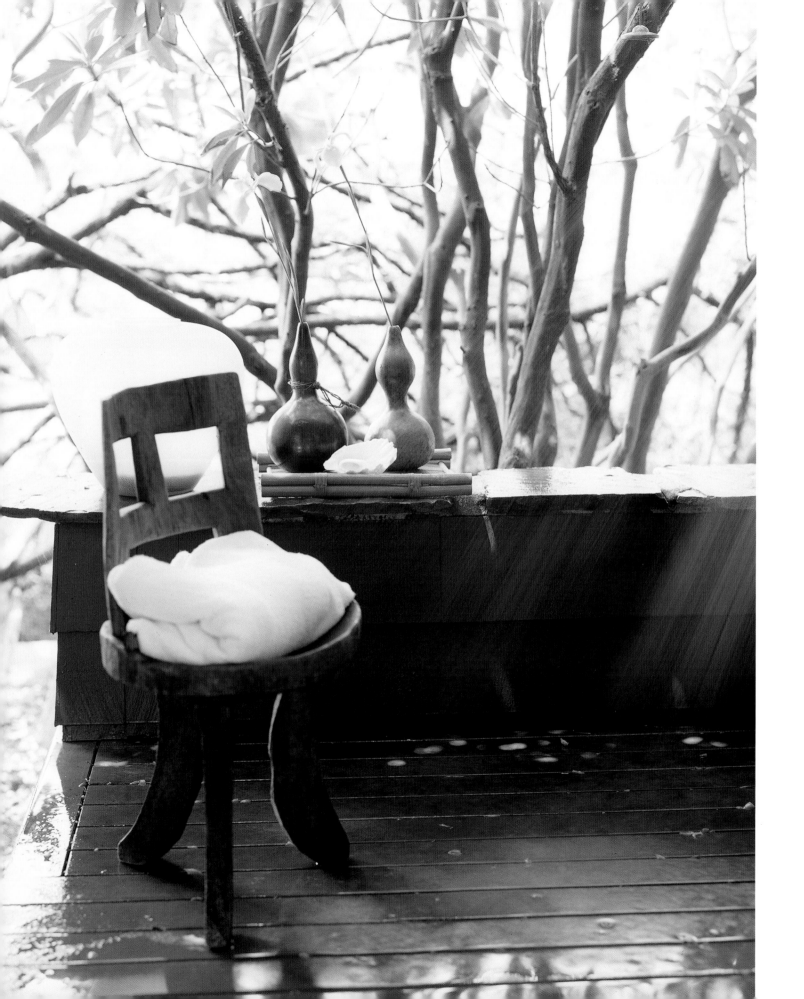

WHEN I GO TO THE MARKETPLACE, I'M NOT DISAPPOINTED IF I DON'T
SCORE A BIG FIND. Sometimes you have better luck with small, decorative
objects, the kind of pieces that could be a nice accent in a room. When
I land in a new country, my modus operandi is simple. First, I case out the
obvious souvenir shops in the city and see if anything catches my eye. Then
I go to the marketplace and try to find what I liked at a much lower price.
In most markets, there's a young kid who's very happy to take you around.
When I arrived here, I already had a list of items in mind, and one was horn
cups. Sure enough, the kid led me around the back and knocked on a
door. In every other shop, I only saw one or two cups, but this dealer had
bags and bags. I picked out a selection, looking for a variety of sizes,
shapes, colors, and textures so that when grouped together, they wouldn't
all look the same. I bought thirty cups from him, envisioning them filled
with flowers, pencils, and paintbrushes, or with knives, forks, and spoons
on a buffet table.

Unfortunately, when I got them home, I discovered that some were
not very well made. They leaked when I filled them with water, so I just
poured Krazy Glue on the bottom to reseal them. Now they look splendid in
a log cabin in Jackson Hole, Wyoming, lined up on a little table from
Ethiopia and filled with an array of flowers.

Most people make the mistake of thinking that you have to isolate
an exotic object, but I'm always looking to see how I can incorporate
it into my own environment. The horn cups become just another element
in the composition.

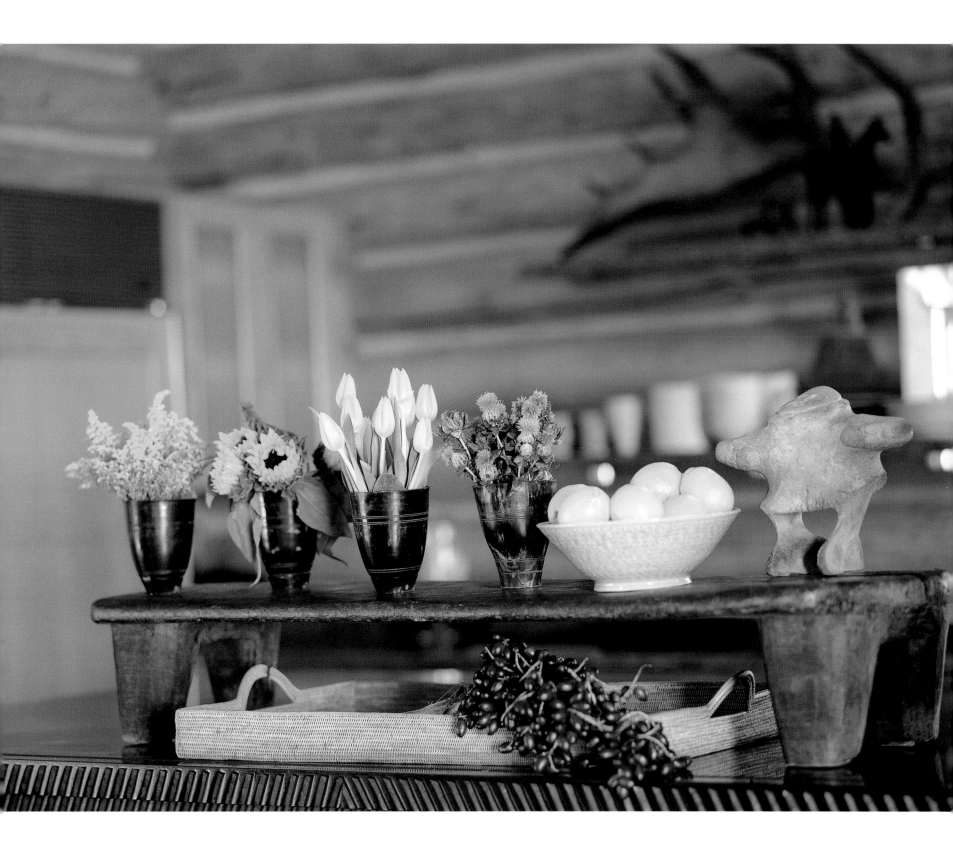

I've always wanted one of those chieftain's chairs that come from Ethiopia. Before I left New York, I tried to find a picture of one that I could show to a shopkeeper instead of trying to describe it, considering the language barrier. It was lucky that I did, because it turned out to be very hard to find them. Most shopkeepers, when shown the picture, nodded their heads and said, "Oh yes, I know what they are, but no, I don't have any." The old chairs they did have in stock were usually rather small and rudimentary, but a chieftain's chair is normal-size. The new chairs were all made of plastic. Finally one dealer said, "Oh yes, I know people who have some." When I came back to his shop a few weeks later, he had four waiting for me to examine. I think he was surprised when I bought all of them.

I love their handmade quality; the arms aren't exactly straight and the seat isn't quite even. I like the way the craftsmen will incorporate little mementos, such as shiny coins or buttons or even a piece of jewelry, into the slats of wood that make up the back. I love the woven leather seats that are darkened and stiff from years of wear.

This one has come a long way from home to alight in this living room on Long Island, where its dark wood becomes an abstract, rectilinear form against the white wall, strong enough to hold its own alongside a contemporary painting and two eighteenth-century Swedish finials.

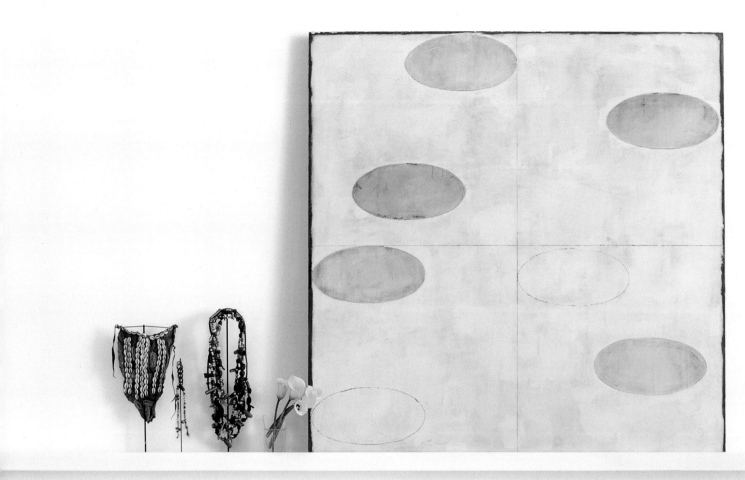

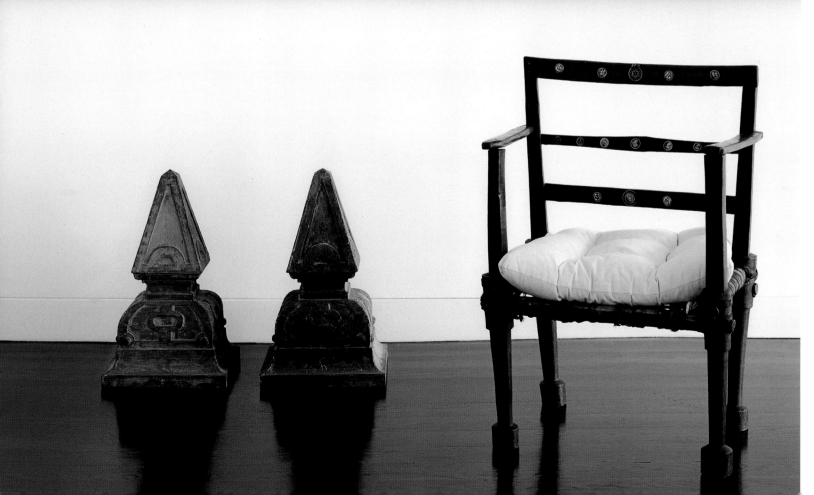

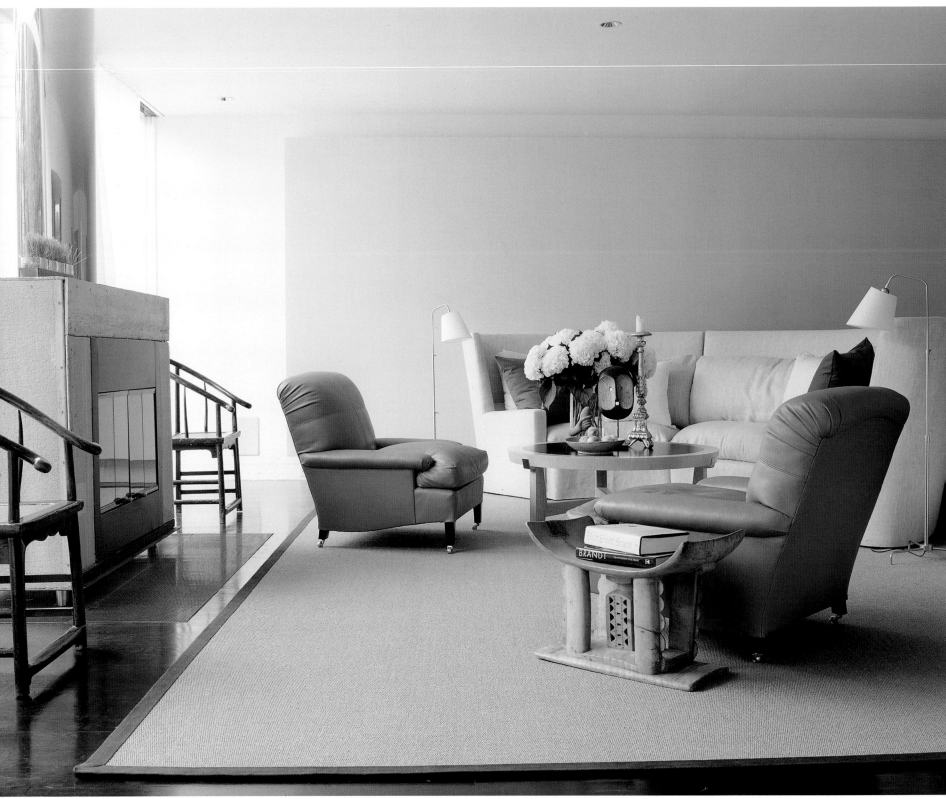

A wall of glass behind the fireplace opens this living room to the trees outside, which in turn give a green cast to the white walls on a sunny day. I wanted to capture that green, so I built a huge panel and lacquered it that same subtle shade. Pulled out from the wall and lit from behind, it looks like a floating plane of color. The furniture is all about hard curves and soft curves—in wood on the Chinese chairs or linen on the cocoonlike sofa.

My shopping instincts are so finely honed by now that the whole process of selection is almost unconscious. Have you ever seen one of those little machines that sort coins into different-size holes? Well, that's what I'm like when I get going. If I'm in a shop filled with furnishings, the first thing I'll look for is a classic shape. Then if that classic shape has been reinterpreted in an interesting way—even better. Then if it's made in a solid color or a natural material—sold.

Another point on my checklist is multiplicity—will I be able to find more than one? Almost any object becomes interesting as soon as you put a group together. One of the secrets of good design is that quantity can make up for quality. For example, say an old cane catches your eye, and you decide to buy it. Don't stop at just one. Look for more canes in every shop you visit, and soon you'll become quite knowledgeable about all their particular forms and variations.

Once you zero in on one item, just keep collecting as many different versions as you can find. When you've got the makings of an interesting display, start to think in terms of a grouping. If your chosen item comes in small, medium, and large sizes, you'll want examples of all three.

Not every single piece you buy has to be a killer. What you're after is a certain charm or individuality (the last thing you want is that mass-produced, department-store uniformity—unless you intend to bowl people over with sheer numbers).

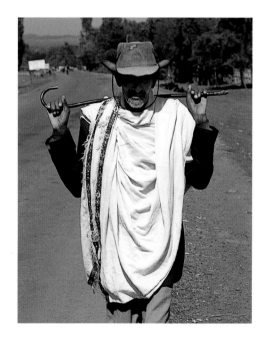

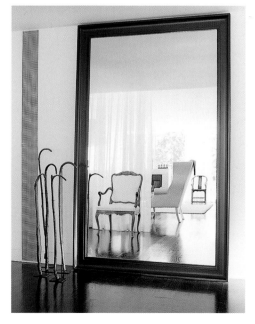

SOMETIMES IT'S ENOUGH TO BUY A BEAUTIFUL OBJECT AND JUST LET IT SIT THERE. But there's another art involved in the way you display it. Often you can give something a whole new dimension by lifting it off the ground and putting it on a stand.

I had looked at these headrests before and set them aside because I couldn't figure out what to do with them. Even when I grouped them on a table, they didn't look quite right. And then I figured out the solution. The trick was to display them at different heights. Then I could really show off the different shapes and patinas. Suddenly they were like floating pieces of sculpture.

I think any tablescape looks better when it includes something high, something medium, and something low. Here's my method for the headrests. First, I lined all of them up on a counter, then I started staggering them at different heights to create a visual rhythm. Then I measured a line from the bottom of the counter, and that showed me how high to make each stand. You can do the same thing with bracelets or necklaces or any object that would look better mounted on a stand.

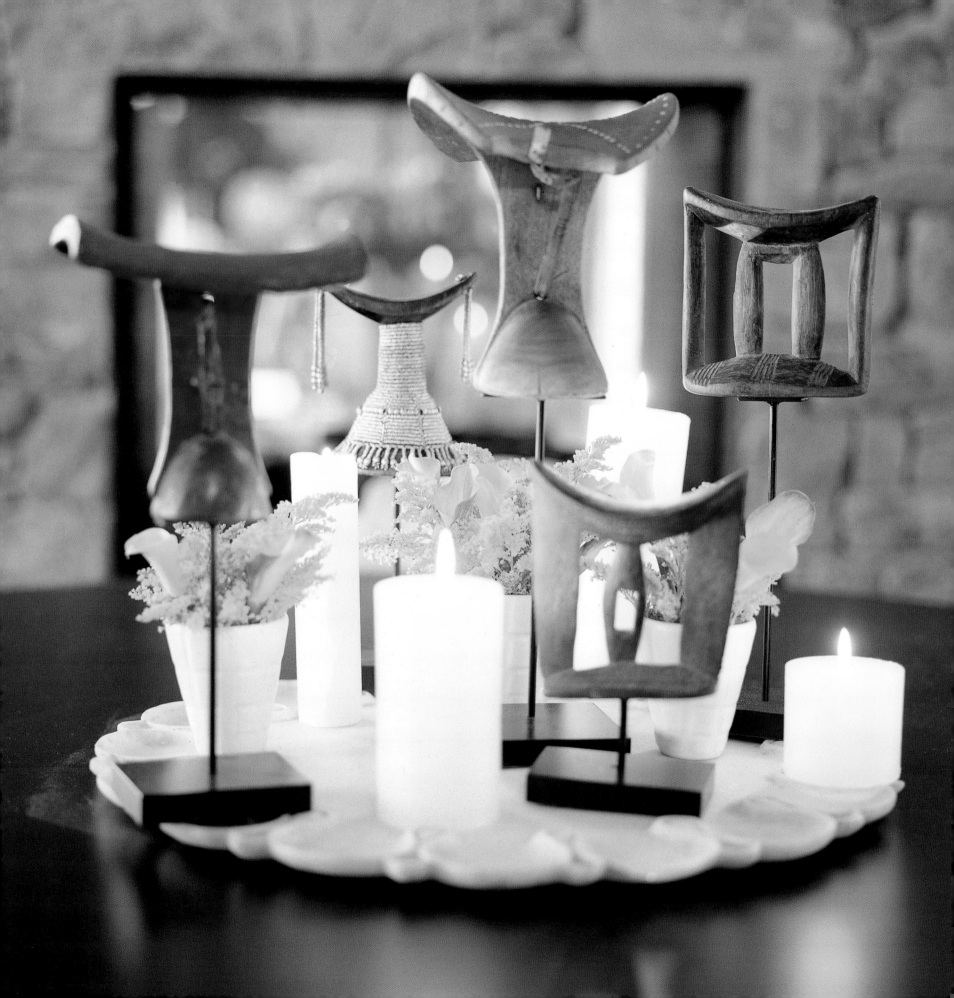

As soon as I read about the Konso tribesmen, who make little wooden funerary figures known as *waga,* I wanted to find some. Originally used as grave markers, they were carved to honor deceased warriors, with bits of animal bone for eyes and teeth. They remind me of the totems made by Native Americans or the more refined likenesses drawn on Egyptian mummies. I'm always fascinated by objects that try to capture the spirit of a person.

 When I found the figures lying in the dirt at a market, they looked forlorn. But once I had them mounted, they regained their fierceness. You always have to look past the dust to find the essence of an object. Here in Wyoming, they seem as elemental as the rest of the materials—log cabin, wood, stone, linen, rattan—in this living room. I stood them as a group to reinforce their power. One object alone can look like window dressing; three or more is a statement.

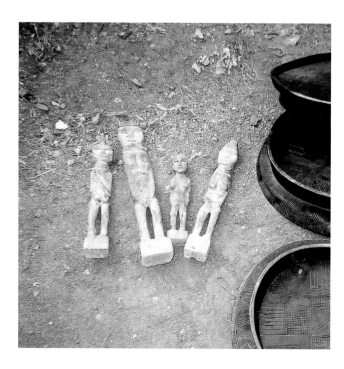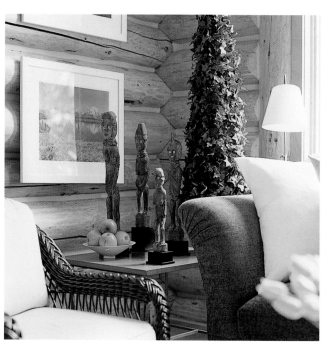

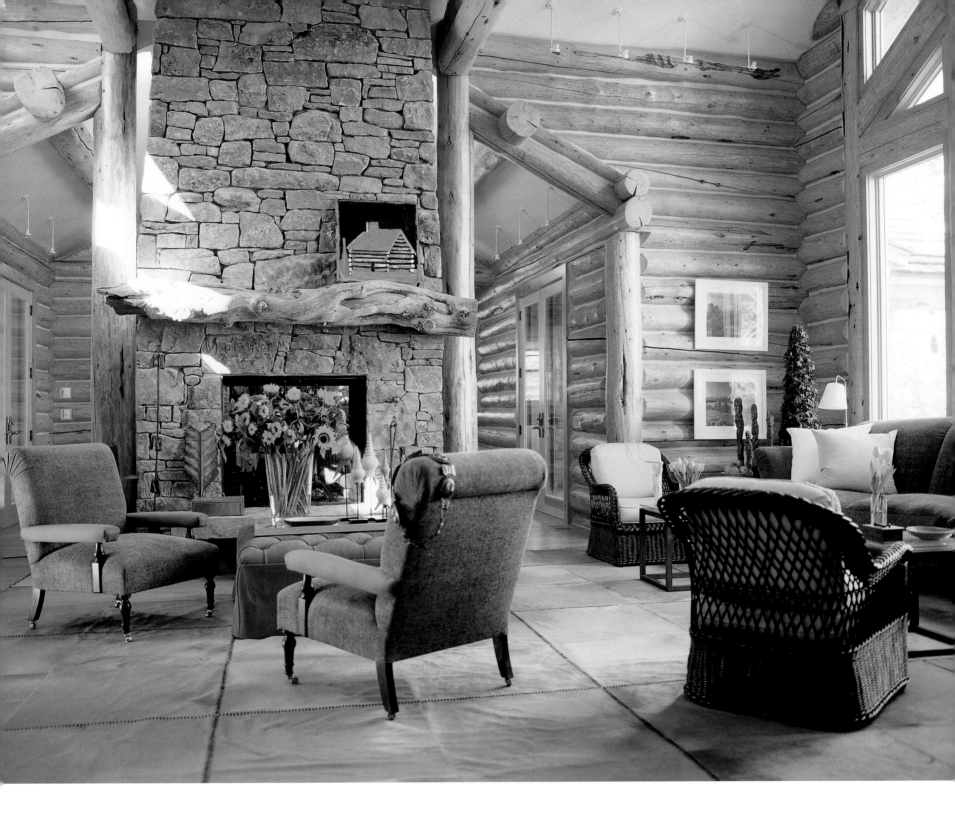

MADAGASCARSCALE

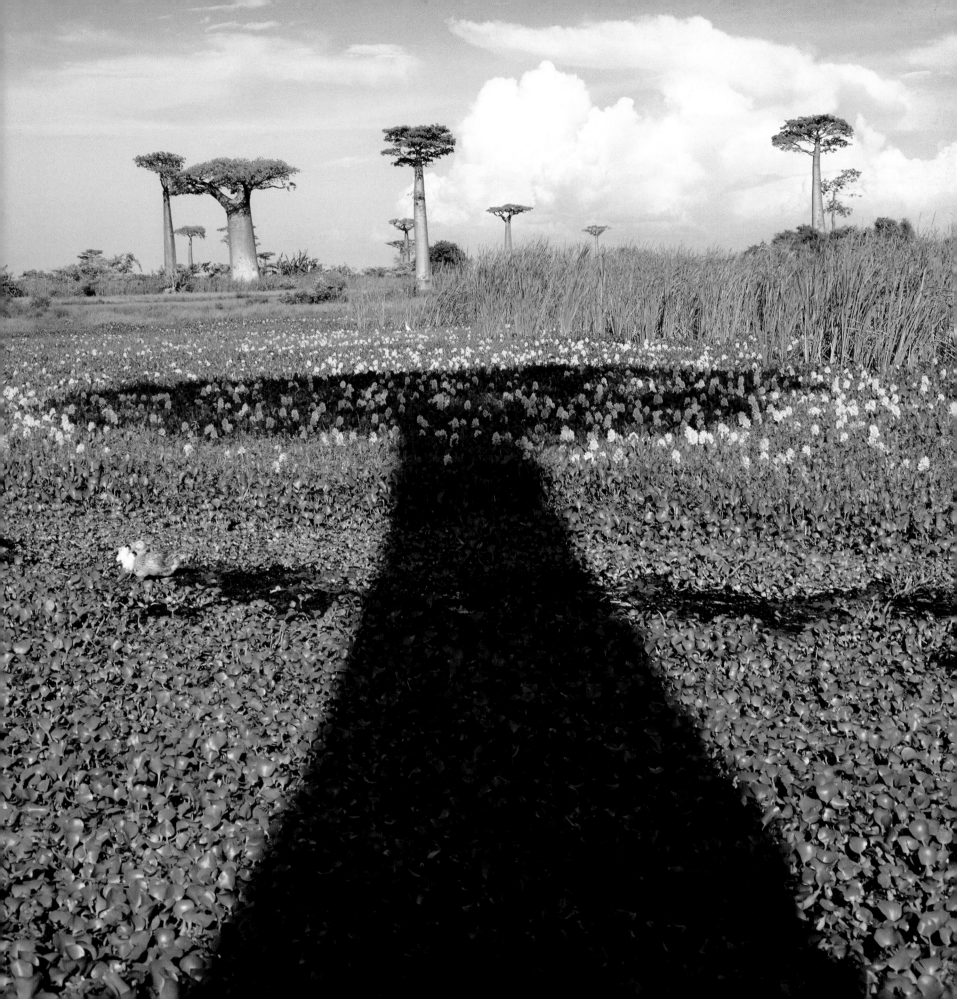

ALL I KNEW ABOUT MADAGASCAR WAS WHAT I READ IN THE GUIDEBOOK. IT'S THE FOURTH-LARGEST ISLAND IN THE WORLD (ONLY GREENLAND, NEW GUINEA, AND BORNEO ARE BIGGER) AND JUST ABOUT THE SIZE OF TEXAS. MILLIONS OF YEARS AGO, THE LANDMASS KNOWN AS MADAGASCAR BROKE OFF FROM THE EASTERN PART OF AFRICA, AND IT REMAINS AN ECOLOGICAL WORLD ALL ITS OWN. MOST OF ITS PLANTS AND ANIMALS ARE UNIQUE TO THE ISLAND.

A CHAIN OF MOUNTAINS BISECTS THE ISLAND LIKE A SPINE. TO THE WEST IS A DRY, RUGGED PLAIN; TO THE EAST, A LUSH RAIN FOREST WITH OVER 170 SPECIES OF PALMS, 165 OF THEM FOUND NOWHERE ELSE ON EARTH. THE UBIQUITOUS RAFFIA PALM IS THE PROGENITOR OF A MILLION BASKETS, HATS, AND MATS. WITH ALL THIS INCREDIBLY RICH FLORA AND FAUNA, IN HABITATS COMPRISING EVERYTHING FROM DESERT TO SWAMP, MADAGASCAR IS ONE OF THE MOST BIODIVERSE PLACES ON EARTH. NO WONDER THE PEOPLE SEEM EQUALLY HETEROGENEOUS.

THE ETHNIC MIX IS APPARENT FROM THE MOMENT YOU LAND AT THE AIRPORT. I SEE FACES THAT LOOK INDONESIAN, AFRICAN, INDIAN, PAKISTANI, CHINESE, AND EUROPEAN—SOMETIMES ALL AT ONCE. I HAVE THE SENSE THAT I'M IN THE FAR EAST, RATHER THAN AFRICA. ARCHAEOLOGISTS PROPOSE THAT THE FIRST SETTLERS SET SAIL FROM THE FARAWAY SHORES OF INDONESIA AND THE MALAY PENINSULA ABOUT TWO THOUSAND YEARS AGO. LATER ARRIVALS FROM AFRICA, ARABIA, AND ASIA FORMED THEIR OWN TRIBES. A PORTUGUESE FLEET LANDED ON THE ISLAND IN THE SIXTEENTH CENTURY, PAVING THE WAY FOR THE EUROPEANS. TODAY, THE INHABITANTS OF MADAGASCAR, KNOWN AS THE MALAGASY, ARE DESCENDANTS OF EIGHTEEN ORIGINAL TRIBES, WHICH HAVE ALL MIXED AND MINGLED.

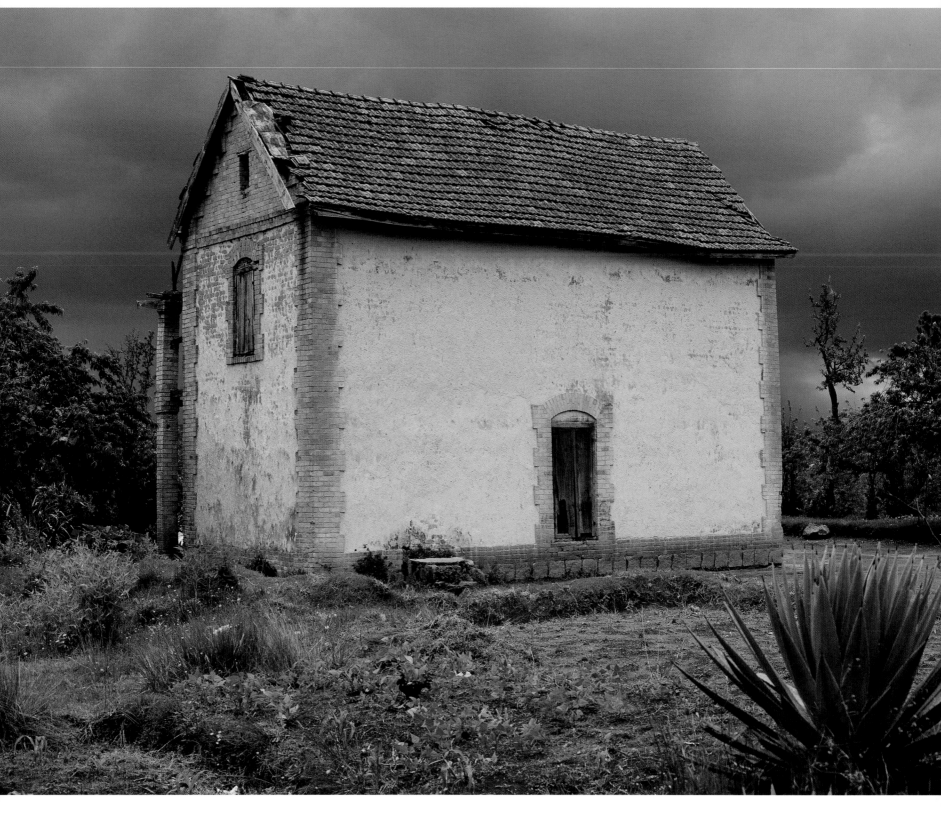

By the late eighteenth century, the king of the Merina tribe (a Malay-Polynesian group) ruled the country. His capital, Antananarivo, in the central highlands, is now the nation's capital. It's small and intimate, with mostly one-story dwellings in the French Colonial style. Madagascar was a French colony for seventy-five years.

On the way out of the city I spotted my first market and was dazzled by the profusion of fruits: peaches, strawberries, mangoes, plums, bananas, and papayas. Madagascar has a wide range of topography, and everything seems to grow well. Scents of pine, clove, and eucalyptus filled the air.

As you drive along, suddenly you'll see ten roadside stalls, all selling raffia bags or hats or whatever. Families will band together and specialize in one item, such as toy cars made out of salvaged tin cans. In one hut, they'll be cutting the tin; in another, daubing it with paint; and in another, assembling the final car. With very little to work with, it's amazing how they've established a whole cottage industry. One family will make miniature bicycles, another will make miniature soda trucks, and the finished products will be neatly lined up on boards to entice passing cars.

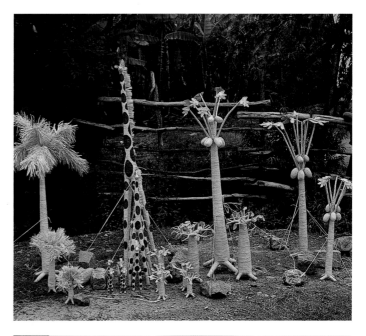

We're heading south through the highlands toward Antsirabe. Here, houses are generally built of red brick, made from the earth. All along the way, you see smoke billowing from large stacks of bricks being baked. Most houses have a porch and a pitched roof. The front faces west, and no doors or windows face east—it is considered *fady*, or taboo. *Fady* is an all-encompassing word for a complicated system of traditions that is still very powerful today.

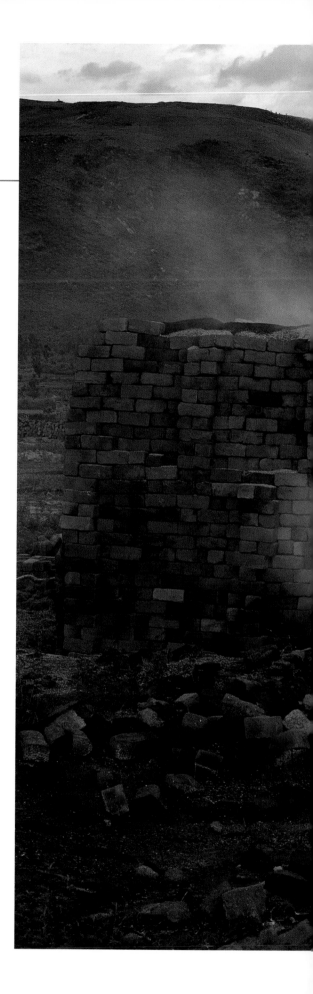

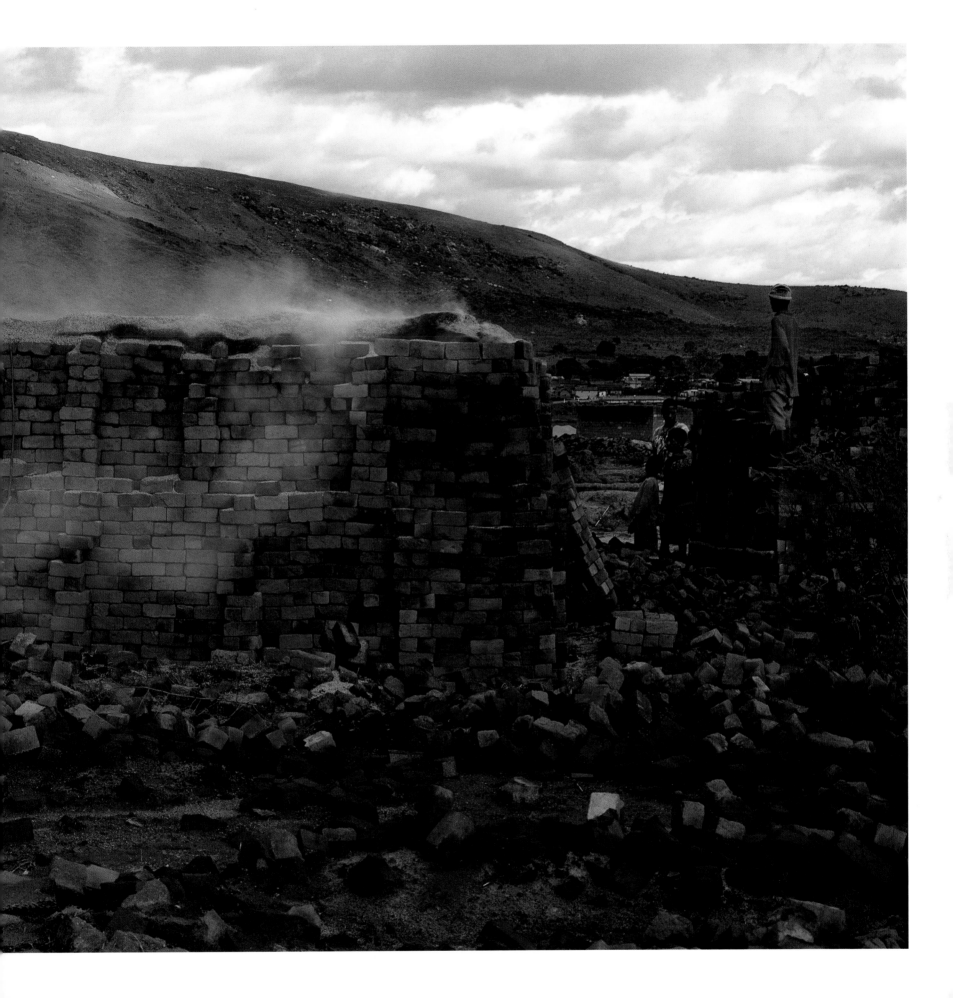

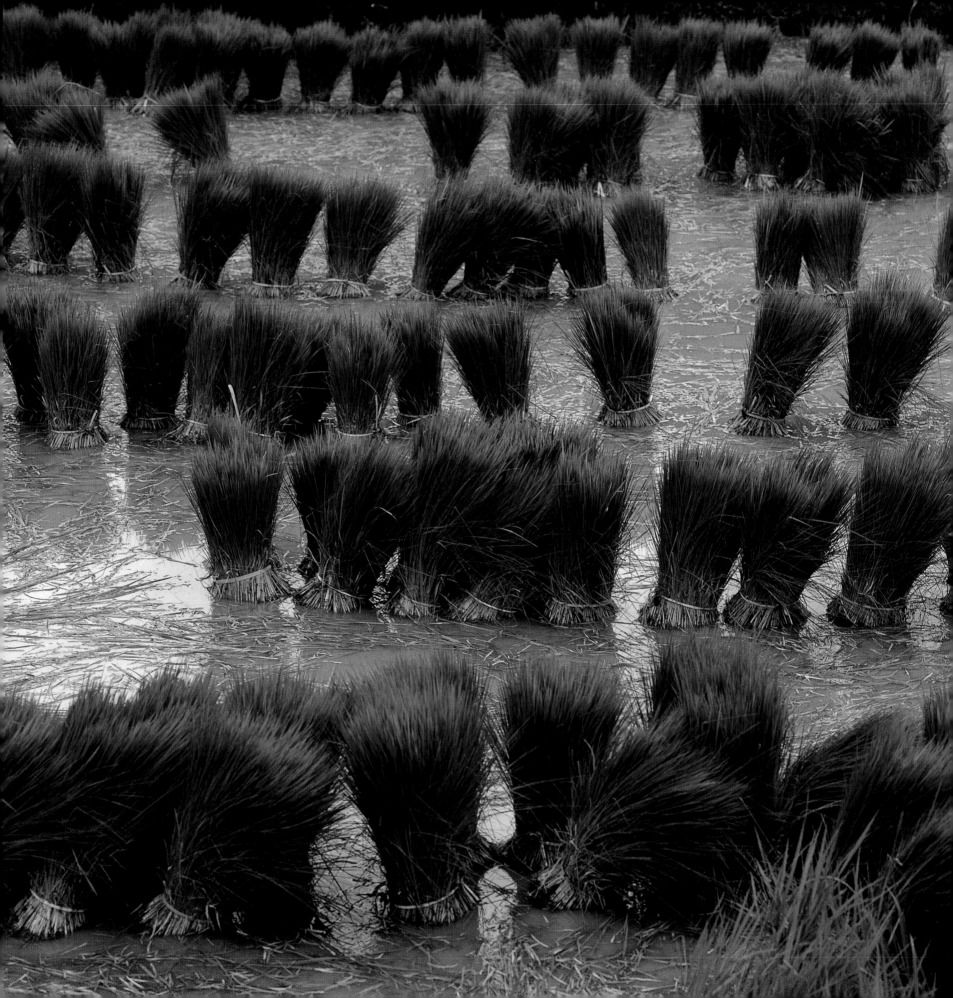

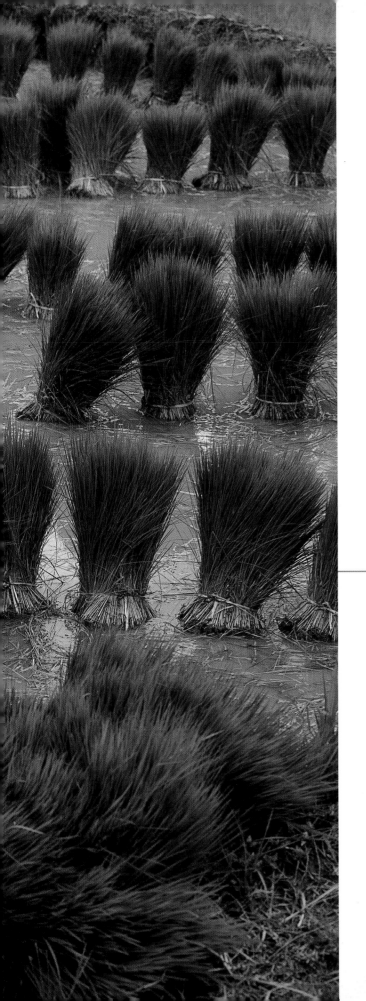

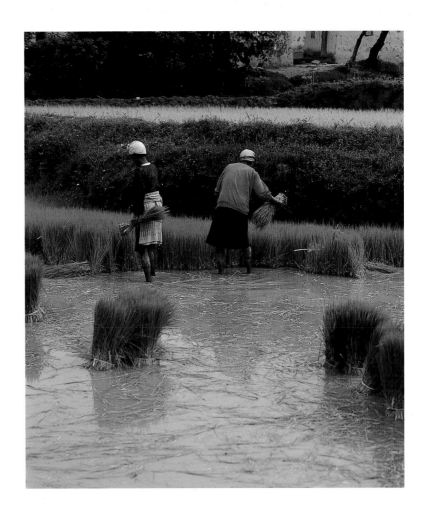

The countryside is terraced with rice
paddies, and the new plants have turned
the ground into a soft blur of green. My
guide explains that the cultivation of rice
is very labor-intensive. First, the farmers
plant the seeds in a small plot, flood
the ground, and wait until the sprouts
come up. When they're six or seven inches
high, they dig up the tightly packed
seedlings and replant them in large fields,
where they are separated and spaced farther
apart. What I found interesting was the
geometry. If you look at the field in a
certain way, you see very exact rows. Step
three feet to the left, and suddenly you see
the seedlings en masse, like a blanket
of color. It's such an intense, vivid green.

My guidebook mentioned the market in the village of Ambatolampy along the way to Antsirabe. So we stopped, but these local markets are not about crafts. They're more about food and provisions. I did pick up some vibrant *pareos*, or sarongs, printed with fruits and flowers, the kind of souvenir that's manufactured throughout the island in different factories. But I couldn't resist the bright colors and bold patterns.

It was litchi season, and everywhere we went they were selling this fruit alongside the road. I have never before had ripe litchi right off a tree. It's an incredible experience—like eating perfume. I peeled the nuts and filled my mouth with them, inhaling the aroma. I couldn't stop eating them.

In Antsirabe, the major mode of transportation is the rickshaw—a legacy of the Chinese laborers imported by the French to build the railroad. There must be hundreds of *pousse-pousse*, as they're called (a driver would shout "Pousse! Pousse!" when he needed a helpful push going up a hill). Even in the Orient they're disappearing, but here in Madagascar they are an integral part of everyday life.

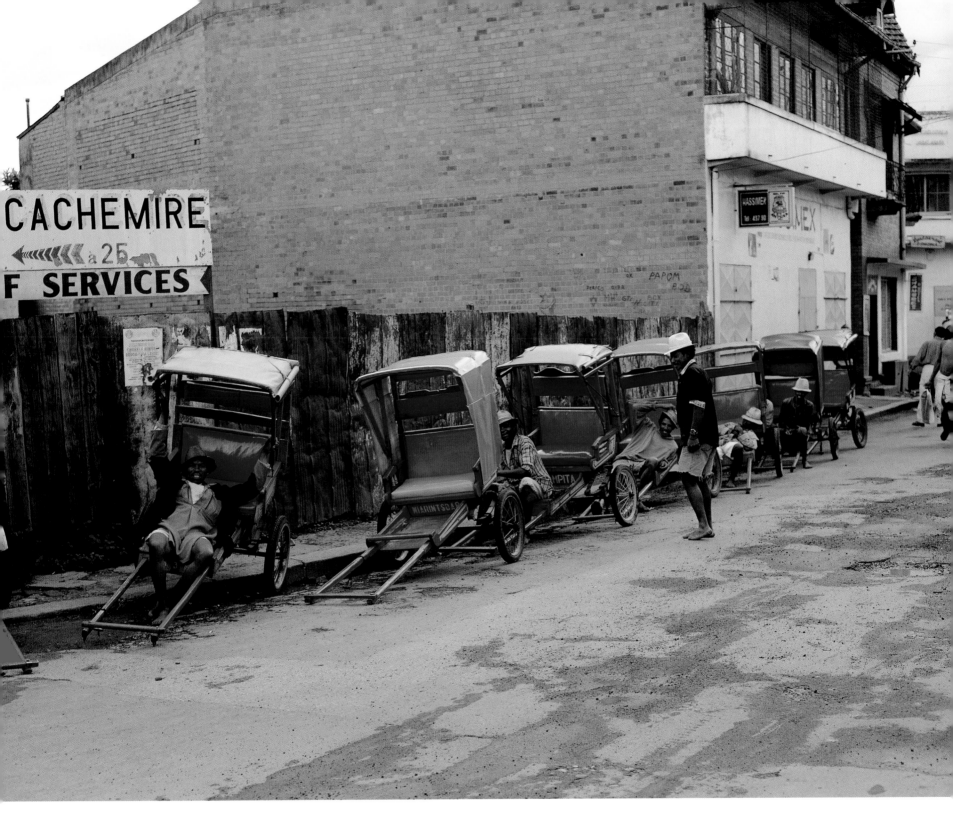

In the morning, we head further south to Ambositra, known as a center of the wood-carving industry. My guide is driving a Range Rover, and the backseat is adorned with crocheted slipcovers. After sitting for hours, I emerge with the oddest designs on my skin. Not quite as fanciful, though, as the elaborate inlaid boxes in Ambositra. I looked through the wood-carvers' shops, and the quality of workmanship on the chess sets and carved figurines is extraordinary. I found some big spoons made of horn, which I'll use as salad servers.

The next morning, I woke to torrential rain. The day's excursion to the village of Antoetra, inhabited by the Zafimaniry people who still lead a very traditional life, was almost canceled. But by 9 A.M. the rain had stopped, and we drove twenty-eight miles through rolling hills, rice paddies, and what's left of the forest (unfortunately, the Malagasy follow the slash-and-burn approach to agriculture). The road was dirt, with some impressive potholes, but we bumped along, fording a few streams. By the time we got to the village, it had started to rain again. We were met by the inevitable passel of kids. I handed out the candy I buy for these occasions, and we walked into the village together.

The Zafimaniry are famous for their houses, which they build entirely of wood, with no nails. Then they carve intricate geometric designs into the walls and doors. There were about forty huts, and everything was brown: brown wood, brown dirt, brown people. A beautiful woman was sitting quietly while another woman picked lice out of her hair. In the center of the village was an altar with offerings to their various gods.

I stepped into some of the huts, smiled at the people. They look at you, you look at them. You laugh, point, and try to communicate. By this time, it was really pouring. One man came over to my guide and explained that the river had flooded, washing out the road, which meant that we could not leave. But this was not a problem, according to him, because we could stay at the house of the principal man of the village. Well, as I have said, I am not the great-outdoors type, given a choice, but the guide told me the chief would be highly insulted if I refused his offer and slept in the van. So here was my moment to give up all my bourgeois comforts and live the real life.

The space was about nine by ten feet wide, with a fire in the middle and one cot, where the chief slept (everyone else got the dirt floor). It was dark and smoky, lit only by the glow of the fire. For dinner, they killed a chicken and prepared it with carrots and potatoes, which we all ate with our hands. Everything was washed down with taoka gasy, a local rum brewed from sugarcane. Everyone talked and gossiped while the children poked their heads through the window and laughed at the big tourist who was stranded in their village.

When it was time for bed, I was generously given the wooden cot, which consisted of four sticks tied together with leather thongs. As soon as I lay down, it broke, to the great amusement of all. Thank God, I can sleep through anything, even mysterious creatures crawling next to me on the floor. At 5:30 in the morning, coffee was prepared for us, strong enough to wake the dead, and we were informed that the road was accessible enough for us to leave. I walked out a little disheveled but not empty-handed. I'd bought some carved wooden containers that might look nice in a bath, to hold Q-tips and such. As we drove away, I wondered what would happen to these gentle people. It must be getting harder and harder to live, following old native ways, as the forest gets chopped down around them. What are they going to do when there are no more trees?

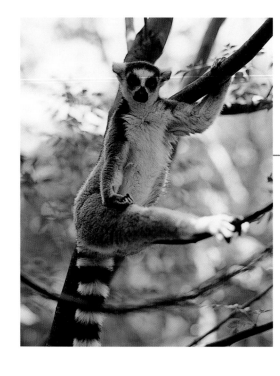

At the Hanfa Reserve, we went hiking through the forest in search of ring-tailed lemurs. The lemur's survival in Madagascar is an evolutionary fluke; everywhere else in the world they were displaced by monkeys. As we duck under branches and clamber over rocks, every so often the guide stops and listens. We move on and again the guide stops, looks carefully around, and starts to make lemur noises. All of a sudden, there's a movement in the trees. It takes me a moment to realize it's a lemur because they're so well camouflaged, with that stripe on the tail, that they blend right into the canopy of the forest. The first thing the lemur does is grab my glasses and scamper back up the tree. Now I will require a guide dog to continue the trip unless we can entice him back. We've brought some bananas, knowing it's their special treat, and luckily the bribe works. I get my glasses back, and he shoves half the banana in his mouth and runs away to eat the rest in private. Meanwhile, a few more of his cohorts have ventured down to get their share. They're very docile and curious, and their fur is so soft. One stood on my head and watched me load my camera.

There are always certain moments on a trip when your creative juices start to flow. It might be the joy of finding exactly the right object, or simply something you see that starts your brain working. Driving through the high plateau did it for me. It had just poured again, and the road—thirty miles long and dead straight—opened up in front of us with grassland on either side as far as the eye could see. In the distance were the mountains. As I was sitting there, all of a sudden I focused on the road disappearing into the horizon, with huge dark rain clouds on the right and billowing white clouds on the left. I pulled out my camera and covered the whole landscape, from the wide, panoramic vistas to the row of clay-colored puddles at my feet. The driver was a little perplexed when I asked him to drive backward and forward on the road, splashing through the puddles again and again—the bigger the spray, the better—so I could photograph it. It was the most excitement I've had since I arrived in Madagascar.

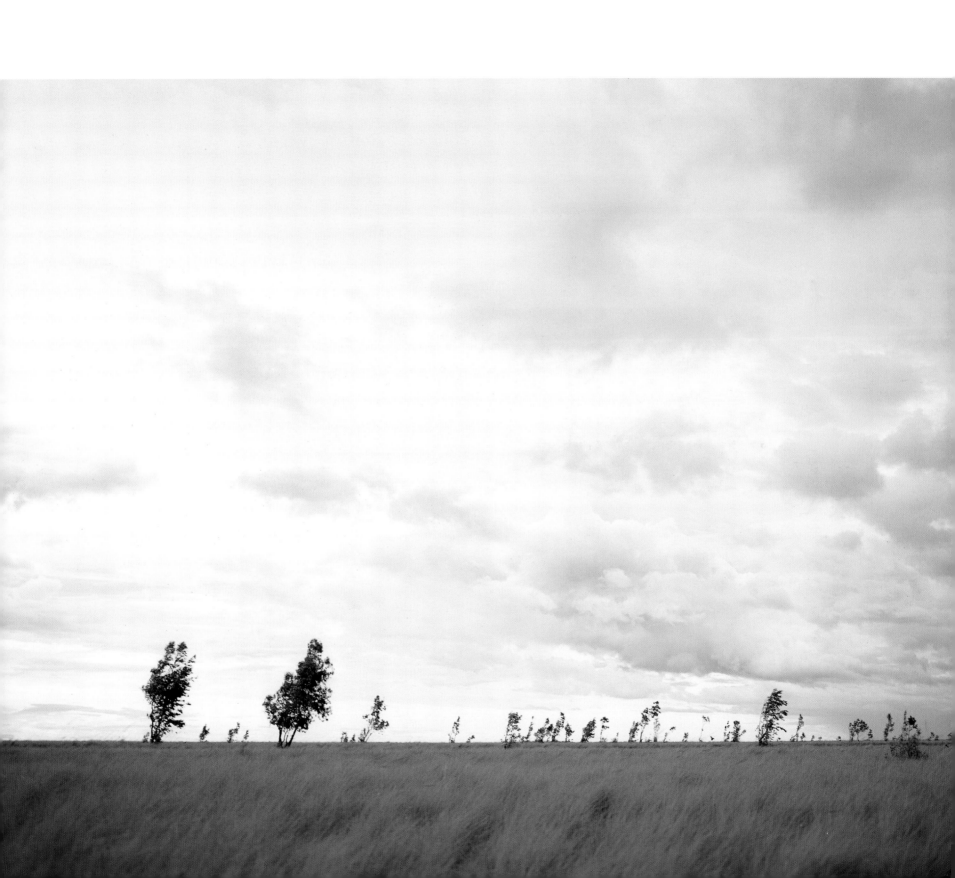

As we head toward Toliara, on the southwest coast, we pass people along the road holding out what look like muddy rocks, but they are actually gemstones, for sale. This is mining territory, and a new boomtown can rise overnight, starting with rudimentary shacks. Then before you know it there is a bar, food, shops, and a whorehouse, just like in the old Wild West. The miners will start in one area, making a hole about two feet in diameter and digging straight down fifty or sixty feet. Then they'll lower somebody in and he'll bring up a bucket and they'll sift through the dirt for gemstones. If somebody in another area brings up a good haul, they will move over there in a minute.

I love gemstones. I like the way they catch the light and change colors. If you walk into a shop in a boomtown like Ilakaka, the shopkeeper will bring out tray after tray with hundreds of stones. It feels like King Solomon's mine. I was tempted by the most beautiful aquamarines I've ever seen, some a deep sea green, others as transparent as tap water. But unless you're a real expert, be careful about spending any serious money. I was told the best stones are saved for the dealers. But I figured, what the hell, I'm here at the source. I succumbed to the aquamarines and some white topaz, which looks like diamonds. Even if the stones turn out to be plastic, they were cheap enough that it doesn't matter.

Some of the most intriguing sights in the region around Toliara are the tombs of the Mahafaly and Masikoro tribes. They resemble large, rectangular huts (you can guess the stature of a person by the size of his tomb), and they're painted with allegorical scenes that tell the story of the person's life. Often the roof will be topped with zebu skulls (zebu are humpbacked cattle considered sacred by the Malagasy and eaten only at funeral feasts). Carved wooden poles used to surround the tombs, but most have been stolen or vandalized. Still, the paintings are there, and they rank as great folk art.

We're headed up the coast toward Ifaty to see the spiny forest, a bizarre place with strange, spiky plants found no place else on earth. They're the only things that will grow in this sandy, barren ground, and they look rather like cacti. But you can imagine how weird they are from names like the octopus tree. The plants seem to be all thorns, very sharp and inhospitable, with only a few tiny leaves. They say, don't touch me, don't eat me, don't even look at me. It's all very aggressive visually. You feel as though you're on another planet or in a surreal painting by Salvador Dali.

Then, just minutes away, there's the beach. Madagascar has miles and miles of coast and incredible deep beaches. Most are completely deserted except for the occasional fishing shack. They offer glorious coral reefs and stupendous snorkeling.

The Capricorn Hotel in Toliara is straight down the street from St. Augustine's Bay. My guide arranged for us to go out to sea early in the morning in a dugout canoe with two fishermen to catch our lunch. The fishermen and I communicated in the international language of hand gestures, and I was transported back to my childhood in Cuba, when I used to go fishing with my uncle for hours. Here, the water was so clear we could see the fish swimming below. I was amazed at how quickly we caught six pounds of fish. We rowed back to shore and the wife of one of the fishermen cooked the fish right on the beach over an open fire and served them with green mango salad and beer— a true delight.

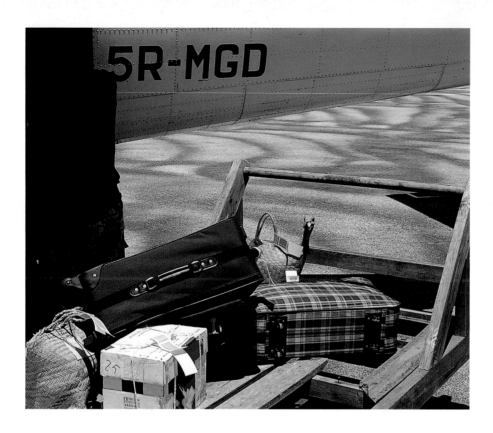

There's only one sure thing in Third World travel: if you're planning to take a flight, it will be delayed or canceled. I was ready at 8:30 A.M. to go to the airport for a 10:30 A.M. flight to Morondava. At 10 A.M. we were told that the airline didn't know when the flight would actually leave. This was not promising, since two flights to two other cities had already been canceled. But after years of futile screaming matches with desk clerks, I have finally learned that when things are out of my control, there is nothing to do but be calm and wait. Luckily, after three hours our plane finally took off—the only one to do so that day. It's amusing to see what people bring on a plane that holds seventeen passengers. One person checked a turkey in a straw bag.

Everybody comes to Morondava, in the center of the west coast, to see the baobab trees. Everywhere you look in Madagascar, you see pictures of these trees—tall and stark, with just a spray of branches on top. In reality, there are very few in a very small area. They have survived the slash-and-burn school because they are 80 percent water. There's a road, the Avenue of the Baobabs, that leads to the trees and that's what you see in all the photographs. But it's hard to tell the height and girth of the trees from looking at pictures. They truly are enormous. I felt as if I was walking amid skyscrapers. The best time to photograph them is at sunset, when they cast long, mysterious shadows. Each angle is better than the last. Their bark is very smooth, almost like skin. To me, they are sculpture.

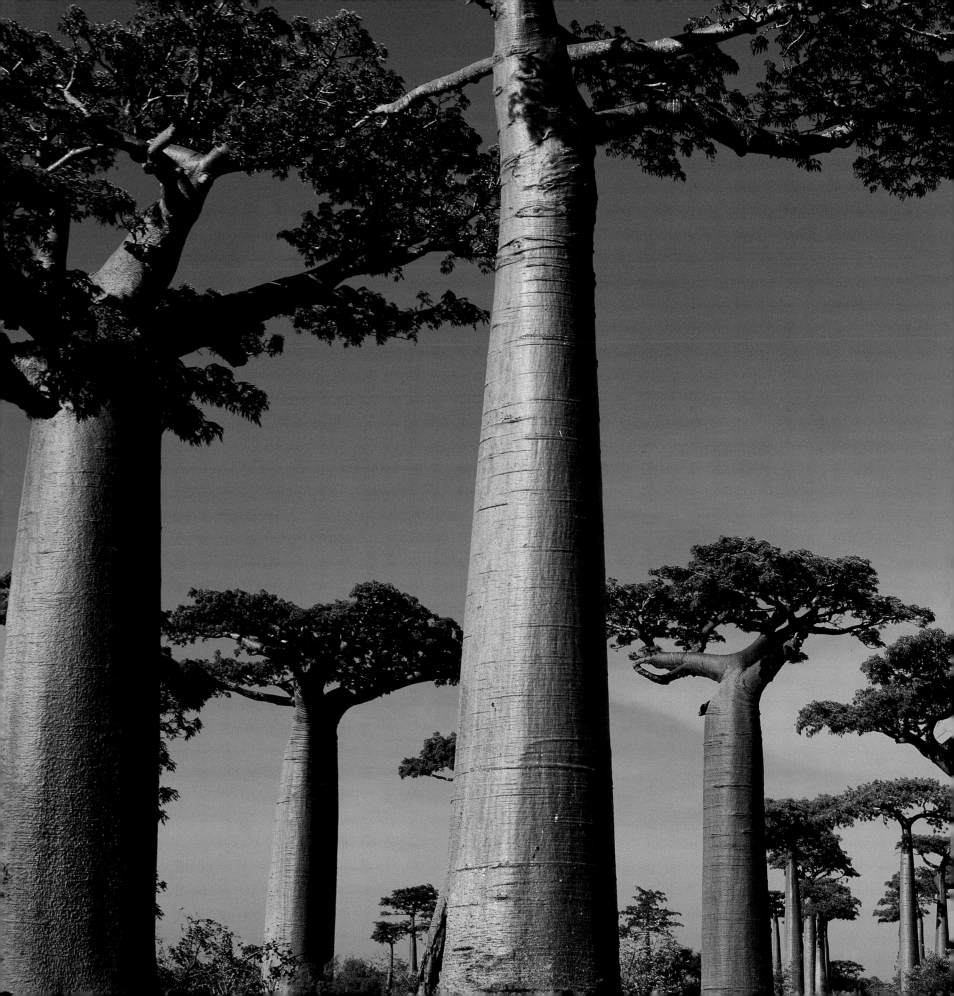

During the whole flight back to Antananarivo, the capital, everybody just walked up and down the aisle, having a grand old time, changing seats and chatting with one another. On the way into town, I went shopping on the Rue Digue, where there are all sorts of shacks selling wood carvings, embroidery, fossils, and spices. I always look for very basic things for the table—chopsticks, place mats, knife rests, salad utensils. A souvenir does not have to be extraordinary; it just has to serve a purpose. It will still remind you of where you have been.

Traffic in the capital is at a standstill most of the time, which is very frustrating. I'm glad we're heading to the less-populated north. Maroantsetra is a busy port at the mouth of a river. Every year, between July and September, the whale-watching boats set out from here, looking for the hundreds of humpback whales that spend the winter in these warmer waters before returning to Antarctica.

I checked in to the Relais du Masoala and headed for the beach, which was magnificent. White sand as far as I could see. There was a sandbar out in the distance, and the warmest water I have ever experienced, as if you had let the hot-water tap run in the tub. I walked a bit, and then went back to get ready for dinner. In the dining room, they had strung lights on a scrawny tree. It was Christmas Eve, which I had completely forgotten. The hotel was run by a Swiss couple who prepared a wonderful Christmas dinner: curried fish empanadas, roasted chicken, tomatoes, and lima beans. The only other guests were a couple with two little girls. He turned out to be a plantation owner from an old French family and she was a friend visiting from London with her two children. When she mentioned that she was taking her daughters to midnight mass, I jumped at the opportunity to go with them.

We took a taxi to the Catholic church, which was quite big, with white walls and wood columns and electric fans humming on the ceiling—welcome because that place was really rocking. There was a terrific band and a choir, and everybody was all dressed up, the little girls in starched pink and baby blue dresses. We were the only white people there. What a treat it was, like a concert with God. The whole place was full of happy people clapping and singing. I was suddenly bursting with Christmas spirit, which may have had something to do with the three rum-and-banana drinks I had had at dinner.

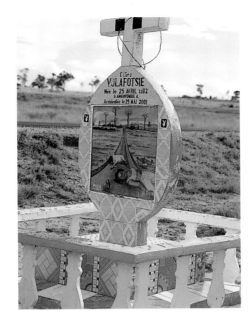

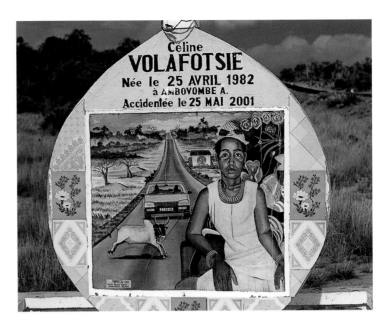

Whenever I go to a new country, I try to bring home a piece of art, old or new, as a memento of my trip. In Madagascar, I was struck by the grave markers they put up along the road wherever a fatal accident occurs. On one side, it might show a woman walking along with a bull, and a car coming toward her. On the other, it would show her lying dead, with the upside-down car beside her. Gruesome, but a wonderful piece of naïve art. Of course, I couldn't take a gravestone home with me.

When I landed at the airport in Maroantsetra, the first thing I saw was a painted wooden sign on the wall, advertising a hotel. The picture had that same naïve quality. While we waited for the luggage, I fantasized about unscrewing it.

I asked my guide if he knew the hotel. I wanted him to take me there, then go inside and find out who had painted it. Unfortunately, the artist had left town. So I told the guide to go back inside and ask the owner of the hotel how much he wanted for it. "Forty U.S. dollars" was the response. I said, "It's a deal." I wanted to go back to the airport and get it right away but the airport was already closed for the night. Besides, the owner wanted to meet me. Now that we had agreed on a price, it was all right. I gave him the money and told him I would pick it up at the airport before I boarded my flight back to the capital. Sometimes I surprise myself in my determination to get what I want. I was still worried that he was going to change his mind. But sure enough, when we got to the airport, they handed it over. As the plane took off, I felt exalted—at last, a real find, and quite unexpected.

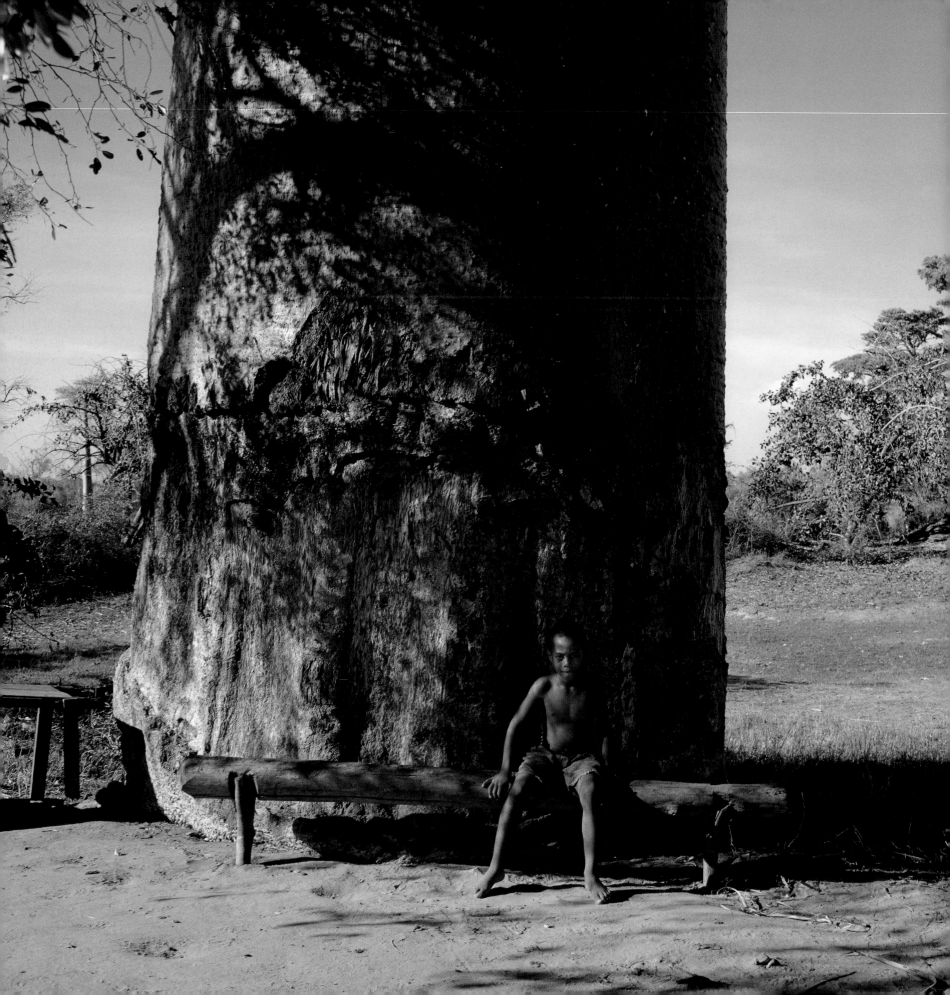

MADAGASCAR SCALE

MY ANNUAL DECEMBER TRIP COUNTS AS MY EDUCATION FOR THE YEAR, and I make it a point to stop and analyze what I'm looking at. The baobab trees of Morondava are enormously tall, but you don't realize just how tall until you see them in relation to something smaller, such as a person. The drama of scale is not there without the juxtaposition. You need the small in order to get the full impact of the large, and that's an important lesson.

When it comes to a room, you wouldn't want all your furniture to be big or all your furniture to be small. You have to play one against the other. I might put a small Warren Platner table next to an oversized wing chair, or a large photograph on a small wall. There's something interesting about the shift in scale. Perfect symmetry is not quite so exciting as a delicate balance.

The image of the baobab trees against the blue sky is not so different in effect from these dried grape vines against a white wall in an apartment in Stockholm. Both lead your eye straight up and remind you of the astonishing originality of nature. The roughness of the gnarled wood points up the smoothness of the plaster walls and brings a sense of wildness into a very refined living space.

Whenever I do a composition like this, I think of ikebana—the Japanese art of floral arrangement. The flowers are never symmetrical. Some are tall, others medium, and others low; this arrangement creates a sense of tranquillity and balance. Here, I have the high branches, the medium limestone fireplace, and the low-backed 1940s French chair. The still life on the mantel replicates the same high, medium, and low—on a smaller scale—with the freesias, the Edward Steichen photograph, and the cascading ivy.

The balance that we find so pleasing is not just about large and small. It's also about playing old against new, textured against smooth, intricate against simple. This doesn't mean you have to go out and buy all new things. The concept will work with what you already own. Just be sure to take a good look at each individual piece and see if it has a good dialogue with what you're putting next to it. It can be as simple as a draped table next to a ladder-back chair. Where one gives you soft fabric, the other gives you hard wood.

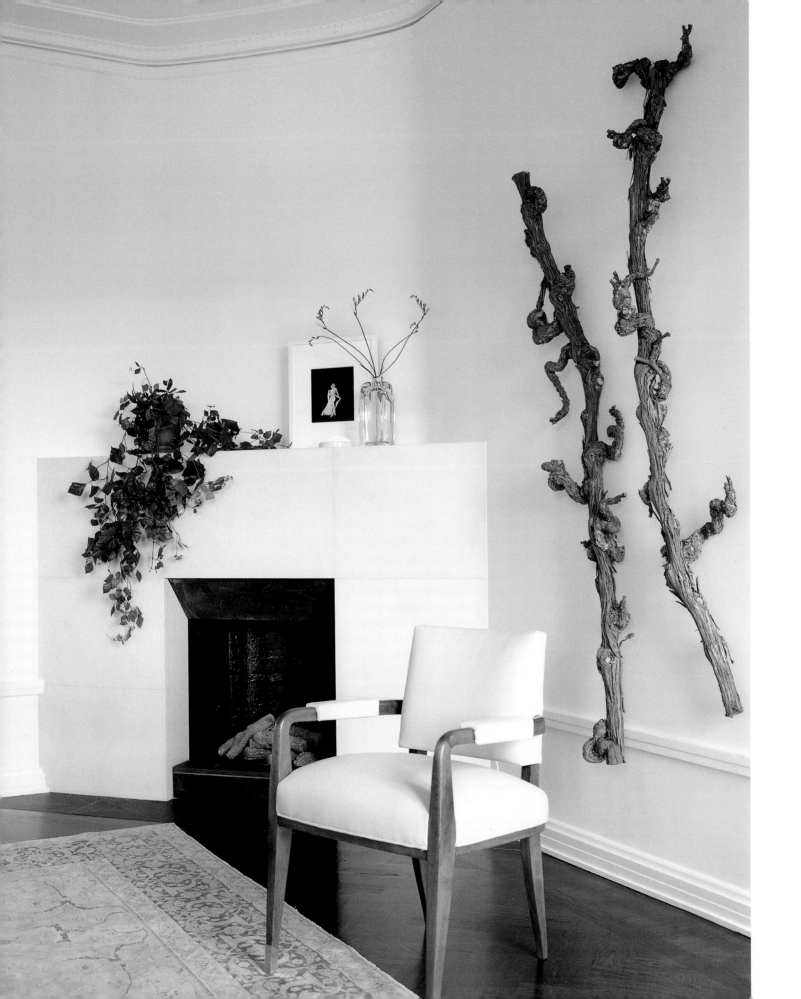

ONE OF THE MOST COMMON MISCONCEPTIONS IS THAT EVERYTHING IN A SMALL ROOM SHOULD BE SMALL. Don't believe it. I'm not advising you to cram in three sofas, but a tall mirror could add a lot of presence and— an extra advantage—it would not take up valuable floor space.

Entrance foyers can be so predictable: the table, the mirror, a small chair to sit in while you pull off your boots. I decided to take the same elements but put them together in a totally different way in the Stockholm apartment.

I chose a large nineteenth-century Chinese lacquered table, and instead of placing it against the wall, I let it float in the middle of the room. The table was so tall it almost dwarfed the 1940s French chair, but that shift in scale is exactly what I found intriguing. To me, the chair represents a modern take on a traditional form, and the table must have been very modern for its time, so it was an interesting relationship. By setting the white marble bowl underneath, I made sure you noticed how delicately the legs curved.

A huge mirror leans against the wall, taking the typical idea of a mirror in the foyer to new heights. At this scale, a mirror becomes very powerful, more like an art object. It adds mystery and depth to the room, as well as a touch of the surreal.

The smooth, reflective surface is echoed by the glossy wood floor, left bare of the traditional carpet. This apartment is part of a 1910 building, and when I said I wanted to stain the floors dark, I was told that nobody in Sweden does dark floors (or pure white walls, for that matter, only cream or pale gray). The clients were afraid it would make the apartment dark, but in fact it makes the walls feel even whiter.

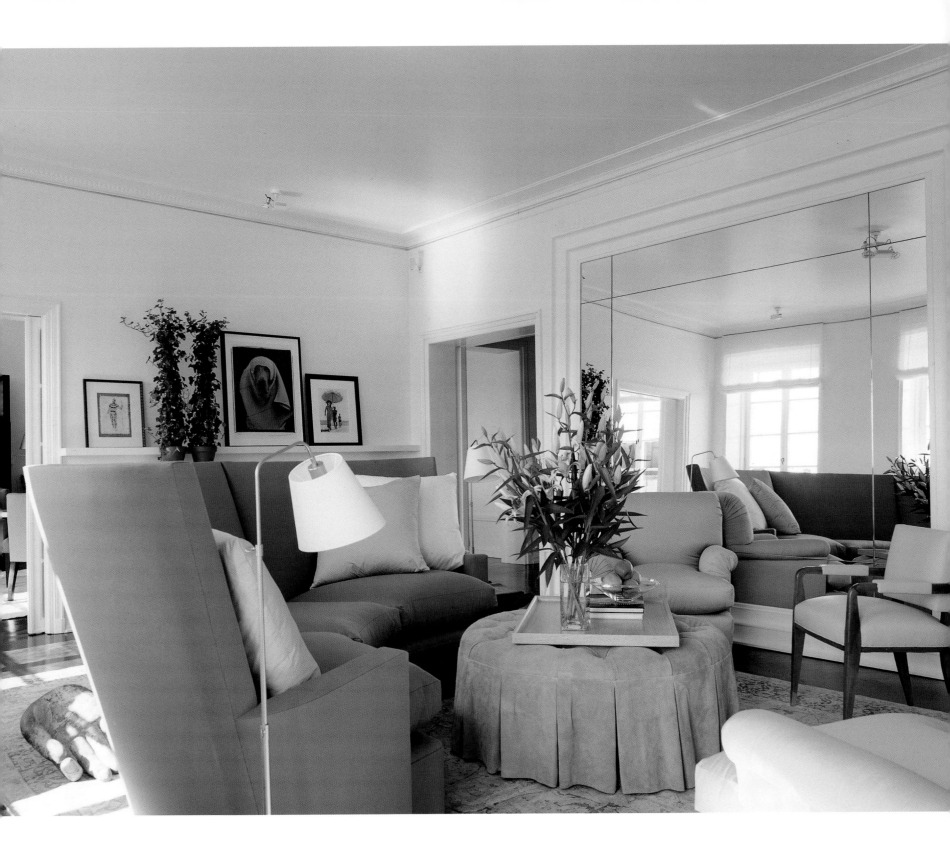

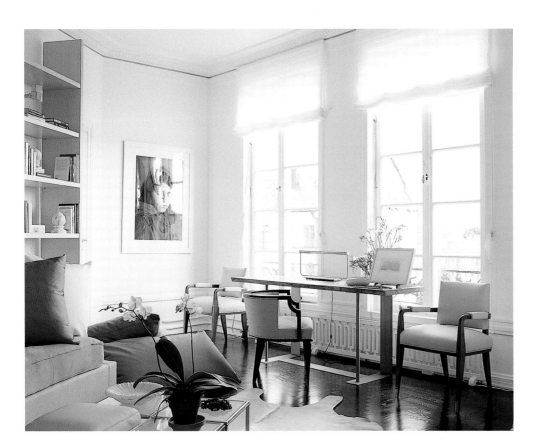

In the Stockholm living room, an overscaled sofa with a welcoming curve creates a convivial seating area—more interesting than the typical pairs of sofas and chairs. Another large mirror picks up the theme I started in the foyer and faces the windows to maximize the light during the long winter.

I ran a picture ledge throughout the apartment to make room for the clients' growing photography collection. I think art works best when it's not tied down. If you hang a picture in one place for too long, you stop seeing it. A picture ledge allows you to move things around as you acquire new pieces, to feature certain things at certain times, and to create different stories with the same artworks. The shelf is at the same height throughout the apartment to create one consistent horizon line.

I continued to play with the theme of reflectivity in the dining room, but instead of using a mirror this time, I set a slab of polished steel against the wall. Ten feet high by four feet wide, it could be mistaken for a work of art and offers another kind of reflection.

I designed a dining table with a steel base and an oval parchment top. Two eighteenth-century Chinese lacquered cabinets, which hold the sound system as well as china, flank a 1940s French console. I like the contrast of the modern steel next to the venerable cabinets.

BENJAMIN MOORE
AIRWAY
828

BENJAMIN MOORE
POLAR WHITE
2069-70

BENJAMIN MOORE
STRATFORD BLUE
831

BENJAMIN MOORE
PATRIOTIC WHITE
2135-70

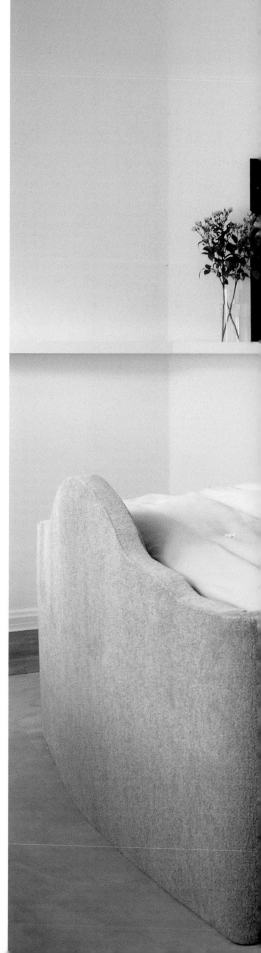

For the same apartment, I designed a new version of a sleigh bed, with an undulating headboard and footboard, then set it in the middle of the bedroom. A modern cubic drawer is tucked underneath a traditional Chinese table. The carpet and walls are watery shades of blue. Sliding doors made of frosted glass hide the closet.

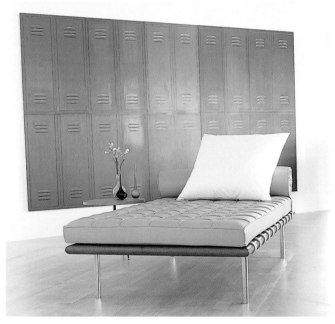

CONTEMPORARY ART CRIES OUT FOR BIG, UNINTERRUPTED SPACE, so I turned a Miami apartment into a loft for clients who are avid collectors. I smoothed out the walls, eliminated baseboards and moldings, and poured a concrete floor the color of wet sand.

When you walk in, across strips of wood set into the concrete like a virtual carpet, you feel as if you're swimming in space. Directly in front of you, a large rectangular insert of bleached oak is like a raft in the middle of the apartment. There's just one piece of furniture floating on it, Mies van der Rohe's sleek Barcelona daybed, accompanied by a Jacques Adnet side table. (The lockers behind them are not real—it's a painting.)

As you move toward the dining area, Philippe Starck's clear plastic Louis Ghost chairs allow you to see straight through to the dining table, with its brushed-steel base and icy resin top. The palette throughout the apartment is lime green and pink, in tribute to 1950s Miami. The green on the dining chairs carries through to the living-room furniture, which features an overscaled sofa and a pair of Eero Saarinen Womb chairs. A run of sheer white curtains comes right off the wall and continues behind the sofa to differentiate the living room from the foyer without actually closing off the space.

People have conflicting opinions on how to decorate when there will be serious art on the walls. Some feel you should make the space as neutral as possible so it will in no way compete with the art. My sense, in this apartment, was to go with the flow. The art is so powerful that I had no qualms about bringing in more color. In fact, I thought the play of different colors, shapes, and styles of furniture would in some way balance the art. The last thing I wanted was an apartment that looked as though no one lived there, like a museum.

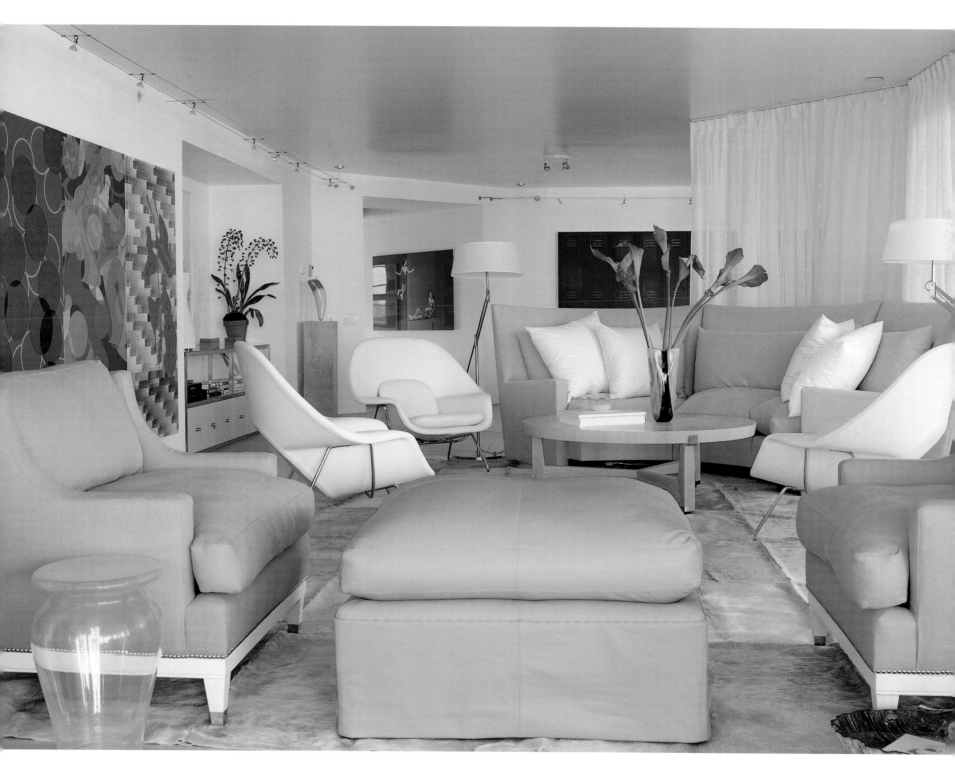

THE MIAMI MASTER BEDROOM IS A FUN-LOVING RIFF ON PINK AND GREEN, with a two-color rug that sets the scene. Bright pink delineates the sleeping area, like an island in the green. The bed is off the wall, moved into the middle of the room to take full advantage of the ocean view. A sheer lime green curtain hangs behind it so that you don't see everything as soon as you walk in. It also subtly divides the room into a sleeping area and a study area, where a painting from Yasumasa Morimura's Frida Kahlo series hangs on the wall. By the window, Arne Jacobsen's 1956 Egg chair offers a soft perch in pink leather.

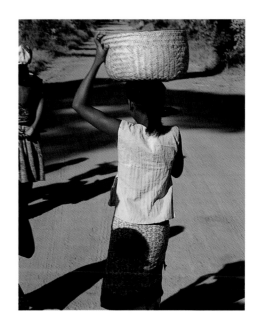

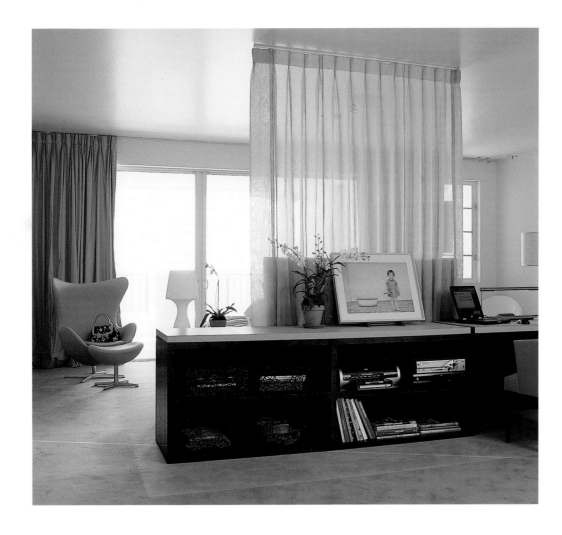

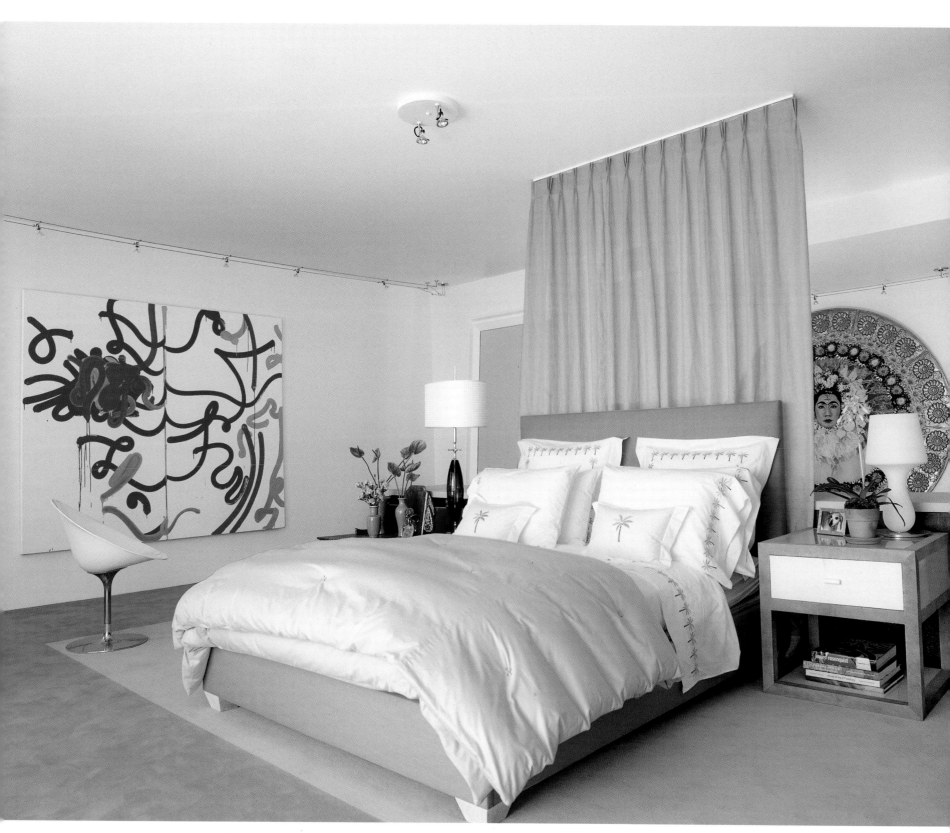

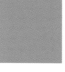
BENJAMIN MOORE
GRAPE GREEN
2027-40

BENJAMIN MOORE
SECRET
RENDEZVOUS
1341

BENJAMIN MOORE
YELLOW FINCH
2024-40

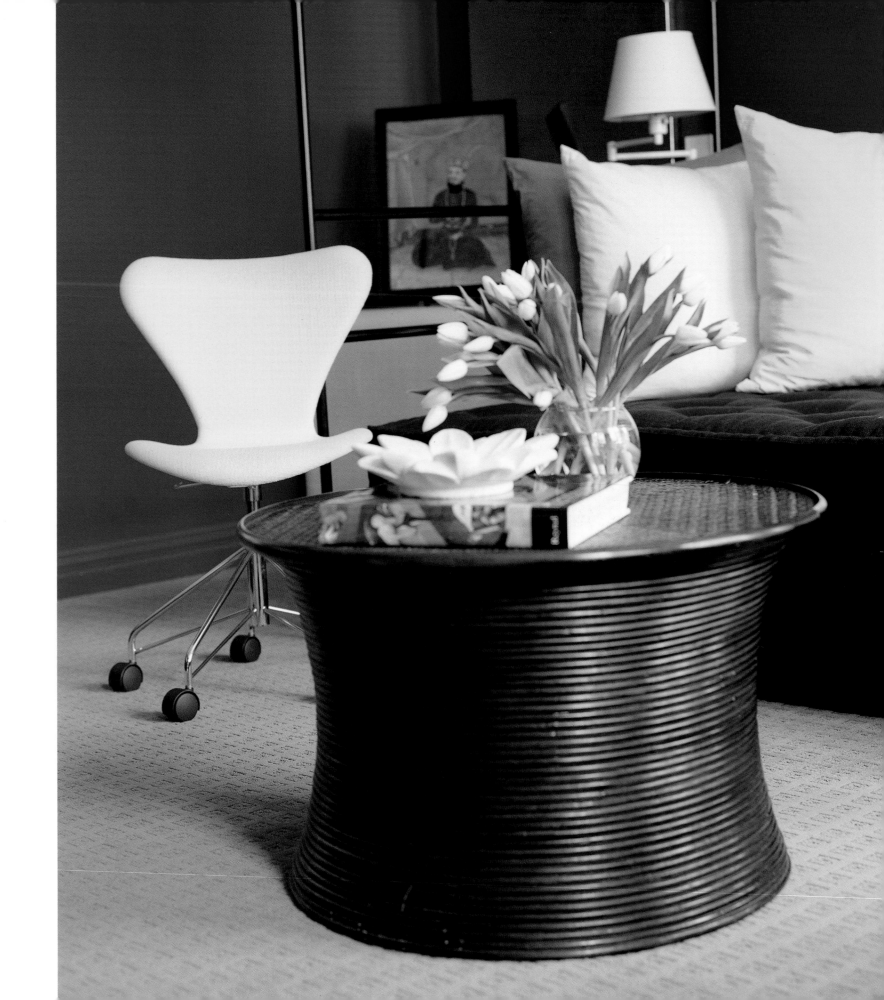

BENJAMIN MOORE
BRONZE TONE
2166-30

BENJAMIN MOORE
EVENING BLUE
2066-20

BENJAMIN MOORE
YELLOW RAIN COAT
2020-40

I liked the combination of colors on this umbrella in the marketplace, and I used my own version in a children's playroom, where the iridescent blue is punctuated by the bright yellow of Arne Jacobsen's Ant chair. The steel daybed can also sleep guests.

IN THE VILLAGE OF ANTOETRA, where I spent a rainy night in the chieftain's hut, I saw a little boy holding carved wooden containers and bought them all. I thought they would look nice in one of my bathrooms, and they do.

WOMEN COME IN FROM THE COUNTRYSIDE TO SELL THEIR EMBROIDERY IN THE CAPITAL. I thought this piece was quite charming in its naïveté, rather like a painting by Grandma Moses. Made into a pillow, it adds a splash of color to a wing chair.

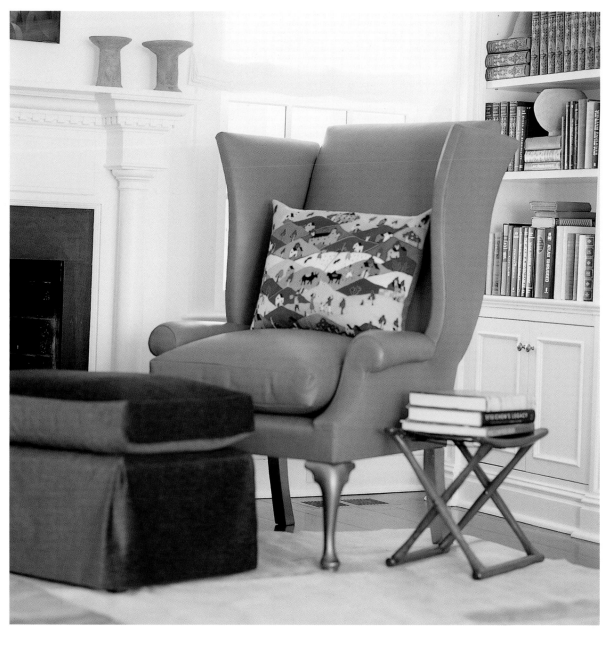

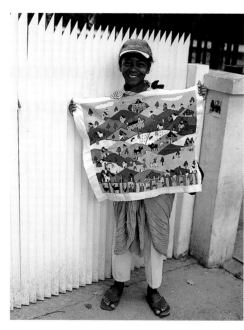

MYANMARCOLOR

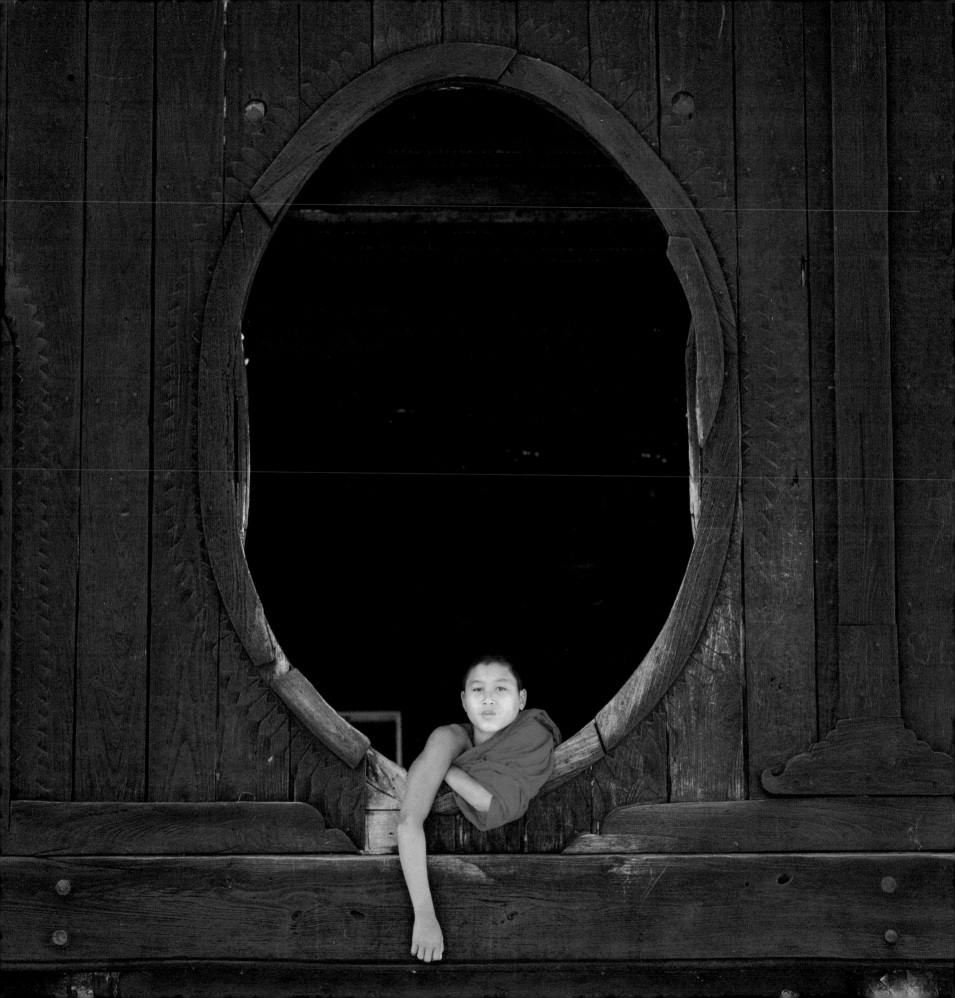

BURMA IS A PLACE I'D ALWAYS DREAMED ABOUT, ALL THE MORE ENTICING BECAUSE OF THE FORBIDDEN QUALITY OF GOING TO MYANMAR (THE COUNTRY WAS RENAMED BY THE MILITARY JUNTA IN 1989). JUST MENTION MANDALAY OR RANGOON (NOW YANGON), AND IMAGES FROM OLD BLACK-AND-WHITE MOVIES—CEILING FANS, SLOUCH HATS, AND SHADY CHARACTERS—COME TO MIND. YOU EXPECT MARLENE DIETRICH TO STRIDE OUT OF THE STRAND HOTEL.

BUILT IN 1901 ON A BROAD BOULEVARD FACING THE RIVER IN THE CAPITAL, YANGON, THE STRAND TRANSPORTS YOU BACK TO THE BRITISH COLONIAL ERA. THE MOMENT YOU WALK THROUGH THE DOUBLE DOORS INTO THE LOBBY, WITH ITS BLACK-AND-WHITE MARBLE FLOORS AND FAN-BACKED RATTAN CHAIRS, YOU ARE MET BY WHITE-GLOVED BELLHOPS WHO RELIEVE YOU OF YOUR LUGGAGE. THE SCENT OF GINGER FLOWERS LINGERS IN THE AIR. THIS FIRST IMPRESSION ALREADY TELLS YOU SOMETHING ABOUT BURMA, ITS HISTORY, AND THE TROPICAL LANGUOR NOT FAR BEHIND THE DECOROUS FACADE. THE BREAKFAST AREA IS SET WITH WHITE LINEN AND SILVER, AND THERE'S A WONDERFUL TEAK-LINED BAR.

Right across the street from the Strand is the ferry terminal. I crowded into the boat with schoolgirls, monks, office workers, and farmers for the twenty-minute ride across the river. The Burmese people are still refreshingly un-Westernized, with men wearing the traditional *longyi*— a cylindrical length of fabric wrapped around the hips—instead of pants. Peddlers walked through the boat, hawking yogurt, quail eggs, cigarettes, and fresh fruit. From the top deck, there was a splendid view of the city—a curious mix of graceful Colonial buildings and undistinguished 1960s architecture, cars and rickshaws, computer shops and street vendors.

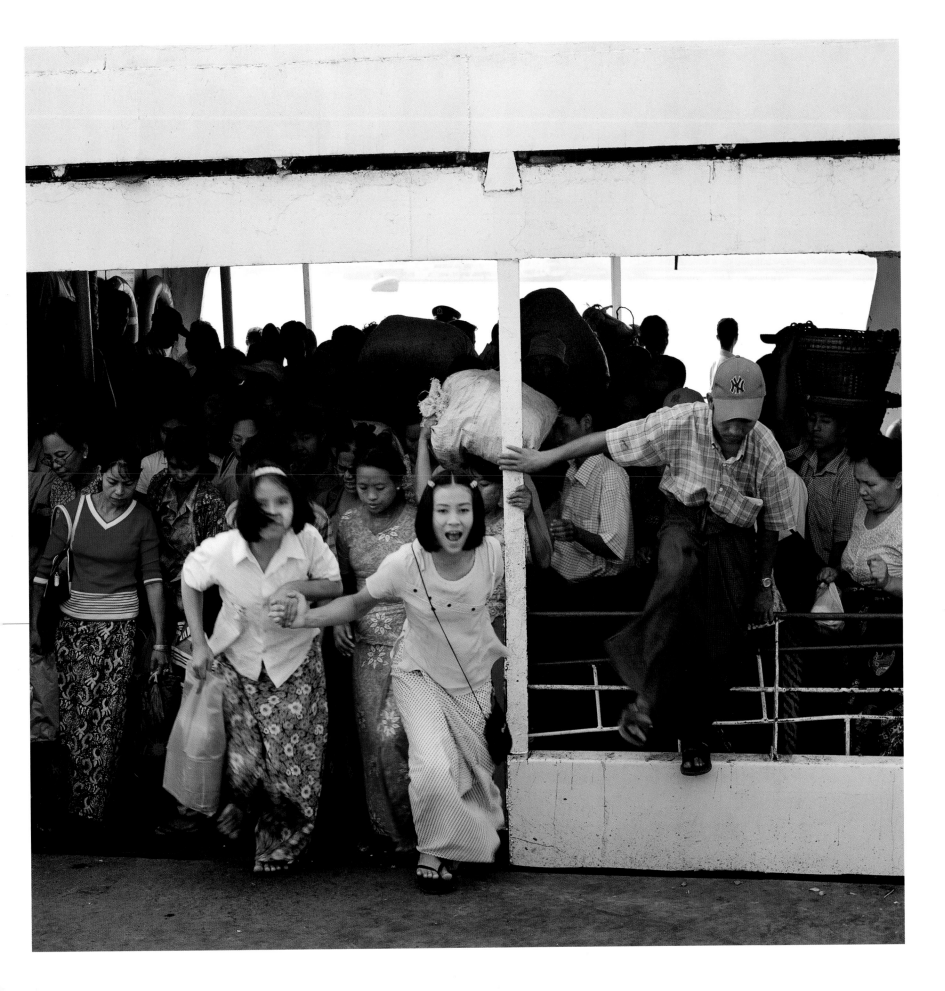

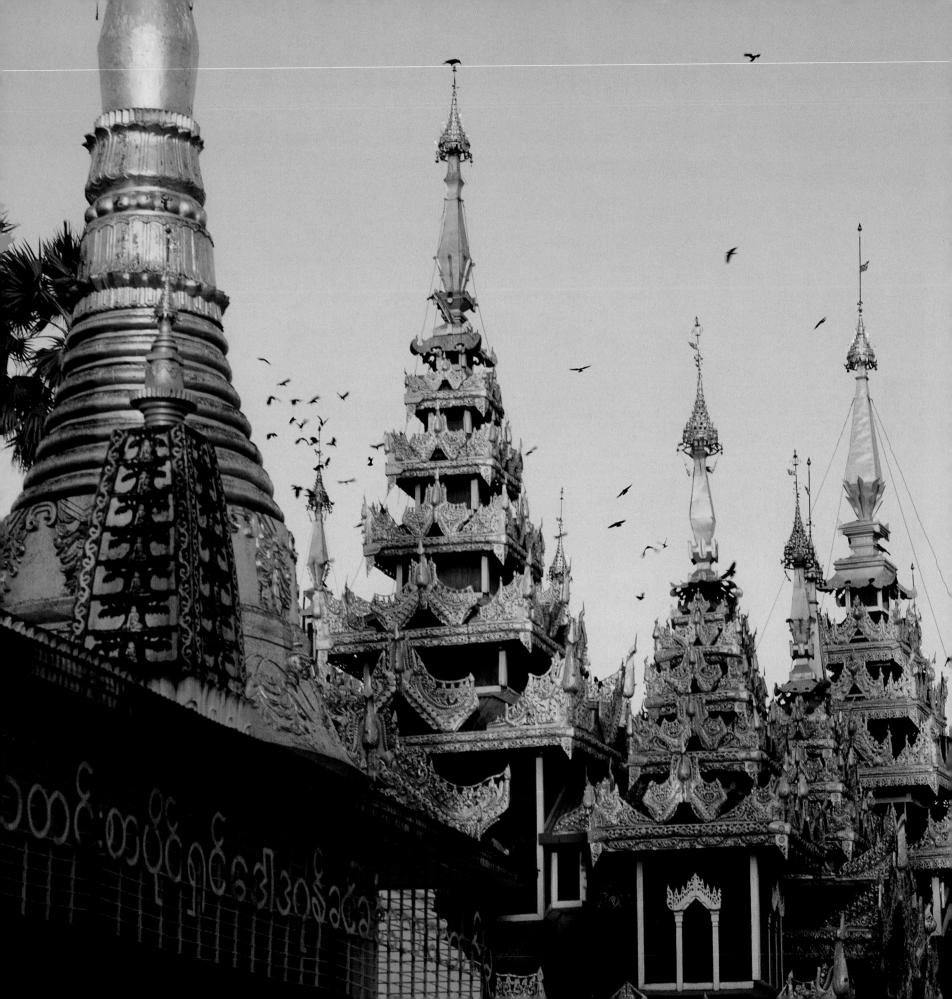

I spent my first afternoon at the most sacred site in Yangon, the Shwe Dagon Pagoda, which according to legend was built over 2500 years ago to hold eight precious hairs of the Buddha. It's an elongated domelike structure, 326 feet high, completely gilded with gold and encrusted with diamonds, rubies, and sapphires at the very top. Here, as in the pyramids of Egypt or the spire of the Empire State Building, it's that aspirational reach for something higher that I find so moving. Yet the Buddhist stupas in the Far East have a softness as opposed to the West's hard edge; the imagery of the building has to do with the lotus flower, conveying growth and enlightenment. The large main temple with its intricately carved fretwork is surrounded by dozens of smaller ones, built by wealthy people as offerings.

You might think a holy place like this, high on a hill, would rarely be visited. In fact, people come every day. The whole compound is a gathering spot where boys meet girls, where grandmothers sit and watch children playing, where everybody is walking, chatting, eating, and laughing, enveloped in the scent of burning incense. The whole fabric of society is permeated by religion. I sat there for hours, just enjoying the animated scene. On the way out, walking down one of the four access stairways lined with shops, I bought bowls and bells and prayer beads, delicately carved out of sandalwood.

The next morning, I took a flight to Kengtung to visit the hill tribes. I was lucky enough to be there for a once-a-year festival, when all the young people get dressed up in their finery and parade around in an informal courtship dance. It gave me a chance to check out the local craftsmanship, and I was immediately taken with the old silver coins that decorate their hats and hang around their necks. The next day I went to the market and bought huge hammered silver buttons as big as breastplates and earrings and unusual pendants in the shape of a fish—dangling with tweezers and ear cleaners—almost like a manicure set. Whatever you're buying is put on a scale and you pay a price based on the weight of the silver.

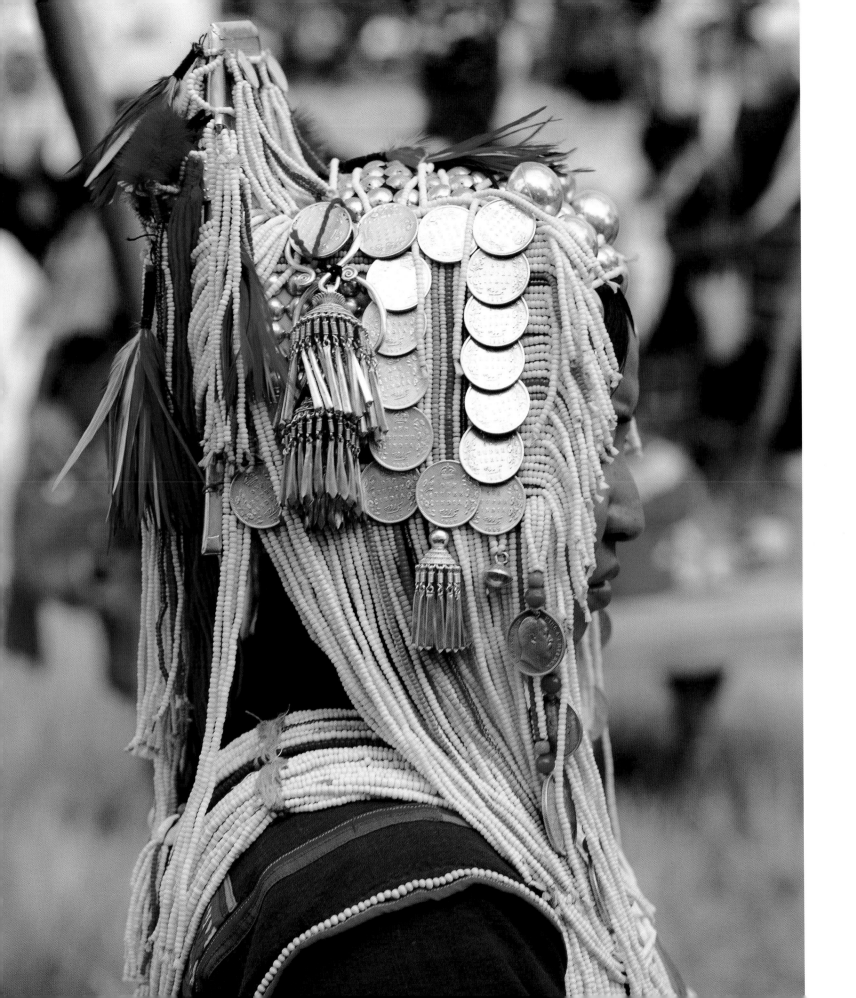

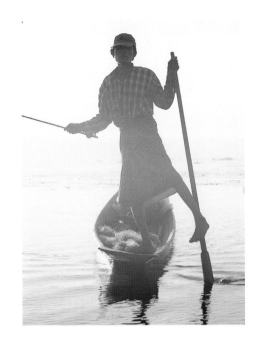

Then it was on to Inle Lake, one of Burma's most beautiful natural attractions—a wide expanse of water veiled in mist and dotted with clumps of water hyacinth. In fact, the reeds proliferate so fast that they pile on top of each other, creating floating pads of gunk that are cultivated by the local Intha farmers, who plant rice and tomatoes and flowers. Houses are perched on stilts at the edge of the lake. The whole place is a floating universe, with fishermen poling flat-bottomed canoes. The daily market is held on board. You paddle from boat to boat, buying food or cooking utensils or clothing. We took a speedboat to the Lake View Resort, a secluded hotel with individual bungalows—each with a private balcony—overlooking the lake. I was tempted to lock the door and never move. It was only the promise of glorious silks and other treasures that forced me to emerge.

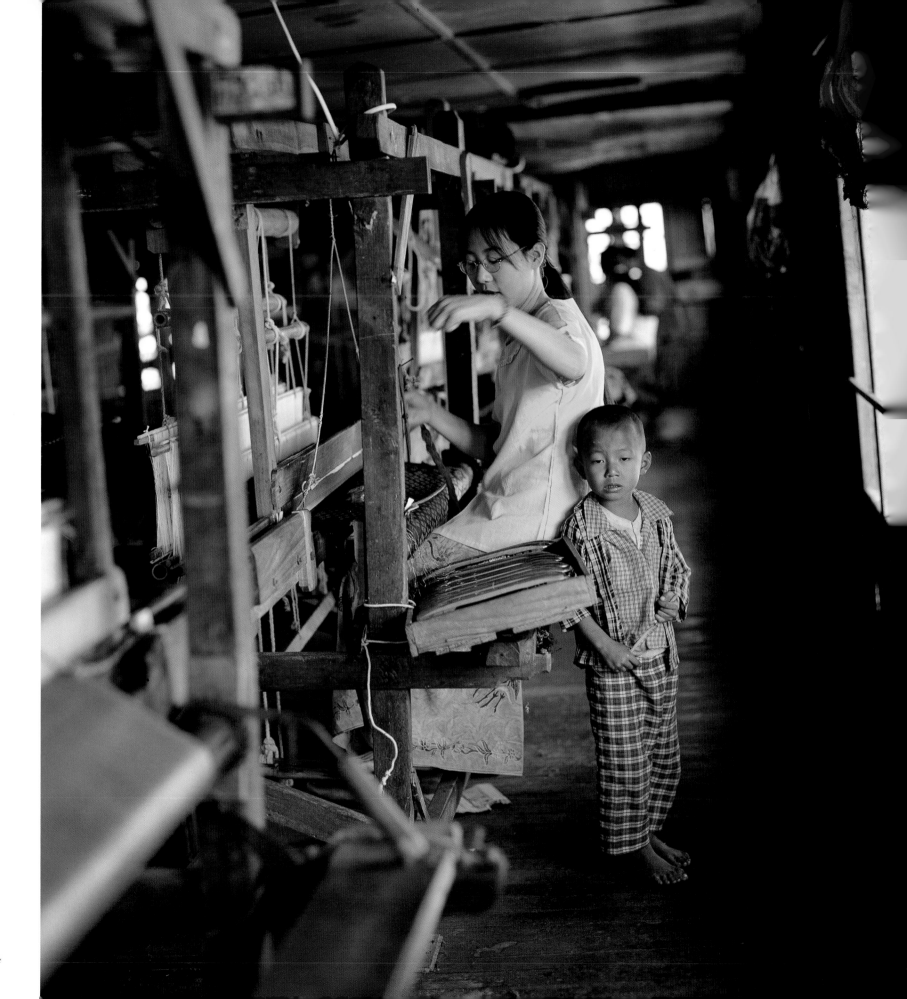

As you approach the lakeside village of Inpawkhon, the first thing you hear is the rhythmic clicking of the looms. Weaving is a true cottage industry, employing most of the village. You can see the whole process, starting with spinning the fibers into yarn. I bought vibrant lengths of silk straight off the loom, and ikat cloth in traditional patterns.

There are more than 250 monasteries along the lake, and the most famous is probably Nga Phe Kyaung, more familiarly known as the Leaping Cat Monastery. For generations, the monks have taught cats to jump through hoops and perform various other tricks, to the delight of tourists. On the walls are magazine and newspaper articles from all over the world, plus letters and postcards from visitors.

An afternoon flight took me to Mandalay, Myanmar's second-largest city and the royal capital from 1857 until the British took over in 1885. Only one building remains from King Mindon's original nineteenth-century palace, the Shwe Nandaw Kyaung; the rest were bombed during World War II. It holds a replica of the Lion Throne. But for me, the most beautiful thing was the teak floor, worn down by countless bare feet to a soft, smooth patina.

My hope was to stay in a private monastery for one night, and my guide had some connections in Sagaing and thought it was a possibility. I felt it would be proper to arrive with offerings, so I went out to buy cereal, cookies, coffee, and some very pretty flowers, white for purity. Then we were off, cruising down the wide boulevards of Mandalay, past hundreds of men and women on their bicycles. The road to Sagaing, the religious center of Myanmar and home to five thousand monks and nuns, took us past stone- and wood-carvers' workshops. These are the artisans who make the Buddha statues you see in every temple, and people come from all over to purchase them. They say the quality of a Buddha has to do with the expression on his face. The higher the skill of the craftsman, the more gentle the smile.

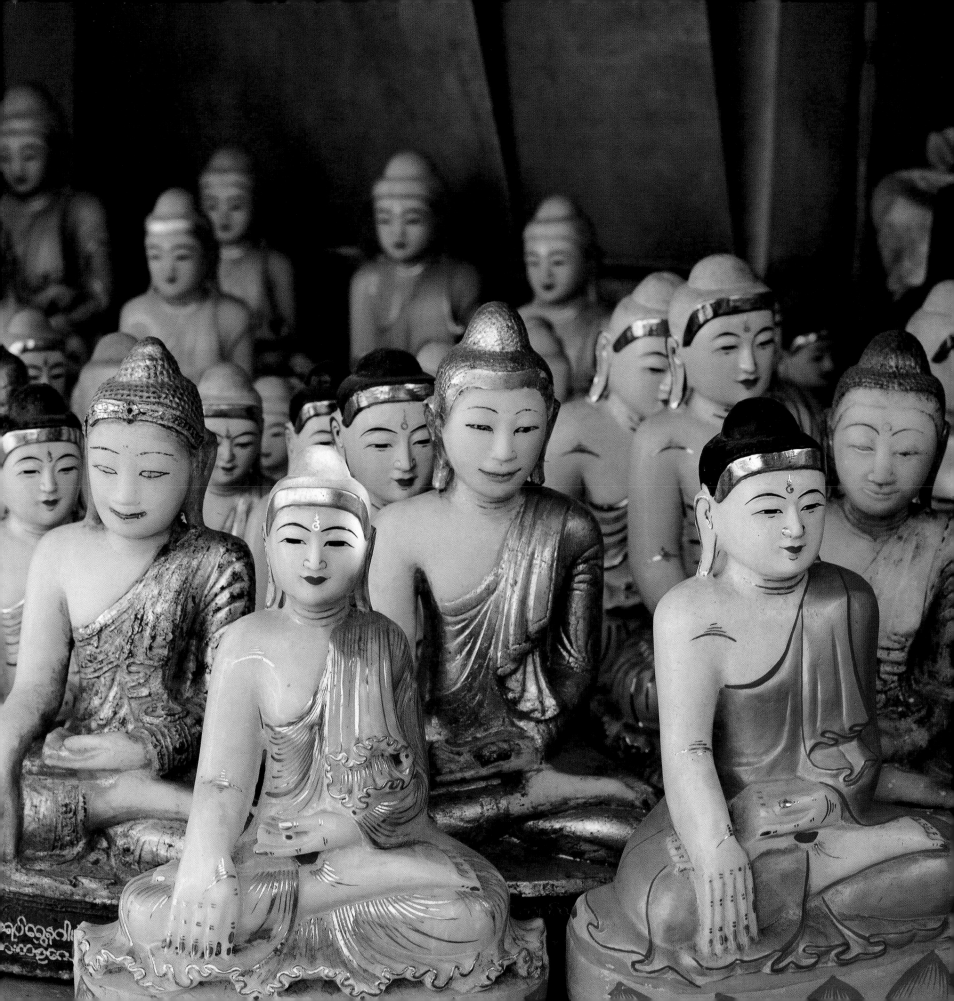

It didn't take long to climb Sagaing Hill and search out the monastery known to my guide. As soon as I walked in the door, I felt comfortable. Maybe I loved it because the aesthetic was so familiar. The open spaces, the minimal furnishings, the sharply angled stairs all gave me a sense of home. Sunlight filtered in through the windows and I could hear the soft tinkle of chimes. I presented my gifts to one of the monks and we spent the afternoon talking through my guide, who translated. Lunch—fried rice and vegetables—was prepared by the monk's mother, and it was by far the best meal of the trip. The bright blue sky, the softness of the breeze, and the bowl of star fruit picked right off the tree (in whose shade we sat) were too much for words. The sense of peace and tranquillity was palpable.

I was asked to join all four monks in their meditations, which involved one hour of sitting in the lotus position. For me, that takes a lot of commitment. Then they continued for two more hours while I photographed the compound. I was happy to comply when they asked me to join them in working in the garden—one of my great pleasures. By 10 P.M. it was time to turn in, which was fine with me since I would be getting up at 5 A.M. to pray with the monks.

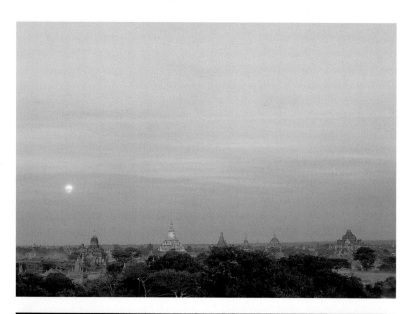

After breakfast I left to catch a flight to Bagan. There are some historic sites that take your breath away. Machu Picchu is one, and Old Bagan is another. You can't quite believe it when you glimpse it from the air. Suddenly, thousands of temples arise from the vast, sandy plain, seemingly out of nowhere.

Built in the early years of the twelfth century, at roughly the same time as Angkor Wat, Bagan is in much better condition and covers a much larger area, approximately forty square miles. As I wandered from one temple to the next, I was impressed with the quality as well as the quantity. You have to marvel at the infinite variations on the basic stupa design. Some temples look like Mayan ruins, with wide stone steps going up the sides. Others are mini-fortresses, with crenellated walls and tower after tower inside. Some temples have been carefully restored, while others, damaged by a major earthquake in 1975, desperately need rebuilding. We climbed up to the terraces of the Mingalazedi Pagoda to watch the sunset. This is the last of the great pagodas, built just before the Mongols invaded Bagan in 1287. As the new moon rose in the sky, the gold-topped spires all around us were still glowing, lit by the last rays of the setting sun.

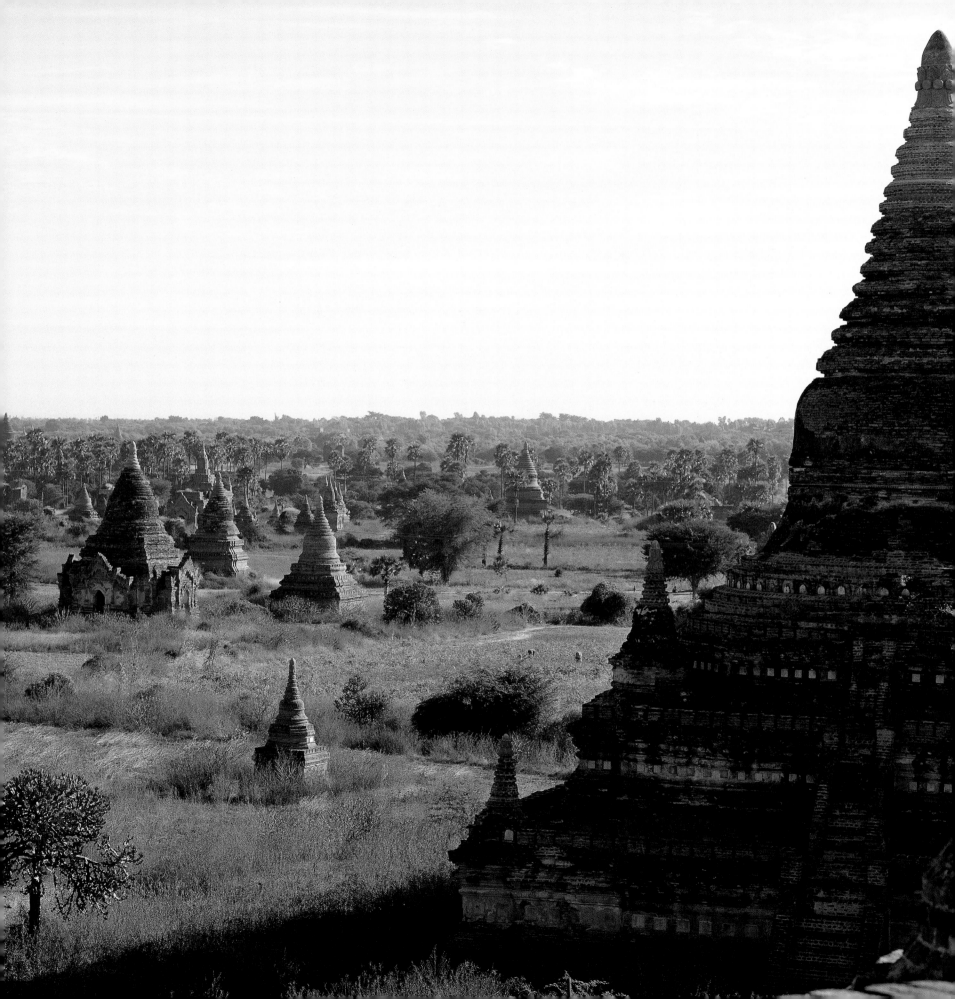

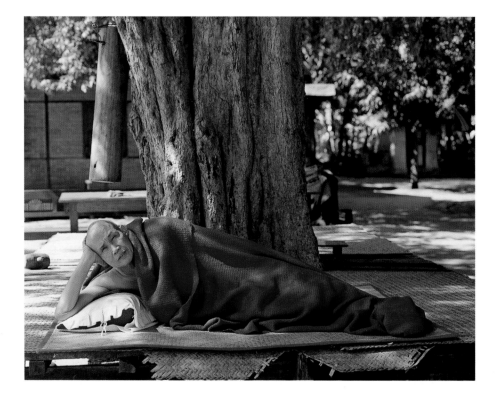

My guide wanted to show me a certain monastery, run by a widely respected head monk. It was near the Shwesandaw Pagoda, which lost its top during the earthquake (the toppled crown still lies on the ground close by). My guide already knew I liked old things, and when we found the monastery, I admired the carvings and fretwork. As my guide gave me a tour, he kept warning, "Don't step here," and "Don't walk over there." The floor was rotten in many places. On the way in, I had noticed a sign thanking a man from Switzerland for his donation toward the restoration. When the head monk came over to welcome us, I asked how much it would cost to fix the floors. The monk mentioned a figure, and I said, "I'll pay for it." This country has given me so much pleasure, I thought it would be nice to give something back. Immediately I went off to exchange more money, and when I came back, the head monk had gathered all the young monks to greet me. They offered me tea and a banana. I handed the money to the head monk and he promised to pray for me. They asked me to sign their guest book, and when I left I felt as if I were walking on air.

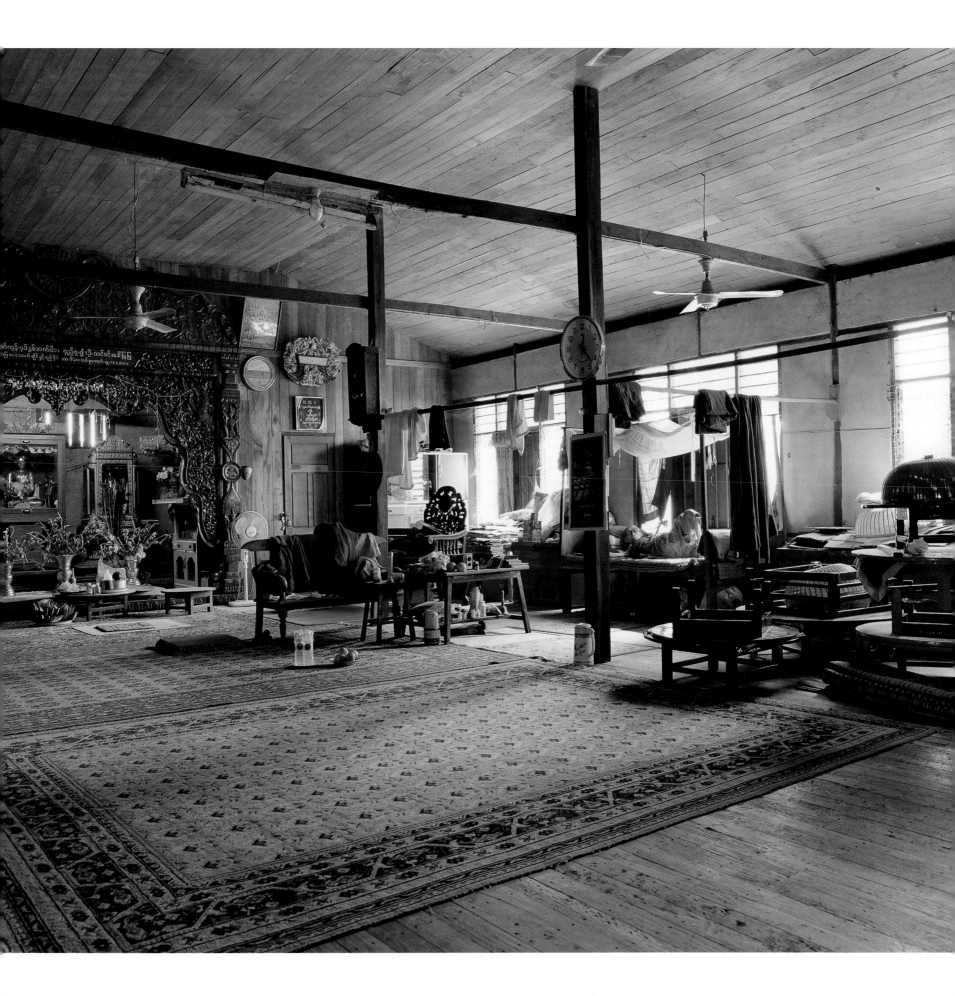

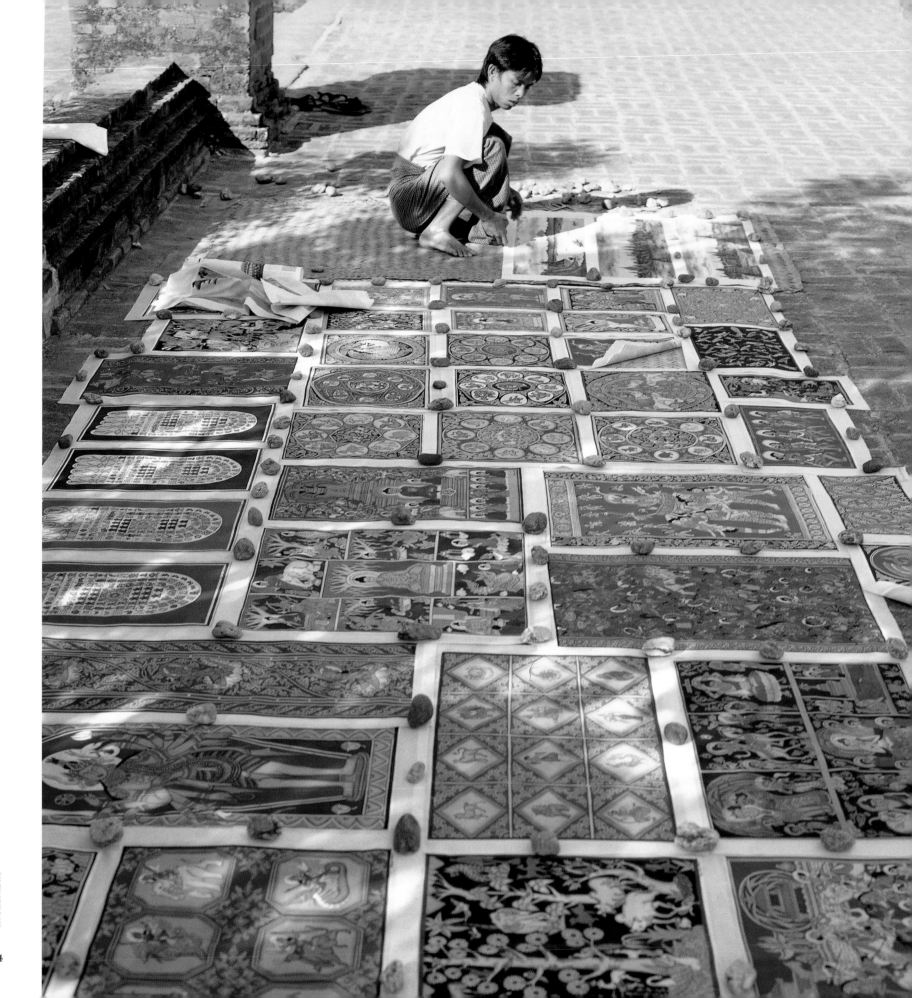

It's a shame that so few people get to see Bagan, with its spectacular skyline of temples. Tourism has plummeted since the crackdown by the military regime. No one wants to support a dictatorship, but when tourists stay away it's really the ordinary people who suffer. Families who have honed their skills at a particular craft for generations cannot sustain themselves if there is no one to buy their wares. Luckily, the interest in Burmese lacquer is still thriving, and Bagan is justly famous for its lacquerware. Much of it is produced in the nearby village of Myinkaba, where some six hundred households are involved in the craft.

Lacquerware is a labor-intensive art form. Even the smallest piece can take weeks to complete. The artisan begins by making a bamboo frame, often interwoven with horsehair, in the shape of the object. Then the first coat of lacquer, made from the resin of a particular tree, is painted on. Once that dries, a paste of pulverized buffalo bone, teak sawdust, and lacquer is spread over the piece to fill in any pockmarks. After that has dried, the object is polished with pumice stone. Then coat after coat of lacquer is painted on and carefully sanded after each application. This creates a smooth, lustrous finish. The final product is built up out of all these eggshell-thin layers. Often it will be incised with a decorative design that shows off the different strata of color. I bought as many bowls as I could take home with me.

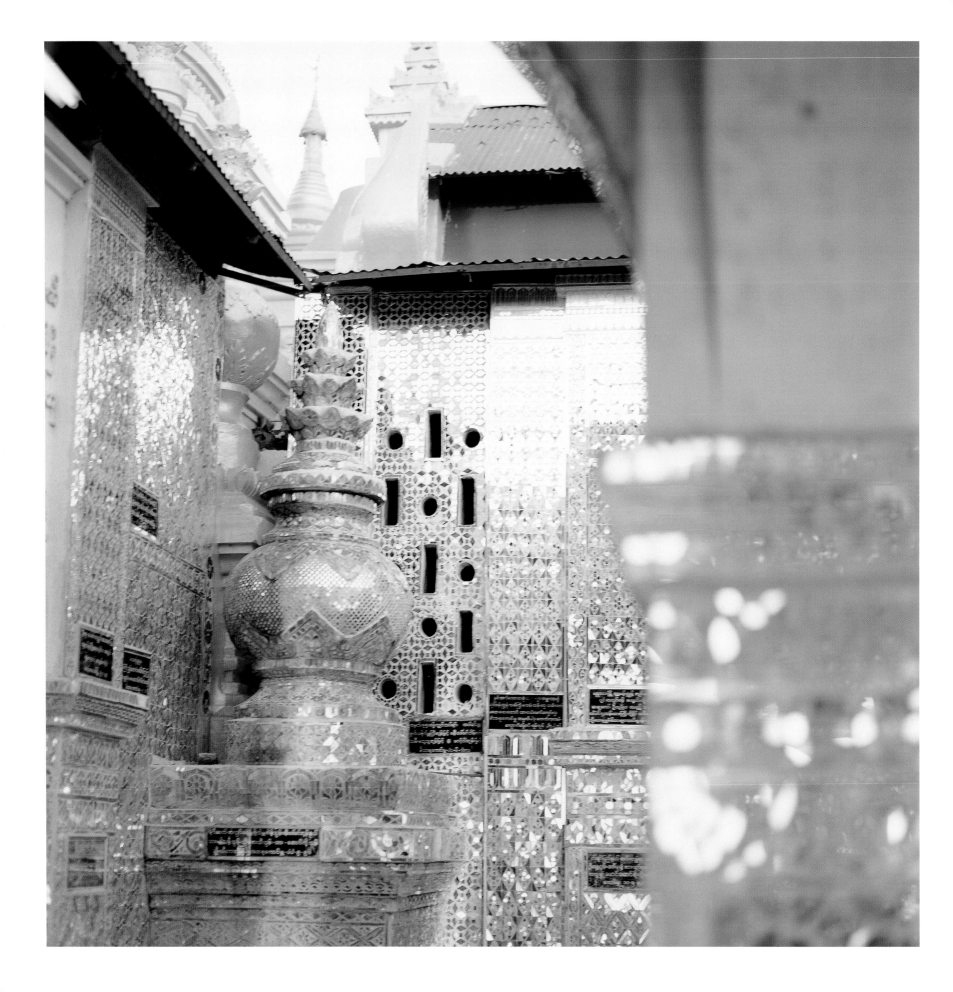

On my way out of town, I stopped to watch a woman make ginger salad, which is eaten after a meal as a digestive. As soon as I tasted it, I wrote down the recipe. First she peeled and sliced the ginger into thin strips. Then she soaked it in tamarind juice—the longer the better. When she was ready to make the salad, she took out the ginger, rinsed it in water, and patted it dry. Then she chopped up a tomato, put it in a bowl with the ginger, and added a little sesame oil, a handful of crushed roasted peanuts, and a pinch of salt. Mix it all up and serve. (If you like a little kick, dice a hot green chili and throw it in.)

I could have explored Bagan for another week, but the trip was coming to an end. Back in Yangon, I sampled another hotel. If the Strand was the epitome of British Colonial elegance, the Pansea Yangon seemed more homegrown and casual, more typically Burmese. Everything in the forty-nine-room hotel, with a wraparound veranda, is made of teak, and the whole place felt very close to nature. From the moment you walk across a bridge over a limpid pool of water to get to the entrance, it's as if you've left all the dirt and noise of the city far behind. Lush gardens beckon, birds warble, and suddenly nothing looks as comfortable as one of those plantation chairs set out on the grass.

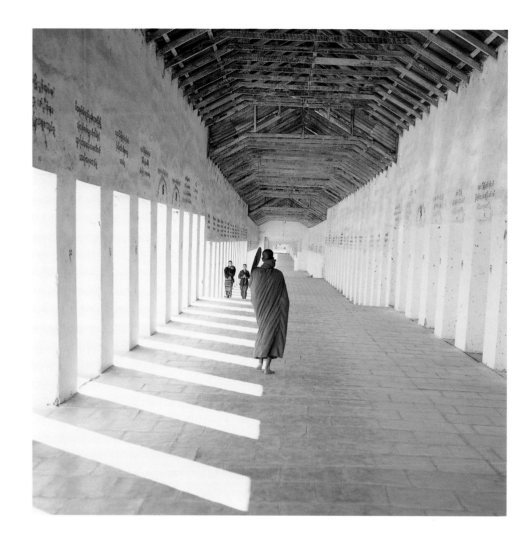

I had last-minute gifts to buy, so I headed out to the Bogyoke (also known as Scott) market, which is like a Middle Eastern souk all under one roof in the middle of town. You may pay a bit more, but the selection can't be beat. You can get everything from jade earrings to the local shampoo, a concoction made by boiling the bark of the tayaw shrub together with large black acacia pods. It sounds dubious, but it really leaves your hair very soft and lustrous.

On the street outside the market, dealers stand on the sidewalk, opening and closing small paper envelopes filled with precious stones. Burma is famous for its rubies, and the darkest, deepest red rubies are known as "pigeon's blood." But the best gems never even get to the government stores. They are immediately exported. Unless you know what you're doing, don't be tempted by the sidewalk dealers. It's too easy to be fooled into buying synthetic gemstones, which are prevalent in the market and pushed on unsuspecting tourists.

Just smile and walk on by, heading straight to Aung Thuka for lunch. This is where the locals eat, sitting down with their newspaper or joining friends at the long table. Point to one of the simmering pots of curry. Some are sweet, others are very spicy. Sauteed vegetables, soup, rice, noodles, and chopped tomato salad all magically appear. Your palate is bombarded with different flavors, as though you're tasting all the ethnic cuisines of Burma in one meal. Lick your fingers (because you'll soon learn to follow local custom and eat with your hands). Wash everything down with green tea or a cold Burmese beer. A meal will cost about four U.S. dollars.

My last day in Burma ended where it began, at the Shwe Dagon Pagoda. After a few weeks in this country, I was feeling relaxed and content—and a little wiser. For instance, I now know I was born on a Friday, which means my planet is Venus—a crucial piece of information if I want to worship at the correct shrine. (The architecture of the pagodas is intricately tied into the complex Burmese astrological system.) I also understand a little more about the Buddhist religion, practiced by about 85 percent of the population. Or let's just say I have a new appreciation and admiration for the gentleness of this way of life.

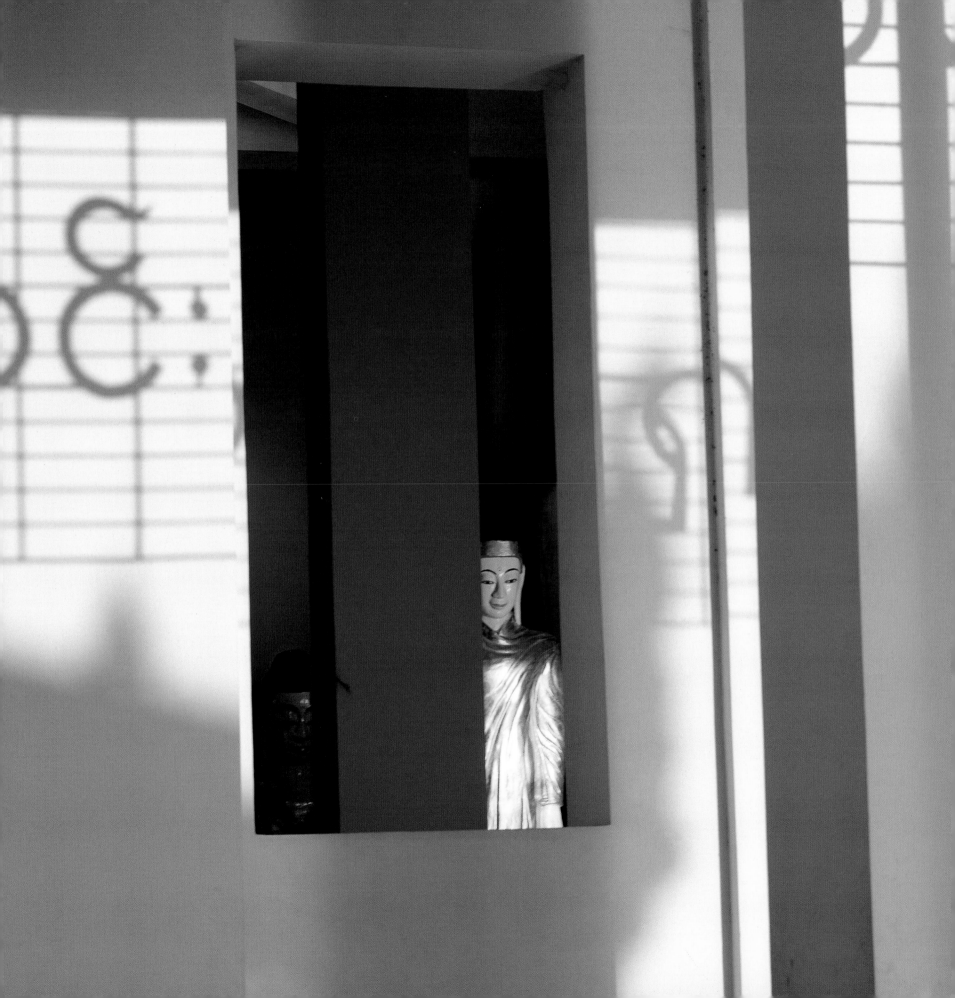

MYANMAR COLOR

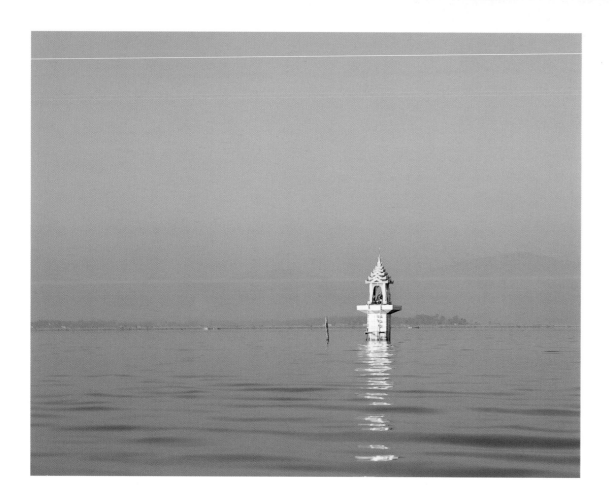

I WAS SO TAKEN WITH THIS SMALL FLOATING TEMPLE—a delicately carved and gilded confection rising like a mirage out of the waters of Inle Lake. The shimmer of gold on the blue water was mesmerizing. When I turned to look at the rest of the lake, suddenly the blues lost their magic. They looked a little dull and monotonous without that touch of gold.

This brings up an intriguing fact about color. You can do a room all in one color, or various shades of the same color, and it will work. But if you add even the smallest accent of a different color, the room becomes much more exciting—just as that little bit of gold made all the difference on the lake.

In this guest bedroom, the walls, curtains, carpet, and bed are all slightly different shades of blue, and they look even bluer next to the crisp white linens. The rattan side table adds a warm, natural accent. I couldn't resist finishing the room off with a fragment of Burmese carving— in memory of that moment on Inle Lake.

On the shores of Inle Lake, there's a shop worth a detour, named after its owner, Ana. She has wonderful handwoven silks—old and new—as well as special lacquered pieces.

On display in this bathroom is a whole collection of small Burmese jewelry containers, some bought at Ana's, others found at local markets. They're all made of hand-turned wood and then lacquered cinnabar red, or black over red, or gilded. It's my own little skyline of stupas—a miniature version of the temples in Bagan, where these pieces originated.

This group of objects is what you see as you walk down a long hallway toward the room. It creates a focal point while bringing color and a hint of the past into an all-white, contemporary bath. The exuberantly curved containers also offer a nice contrast to the straight lines of the mirrors. Mounted on steel poles in front of the window, the pivoting mirrors create a sense of privacy, but you can still enjoy the view.

EVEN A SINGLE-COLOR ROOM SHOULD HAVE SEVERAL DIFFERENT TONES. Think of the myriad shades of green in a forest. Light bounces off each shade differently, and it's the play of light that gives a room life. In this Los Angeles study, I wanted to explore a whole spectrum of reds. The walls are covered in tomato red linen. The sofas are upholstered in crimson, the club chairs in magenta, and the leather ottomans in claret. On the floor is a scarlet and shocking pink rug. You are engulfed in color, but the voluptuous red is tempered by a touch of white—in the artwork, on the door frames, and on the ceiling painted in Benjamin Moore's Super White.

Working with the generous proportions of the room, I created a seating group at one end anchored by a comfortable eight-foot sofa surrounded by club chairs. On the other end, to balance it out, a large eighteenth-century Spanish table is flanked by a pair of sculptural Jens Risom chairs. Instead of installing a traditional mantel, I opted for a more sculptural black granite surround—a visual trick that gives the illusion of a larger firebox. A touch of gold on the bronze Egyptian-style stool, on the six-foot-square mirrors, and on the nailheads trimming the twin ottomans adds a gleam, and a sense of drama, to the space. A Burmese lacquered tray holds a grouping of masks from Borneo. The photograph over the sofa was taken at Inle Lake. I hung the artwork at the same height as the doors to create a continuous horizon line. Iridescent silk shades unify the disparate windows. Bronze-colored lampshades add a dark accent.

Before you choose the colors for a room, you have to analyze what emotions you want to evoke in a space. For me, red is energy. It's the color of the blood that pulses through our veins, of the lava that spews from the earth. But an interesting thing happens in this room. In the final analysis, like an all-white space, it's neutral in its own way. All the different reds somehow cancel each other out. It's not overpowering the way one single shade would be. In fact, it's soothing to sit here.

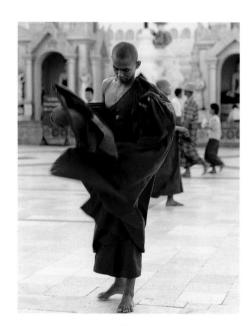

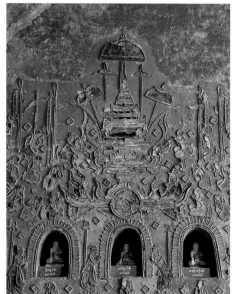

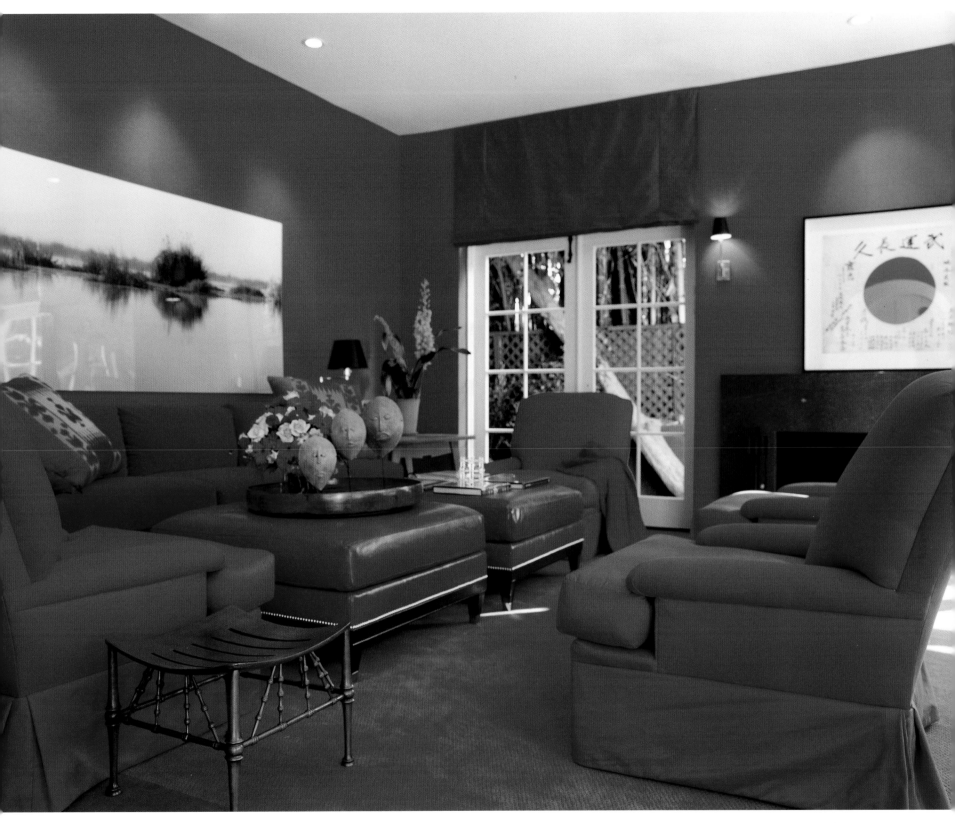

BENJAMIN MOORE
BONFIRE
2001-20

BENJAMIN MOORE
POPPY
1315

BENJAMIN MOORE
CLARET ROSE
2008-20

. BENJAMIN MOORE
SHY CHERRY
2007-20

127

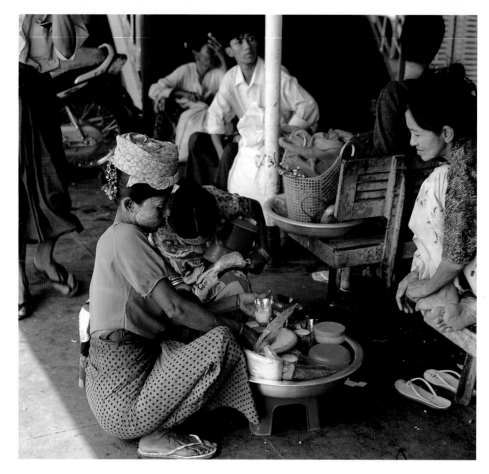

BENJAMIN MOORE
MIGHTY
APHRODITE
1397

BENJAMIN MOORE
TROPICAL ROSE
1355

I saw so much hot pink and fuchsia and lavender and purple in the fashions throughout Burma. When I was designing this restaurant in Las Vegas, I decided to play within that range. I applied color to the space by layering it, starting with the back walls. Inspired by Luis Barragán's architecture, I created openings that exposed different vistas, walls that broke up as you moved within the room.

These virtual windows and vertical gaps give you a slice of the space just beyond and create interesting juxtapositions of color. As a result, the space is always active, always changing. Water runs down a canal above the banquettes. Cutouts in the wall are filled with tanks of water, rigged to produce curtains of air bubbles and lit with lights that change color in a kaleidoscopic way.

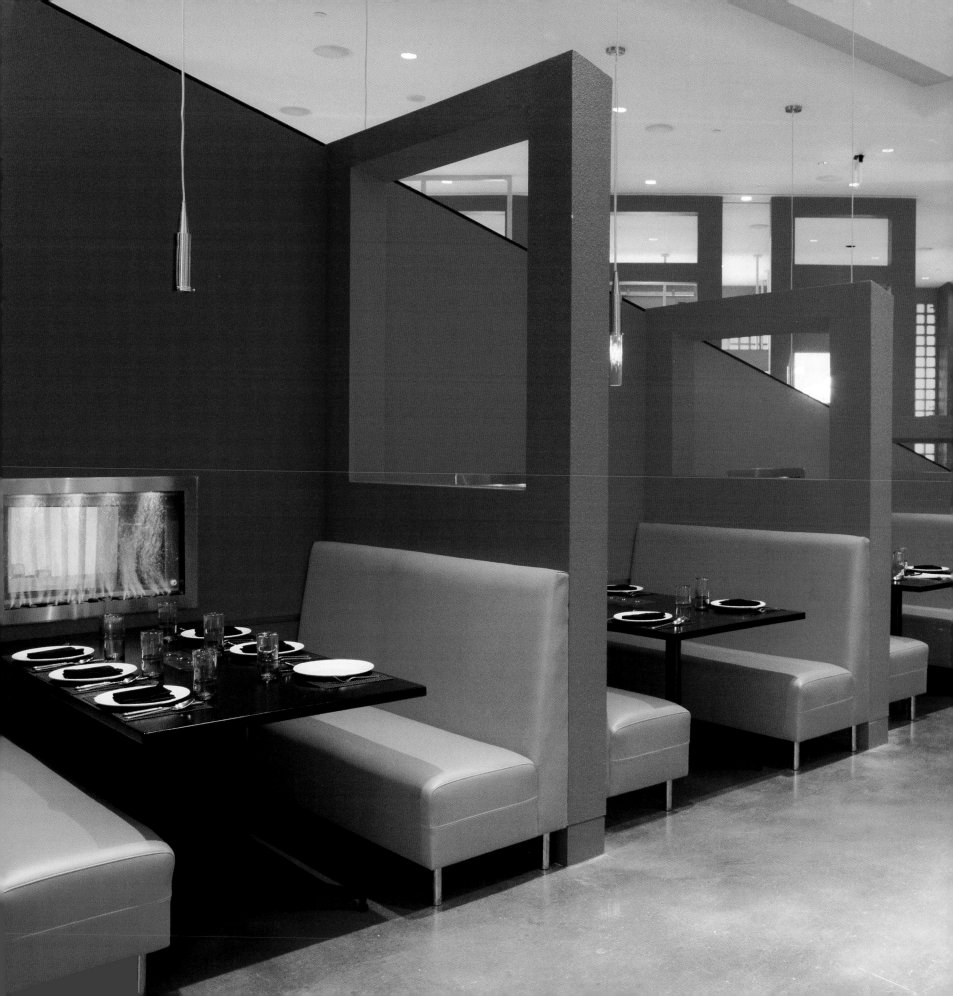

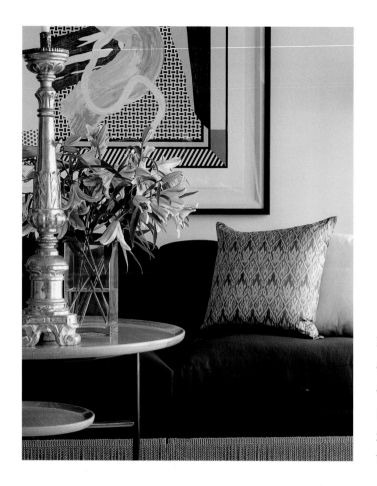

IN THE SPIRIT OF THE ROY LICHTENSTEIN PAINTING ON THE WALL, antique silk bought at Ana's and turned into a pillow adds a spark of color and pattern to this New York living room. The sofa is covered in dark brown polished wool and trimmed with an extravagant bullion fringe in seafoam green. An eighteenth-century Italian gilded candlestick stands on a modern table and brings a touch of theatrics to the setting.

AROUND INLE LAKE, MARKETS MATERIALIZE ON DIFFERENT DAYS and spread out from the boats to sheds near the water, where I would see people selling chickens and cattle next to tables laden with Buddhist prayer books. One dealer had a tempting selection of fragments from old temples, and I was thrilled to find this splendid peacock, still intact and adorned with an intricate inlay of hundreds of brightly colored mirrors. I could already see him mounted on a stand, proud and aloof, and he found a new perch in this master bedroom in New York City.

Silhouetted against the dark upholstered wall, his golden feathers look even more majestic. The dark brown sets off his regal crest, just as it shows off the bed. When you put a light color, such as the blue headboard, against a dark background, it seems to come forward. The crisp white sheets accentuate the contrast, and the bed really pops. I upholstered only this one wall, and only up to shoulder height, to highlight the bed. The rest of the room is painted blue, but I wanted that block of dark color. I was playing the square blue headboard against the rectangular brown wall. Reiterating the same strong lines, I designed a linear night table in steel, with two blocks of light-colored wood for the drawers. The square pulls are made of leather.

BENJAMIN MOORE
BARREL BROWN
2098-10

BENJAMIN MOORE
OCEAN CITY BLUE
718

BENJAMIN MOORE
HEMLOCK
719

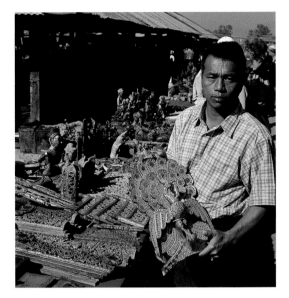

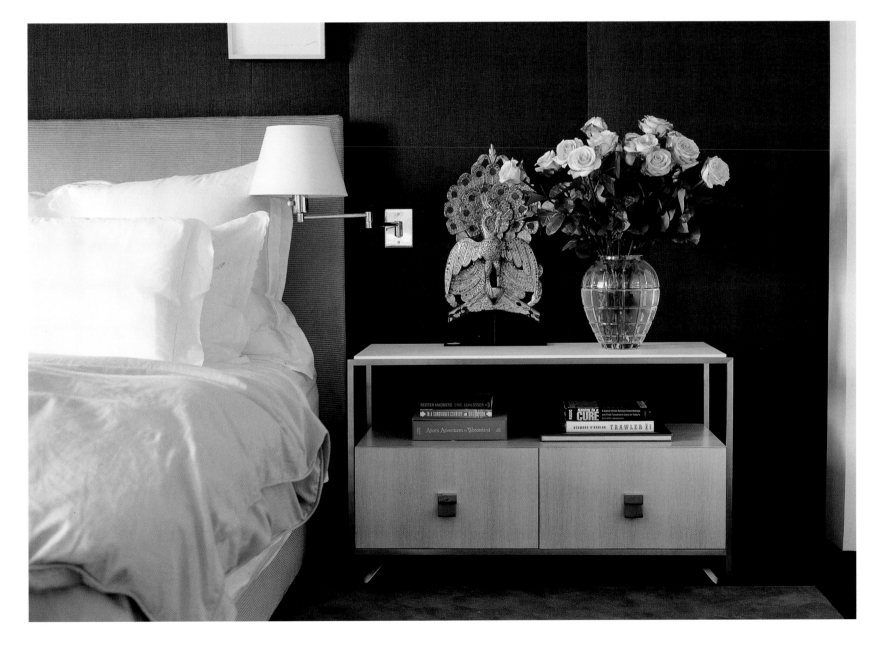

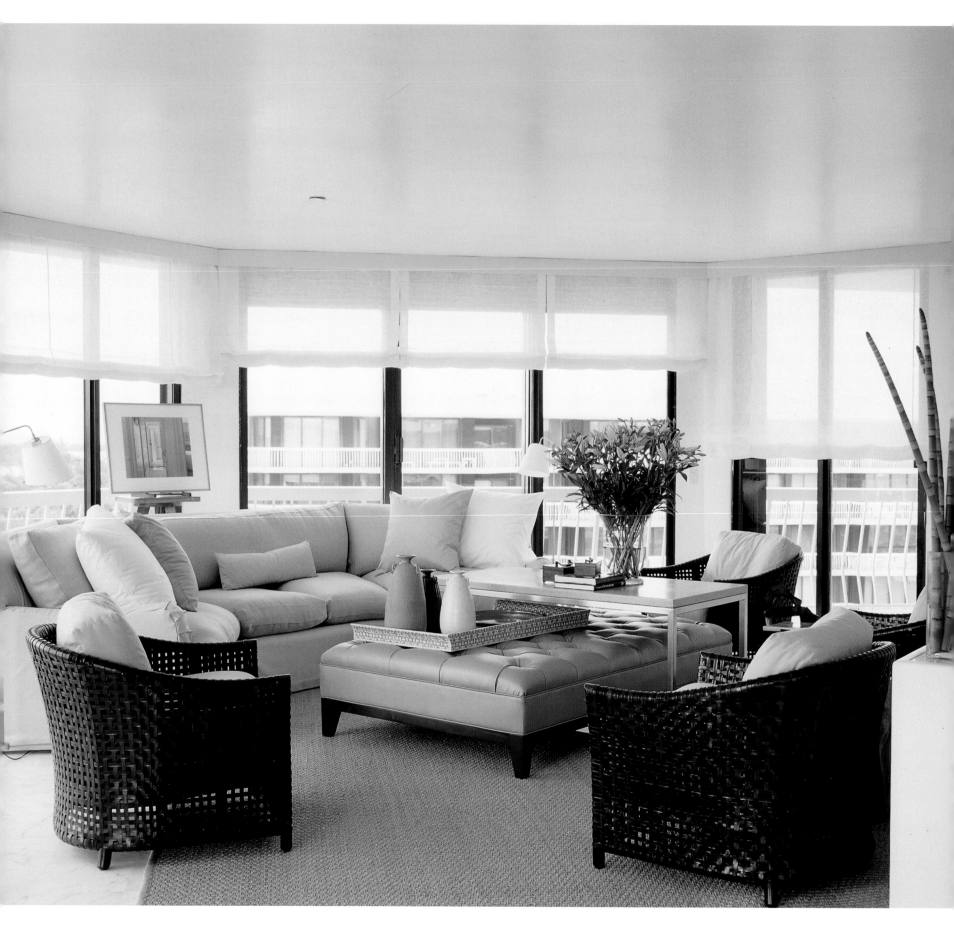

THERE ARE SO MANY REASONS WHY I LIKE WHITE. It brings a strong sense of integrity to a space and cues me to think about the room in a certain way. When the walls are painted white, I read it as architecture. When the walls are painted yellow, I read it as decoration.

White walls are my shell, my canvas. White is the relief I feel a room needs, especially if you're going to mix colors, textures, shapes, periods, and continents with abandon, as I do.

When people think of white rooms, they usually see them as one shade. But nothing could be further from the truth. Even a plain white room takes on dozens of tonalities depending on how light enters the space. The way any color looks is affected by the angles of the walls, the placement of the windows, and the type of artificial lighting used. The same white walls might become pale blue on a sunny day, orange at sunset, and gray at night—while still remaining white.

The Shwe Dagon Pagoda in Yangon is a wedding cake of carved plaster and stone, painted white. But at certain times of day, it takes on the blue of the sky, rather like this Palm Beach living room, which gets its blue cast from the sky, the furnishings, and the Intercoastal Waterway right outside. I also painted the ceiling in a white satin finish, which gives me one more opportunity to capture that blue reflection.

The blue is reiterated on the ottoman, the sofa frame, and the throw pillows. Then I added sand tones with the sofa and chair cushions and with the sea-grass rug. The dark woven leather chairs anchor the space and give a hint of the tropics while picking up the dark bronze of the window frames.

To compensate for the lack of natural light in the foyer in Palm Beach, I created a virtual skylight by building a square cove into the ceiling. Fiber-optic lighting is hidden along the perimeter of the cove. Two marble urns from India form part of a white-on-white composition on top of the Louis-Philippe bronze table, made in France around 1870.

This apartment originally had a separate living room, dining room, and kitchen, but I knocked down the walls to open up the space. My client is an expert cook who loves to entertain, and I didn't want her to feel isolated in the kitchen.

Now the apartment seems twice as large. A table and banquette create an intimate dining area, accentuated by a hanging lamp. I covered the banquette and ottoman in the same blue leather used in the living room, subtly connecting the two sides of the space. The Indian chairs, inlaid with bone, add another kind of texture. A teak cabinet from Burma holds china and glassware. I found the French painter's easel and thought it would make an unusual stand for a slim plasma TV—especially convenient since it can be rolled anywhere.

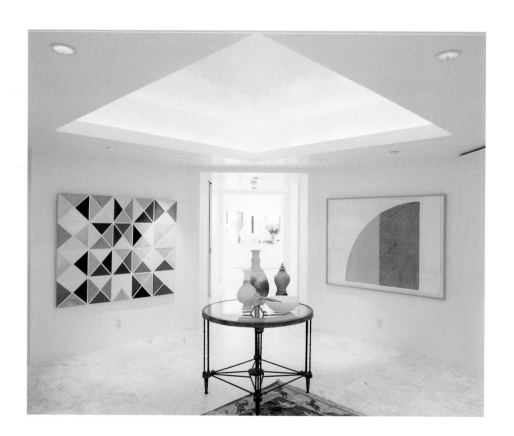

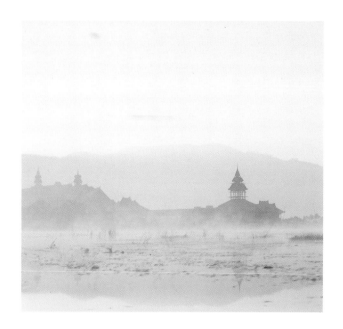

BENJAMIN MOORE
LITTLE FALLS
1621

BENJAMIN MOORE
BLUE HEATHER
1620

BENJAMIN MOORE
SILVER MIST
1619

BENJAMIN MOORE
FIRST SNOWFALL
1618

I LOVE THIS IMAGE OF A MONASTERY COMPLEX ON THE SHORES OF INLE LAKE because everything has dissolved into a blur of color. Water, shore, and sky seem to melt into each other. This kind of soft, vaporous colo puts you into a wonderful dreamlike state, which is why I'll often use it in a master bedroom. Here, in the Palm Beach apartment, the wool carpet is an indefinable shade of gray-blue. It looks like an abstract pool in the center of the room because I designed it with a wide border in pale chartreuse that follows |the angle of each wall. I wanted to make the large room feel more intimate and focus attention on the core, where the bed seems to float, pulled away from the wall. The walls are painted another indescribable shade of blue, with the back section behind the headboard slightly darker.

All these moves reinforce the idea of bed as focal point. The tubular steel bed I designed looks like a line drawing in space. It could hardly be simpler. Then I softened it with a rounded headboard and hung a gauzy curtain, both in shades of chartreuse. Instead of the typical night table, I found an eighteenth-century French painted table and a twentieth-century Warren Platner steel-and-frosted-glass table and put them together. That combination encapsulates the message of my work: good design knows no boundaries.

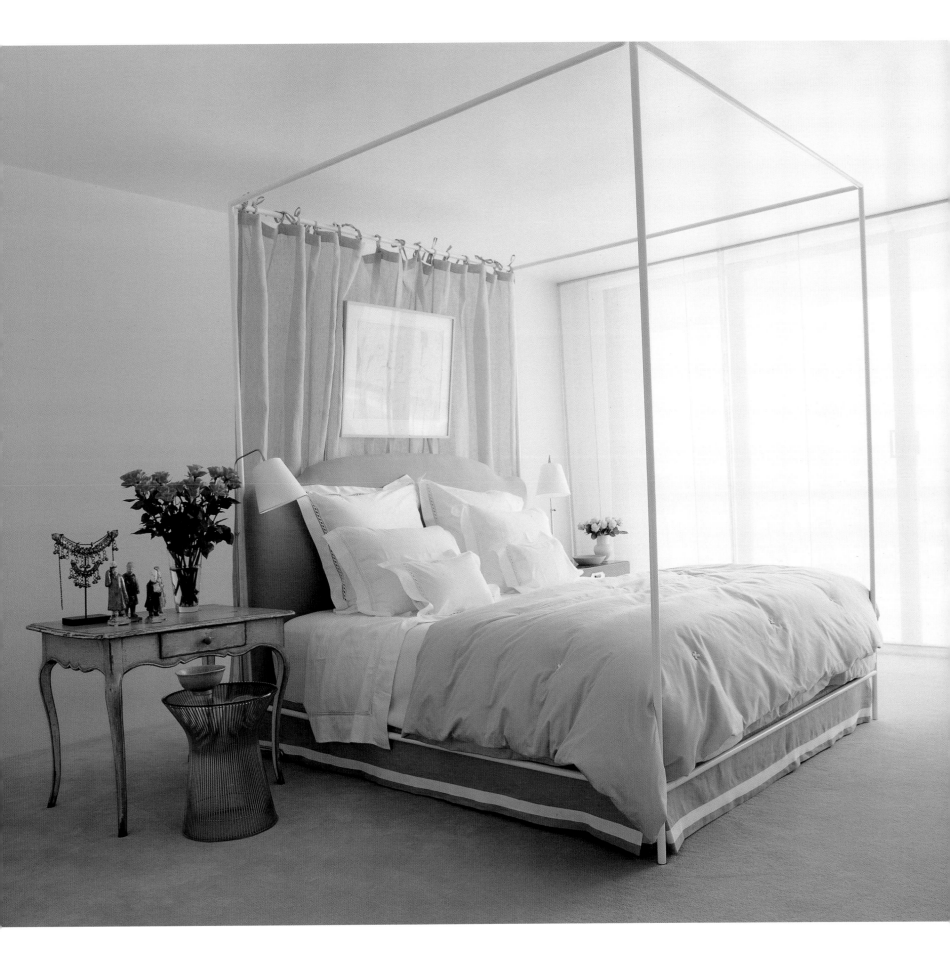

 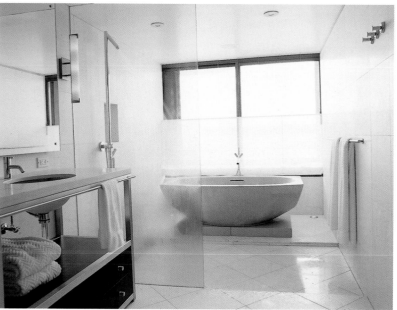

At one side of the bedroom, a limestone floor marks a discrete alcove. A curtain of chartreuse gauze separates the alcove from the bed. A long Italian writing desk made of painted wood is paired with a large-scale mirror so that the lady of the house may use it as a dressing table. The British Colonial teak chair is from Burma.

The limestone continues into the master bath, where just a sheet of glass sets off the shower. The sculptural concrete tub seems to float in front of the window. Privacy is provided by a schoolhouse shade. I put recessed lights in the floor to dramatically silhouette the tub at night.

In the guest bedroom, a louvered wood panel from India serves as a headboard. The walls are painted lemon yellow. The sleek lines of the Noguchi table play against the British Colonial Burmese chair. A nineteenth-century Chinese ceramic window tile is treated like a piece of sculpture.

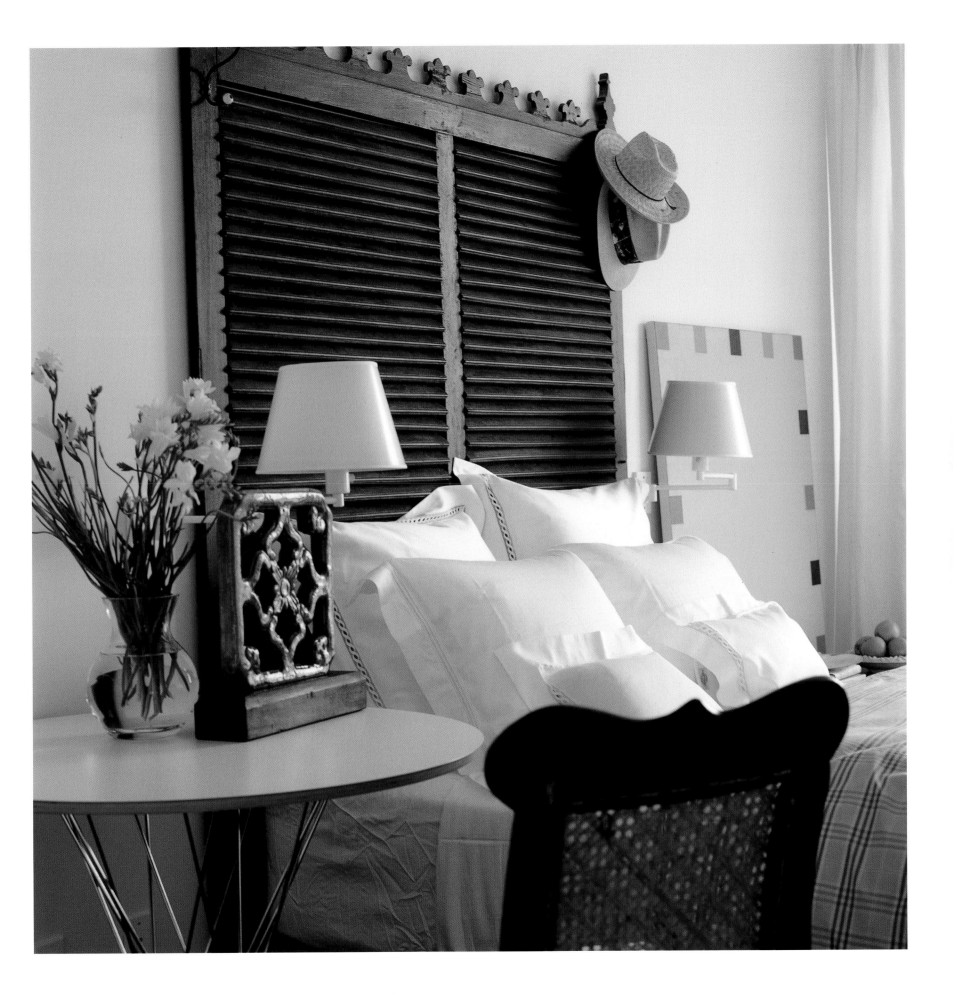

BENJAMIN MOORE
WOODLAWN BLUE
HC-147

BENJAMIN MOORE
BOARDWALK
1102

BENJAMIN MOORE
WOODACRES
1020

BENJAMIN MOORE
PARIS RAIN
1501

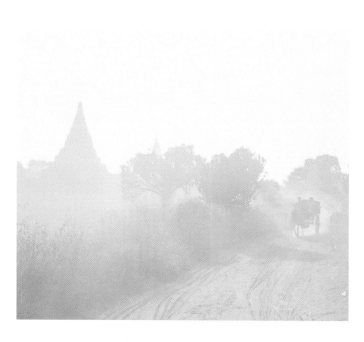

I was struck by how naturally the temples of Bagan take on the colors of the landscape. The brick and stone have been weathered by the elements for centuries, and now they seem to be gradually returning to the earth.

I love using earth tones in my projects because nature has already proved that they work. I will pick up stones and marvel at the coloration. There are so many shades even in something as simple as dirt. The clouds of dust kicked up by this oxcart mute the distinction between browns and greens and blues and make light itself almost palpable.

I tried to achieve something of the same effect in this New Jersey living room, with a gauzy shade across the lower portion of the spectacular two-story-high window. I wanted to diffuse the light and soften all the edges in the room.

When you first walk in, your eye is automatically drawn up—and then down, following the billowing folds of the sage green silk curtains. The room is so vast that most people would feel compelled to fill it up with furniture. But I took the opposite tack and chose just a few overscaled pieces because I wanted to preserve that glorious sense of space. A ten-foot-long sofa is accompanied by extrawide club chairs. Two high-backed, ratchet-arm sofas flank the fireplace and offer a more protective, enclosed place to sit. Instead of the typical large-scale mirror over the mantel, I opted for a small framed photograph, which in an odd way humanizes the space. I put the mirror on the opposite wall, over the long sofa. I hung two large eighteenth-century French wallpaper panels on either side of the fireplace. These are balanced on the opposite wall by a pair of tall folding screens covered in white ribbed silk. So I created high, medium, and low horizon lines in the space—the high curtains, the medium panels, screens, and mirror, and the low furniture. This helps clarify the whole picture and brings the room down to a more human scale.

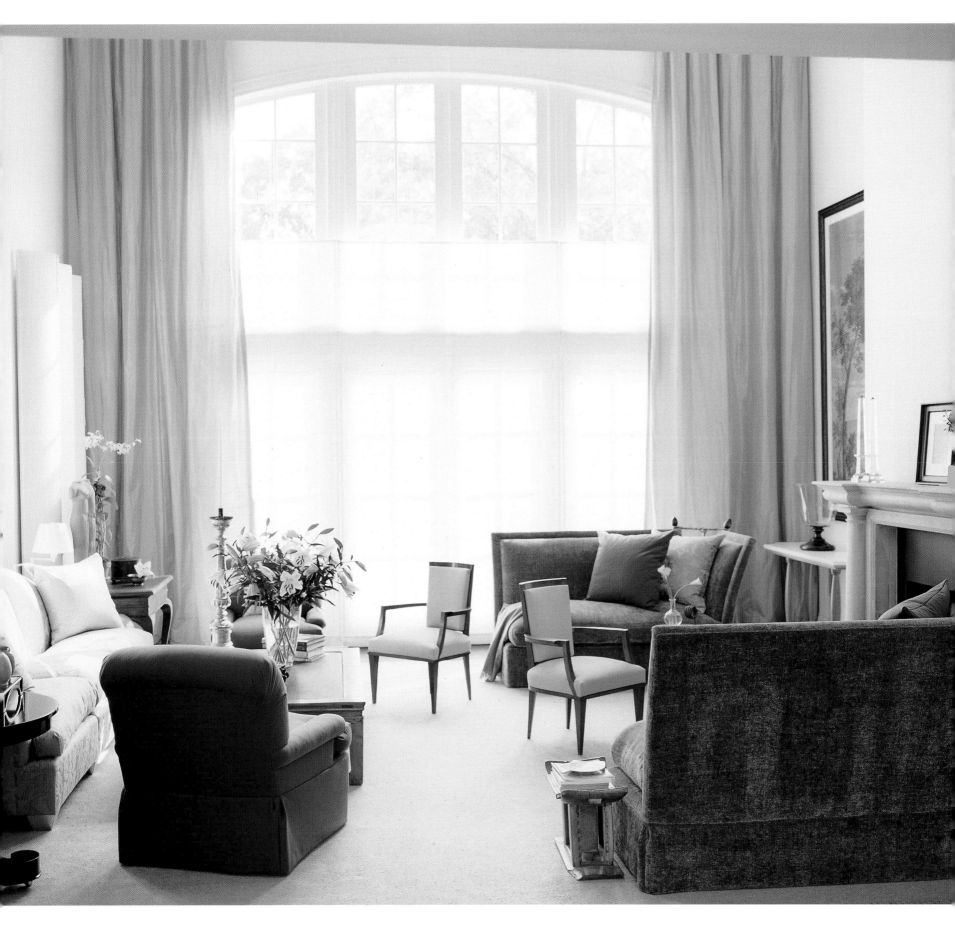

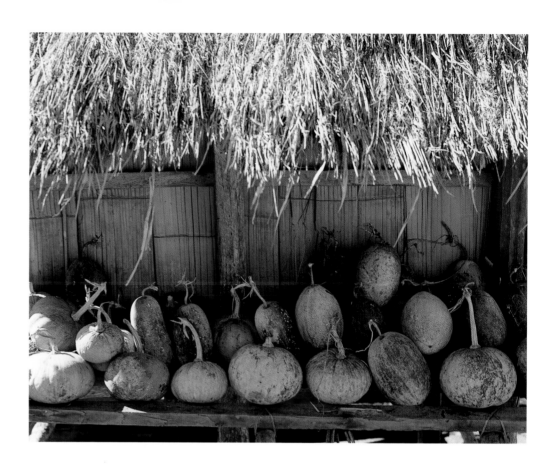

LOOK AT ALL THE DIFFERENT SHADINGS ON THESE GOURDS, sitting next to a straw-roofed hut in northern Burma. What caught my eye was the blend of light and dark tones, from the sun-bleached straw to the silvery sheen of the rind to the dark shadows.

In this kitchen, I blended similar light and dark tones. The woods range from lime-rubbed oak on the chairs to polished mahogany on the island, which consists of a traditional top and legs masking a more contemporary, clean-lined storage space. White Corian on the countertops and backsplash has a matte finish, in contrast to the gleam of stainless steel trimming the cabinets. Niches at the very top of the room hold the client's collection of creamware, creating a wraparound still life.

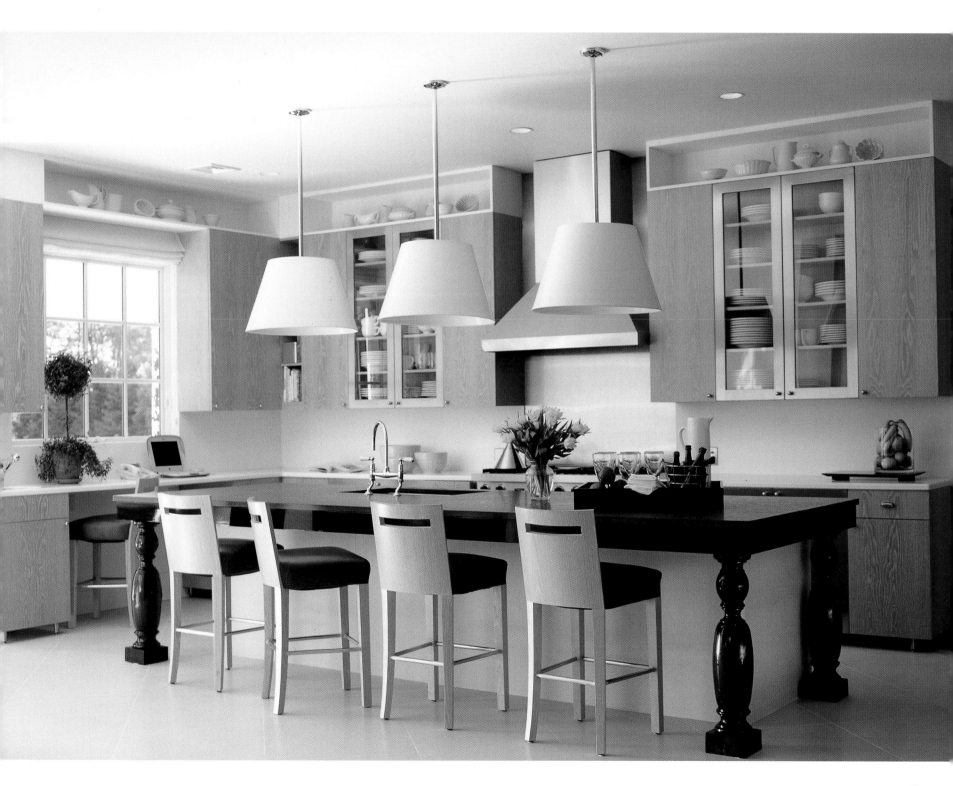

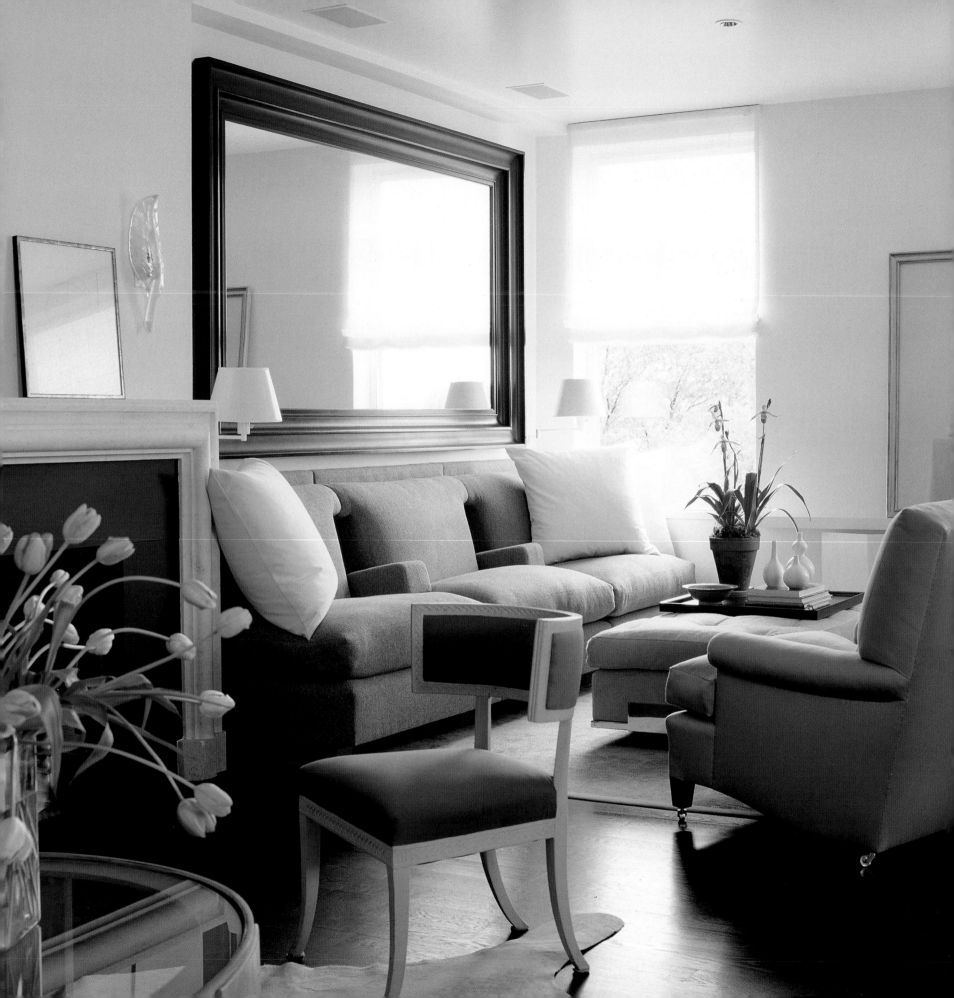

BENJAMIN MOORE
BROOKLINE BEIGE
HC-47

BENJAMIN MOORE
ALEXANDRIA BEIGE
HC-77

BENJAMIN MOORE
WHITALL BROWN
HC-69

BENJAMIN MOORE
YELLOW RAIN COAT
2020-40

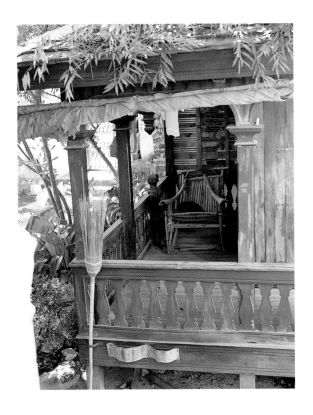

IT'S INTERESTING TO SEE HOW ONE SHOT OF COLOR CAN TRANSFORM A SPACE. In this otherwise neutral living room in New York, I chose a strong yellow for the throw pillows and used them as exclamation points. The sofa and club chair look traditional and vaguely familiar, and so does the Swedish Gustavian chair. But then I like to toss in at least one eccentric, like the 1960s Poppa Bear chair.

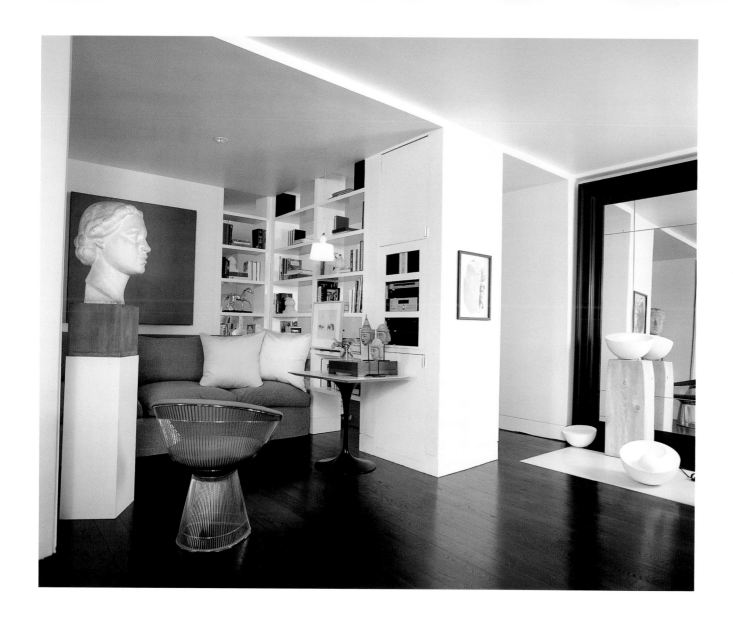

In the library alcove, I picked up the yellow again and added one of Warren Platner's wire-framed chairs, originally designed in 1966. Some people think you should put small furniture in small rooms, but I don't believe in that rule. The overscaled white plaster bust gives this little alcove a bold new identity and great drawing power. Against a side wall, I created a virtual foyer with a limestone insert on the ebonized wood floor and a huge, floor-to-ceiling mirror.

The high-gloss mahogany dining table has a watery sheen. Playing on that reflective theme, I mimicked the still life in the painting with my own version right beneath it.

BORNEOCONTRAST

AFTER A YEAR IN WHICH I HAD SUFFERED ASSORTED AILMENTS AND A BRUISING SCHEDULE, I WAS LOOKING FORWARD TO DECEMBER AND MY ANNUAL TRIP. I WAS READY TO SHUT THE DOOR ON NEW YORK AND INHALE THE FRESH SCENTS OF GARDENIAS AND RIPE FRUITS WAFTING THROUGH MY JEEP'S WINDOWS AS I BOUNCED DOWN THE BACK ROADS OF SOME EXOTIC COUNTRY. THIS YEAR IT WAS BORNEO.

I COLLECT COUNTRIES THAT I WANT TO VISIT THE WAY SOME PEOPLE COLLECT STAMPS. I AM ATTRACTED TO THE MUSIC OF NAMES LIKE ZANZIBAR, MADAGASCAR, AND BHUTAN, HEARD IN OLD MOVIES OR GLIMPSED IN AN ISSUE OF NATIONAL GEOGRAPHIC. IF SUCH PLACES ARE TINGED WITH SOME SLIGHT DANGER AND EXCITEMENT, SO MUCH THE BETTER.

I HAVE TRAVELED THROUGH SOME OF THE OTHER INDONESIAN ISLANDS—BALI, SULAWESI, JAVA, AND SUMATRA—BUT BORNEO, KNOWN FOR ORANGUTANS AND PRECIOUS WOOD, WAS THE LAST OF THE LARGE ISLANDS I HAD YET TO SEE. WITH A POPULATION OF NINE MILLION, IT IS NOT OVERCROWDED; MOST PEOPLE STILL LIVE ALONG THE WATERWAYS THAT INTERLACE INDONESIAN BORNEO (ALSO CALLED KALIMANTAN), MALAYSIAN BORNEO (SABAH AND SARAWAK), AND BRUNEI. THE RIVERS IN BORNEO ARE NOT ONLY A MAJOR FORM OF TRANSPORTATION BUT ALSO THE PLACE WHERE THE BUSINESS OF LIFE BEGINS AND ENDS EVERY DAY. MY GOAL WAS TO EXPERIENCE THE COUNTRY AND ITS PEOPLE THROUGH THESE WATERWAYS.

It's just a short trip from Jakarta to Banjarmasin, the capital of Kalimantan, built on the Barito River delta. Even with a population of eight hundred thousand, Banjarmasin still feels like a small town. Almost every house has a wooden porch overlooking one of the rivers that weave through the streets. I had heard about the floating market, which gets under way at dawn. Compared with Bangkok's floating market, which is primarily a tourist attraction, Banjarmasin's waterway is a major part of everyday life. Canoes and small boats carry a large assortment of tropical fruit, freshly caught fish, river prawns, vegetables, and household goods, all traded and sold boat to boat, with not a tourist in sight. The shops of boat makers and furniture carvers all face the river, where people bathe and wash clothes as well as shop.

Arriving at the rafting site in Loksado, I was met by Baseri, a member of the Dayak tribe, who would be my oarsman. At 8 A.M. the next morning, we floated off onto the Amandit River on a twenty-five-by-six-foot bamboo raft that Baseri had built himself. He propelled the raft by thrusting against the rocks with a bamboo pole. The profusion of greenery, so dense that only narrow shafts of light came through, was extraordinary. Everywhere I looked were ferns, bamboo, and palms, all pushing toward the river. Umbrella-shaped ara trees, 125 feet high, were draped in orchids. The cries of gray monkeys, crickets, and hornbills contributed the classic sound effects, and every so often I caught a glimpse of three-foot-long lizards gliding just under the surface of the water. It all looked like a nineteenth-century nature painting. Halfway through the trip we stopped for tea at a small food shack where local farmers had gathered for lunch at 10:30 A.M.

Suddenly the sun vanished, doused by a downpour. Rain at this time of the year comes very fast, without much warning, and when it does arrive it's torrential. It didn't stop for the rest of the ride, which meant the character of the river changed. The stillness was just a memory. Now the bamboo stalks were waving wildly in the wind, which sent swirls of dry leaves into the water. The rain brought out the scent of the forest and made the ride even more memorable.

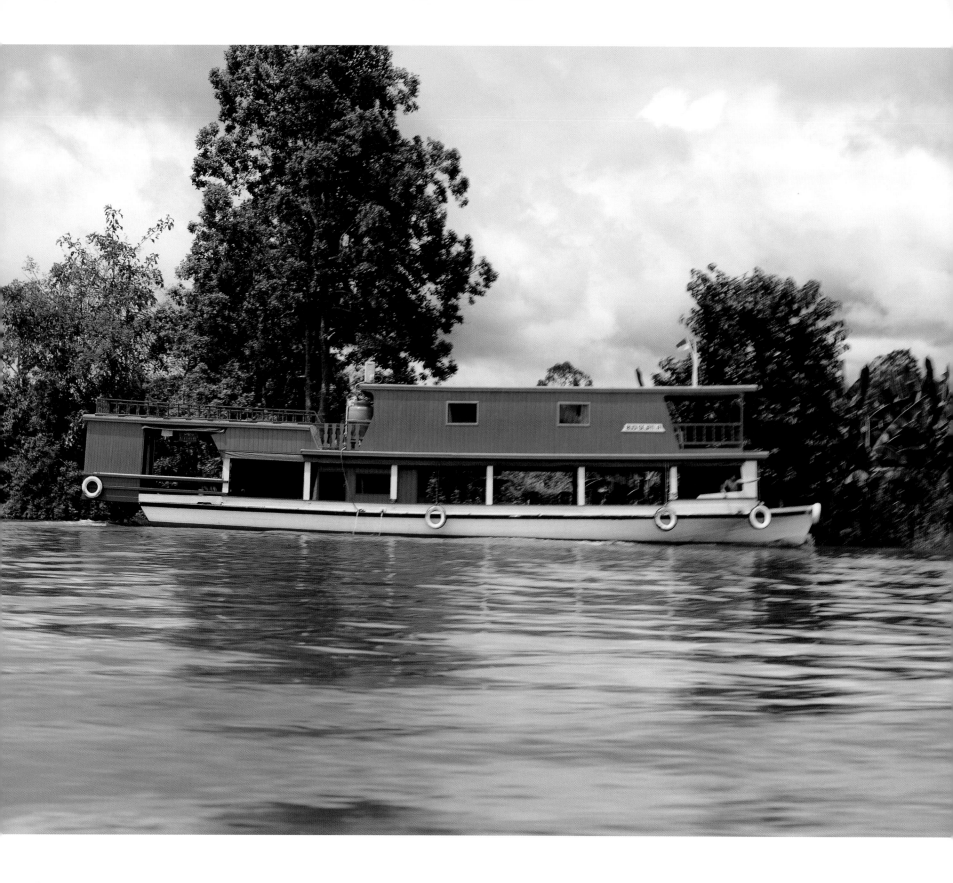

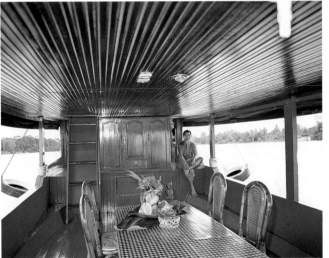

The next day, I took a forty-five-minute
flight from Banjarmasin to Balikpapan, and
then a two-and-a-half-hour bus ride to
the river city of Samarinda. Here, I was met
by Masery, the captain of the *Bubisagati*.
When you plan these excursions from
afar, you never know what to expect, but in
this case, I was pleasantly surprised.
The houseboat was sixty feet long by
eleven feet wide. It had two levels, one at
waterline consisting of a wheel room
and an open dining area (where the crew
slept at night), as well as an engine room,
kitchen, and toilet/shower room. The
second level was an open room with a
mattress on the floor, which served
as my bedroom, and two decks front and
back, all in immaculate condition and
painted a shiny teal blue. There was a
captain for day travel, a different captain
for night travel, an engineer, and a cook.
Masery has been going up and down the
Mahakam River for eighteen years. In
addition to serving as main captain, he is
a carpenter and constructed the boat.
The only shortcoming was that the ceilings
were five feet nine inches high and I
am six feet one inch—but I learned to duck
very quickly.

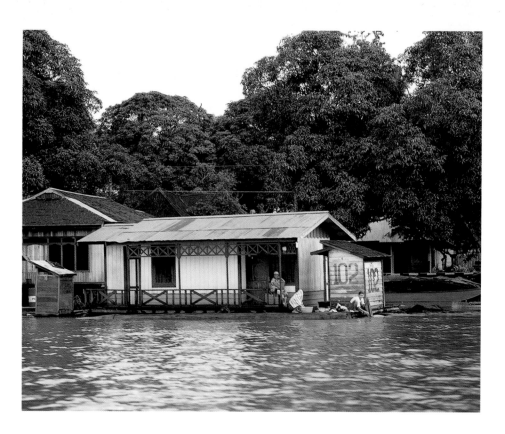

As soon as we pushed off, I started to unwind and just go with the flow. Lying on the deck, I noticed all the shades of gray in the cloudy sky, evidence that more rain was on the way. Seeing the life of Borneo from this vantage point, up close, is fascinating. On the river you are in another world. Young and old, everyone comes to the water for shopping, traveling, fishing, washing, bathing, and cooking. The stifling heat is more bearable with the river breezes. This is what I had been looking for, a moment when time moved more slowly, when I could reflect and just be, with no rush, no schedule, no agenda. At last, New York had vanished. I was in another world, a different dimension.

In the morning we docked and set off by canoe for a three-hour trip upriver, stopping along the way to watch the people make palm sugar. They would climb to the top of a palm tree and cut into the fronds, hanging a bamboo tube to catch the sap, which would later be boiled and reduced to sugar. On the banks, you see wild mango trees loaded with fruit, breadfruit trees, kapok trees, and banana plantations. Everything is so lush. There are monkeys traveling tree to tree, a countless array of birds, and an occasional water python. But it's hard to ignore the never-ending stream of mahogany and ironwood logs being transported downriver. These exotic woods are one of the major assets of Borneo, and as more trees are felled, the people are slowly destroying the jungle and eroding the earth.

Turning into one of the smaller tributaries, we headed inland, getting even more engulfed by the vegetation. I saw bird's-nest ferns and innumerable orchids, proboscis monkeys, the bright blur of kingfishers, and every so often a hint of scent from some hidden flower. The dark, still water created a mirror effect, and everywhere I looked, life was exploding in all sizes and forms, one plant on top of another.

Our destination was the Ma Muntai village of the Banuaq tribe, where we were welcomed by the chief and treated to tribal dances in front of a communal longhouse. Accompanied by a drum and a horn, the women moved in unison in a circle, rhythmically pounding their bare feet, which added one more dimension to the beat. Their low chant accentuated the hypnotic effect. As they danced, I found myself focusing on their skirts, which were made of grass woven into abstract patterns representing monkeys, dragons, and snakes, all part of their mythology. Afterward, walking through the village, I was able to purchase wonderful old skirts and shirts made from cotton and pineapple fiber. The women spend any spare time weaving, while the men practice their blow darts in preparation for hunting monkeys and birds.

We moved on to the village of Mancong, where I spent the night in a longhouse. There were ten small rooms, each with a window, a bed, a fan, bamboo mats on the floor, and the all-important mosquito netting. There were four communal bathrooms and a communal dining room and kitchen. We had brought all our own provisions, and the cook from the boat (who happened to be the captain's aunt) prepared an excellent Indonesian meal, which usually consists of multiple dishes served at the same time—a couple of soups, some fish, chicken, sticky rice, and vegetables, with fresh fruit for dessert.

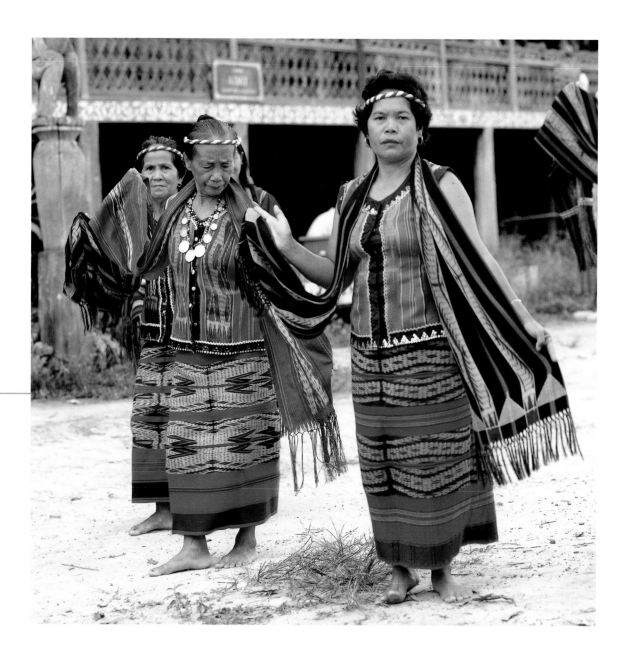

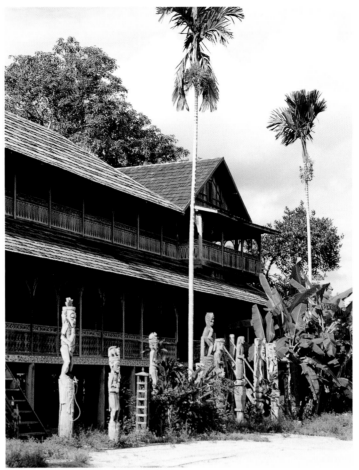

In the morning, we made our way by canoe to a rendezvous point and were welcomed back to the houseboat with a great lunch of freshly caught catfish (still alive when we arrived), grilled eggplant, and fried rice. The next leg of the trip was slow; we moved against the current at barely ten miles per hour. Many of the houses along the river are built on logs or stilts to protect them from floods. The Mahakam is the second-largest river in Borneo, running four hundred miles from the highlands to the sea, and the deepest (approximately 130 feet). It was brown with muck washed down from upriver, due to the rainy season. We stopped at Muara Pahu, one of only three places in the world where you can see pink dolphins. They like to congregate here, where three rivers converge, living in freshwater rather than saltwater. I spotted what looked like a whole family playing together, and they were the loveliest shade of pinkish, pearly gray.

The Muslim crew on the boat prayed five times a day for thirty minutes each time, starting at 4:30 A.M. and ending at 8 P.M. No matter what they were doing, they all just stopped at a certain hour. Suddenly, you would see rowboats left to drift while their oarsmen turned toward Mecca. It was interesting to find such structure in a place as wild as this. The faith is so strong. The continuity of traveling upriver and the rhythm of the praying had a very soothing effect. We continued our cruise upriver to Long Iram, where we got out and walked through the town, past the local vegetable gardens, to the village of Tering. I was curious about the Dayak Bahau tribesmen, who traditionally perform a mask dance to chase away evil spirits.

Early the next day we were off by canoe for a two-day excursion further up the river, where the houseboat could not go because of shallow water and rapids. It was a very small canoe, making it difficult for a person of my height. I felt like a giant coming out of a little car. My companions found it very amusing because they can slip in and out of the canoes effortlessly.

After carefully extracting myself from the canoe, I explored the village of Rukun Damai, inhabited by the Dayak Kenyah tribe. There, you still see older women with impossibly long, stretched earlobes, but the younger people have abandoned the custom. I was taken aback when I held one of the earrings; it had to weigh two and a half pounds. I was told that it is very painful to have such weight on your earlobes, especially at first, but one gets accustomed to it.

With two ceremonial longhouses, the village is larger than most. Accommodations consisted of a five-room guest house built on logs floating in the river, which served as the ferry dock as well. My room contained a pillow and a mattress on the floor. In order to get back to dry land, you had to step gingerly along a log. I was apprehensive, but I managed to keep my balance.

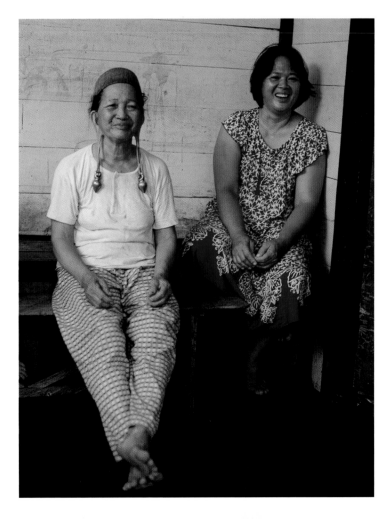

The next day we arrived in Long Bagun, which was as far north as we would go on the river. After that, the rapids become more dangerous. The village is known for the large numbers of swallows that nest in the lime caves on the cliffs. These are the birds whose nests are used in the famous bird's nest soup. This is a big source of income for the town. During the three-month nesting season, police guard the lime caves twenty-four hours a day. Rifles are fired every hour to remind any thieves of their presence. People have been killed for stealing a bird's nest. Even collecting them legitimately has its perils. Climbing the rock face is dangerous, and no season goes by without one or two people falling to their deaths. From Borneo, the nests are graded by size and shipped to China, Malaysia, and Japan, bringing in tens of thousands of dollars.

Anyone who has sampled bird's nest soup in his local Chinese restaurant may be wondering what all the fuss is about. But the real thing is made not with noodles but with swallows' nests—spun out of their own gummy saliva, which hardens in the air. Washed and then simmered in chicken broth, the nests are considered a delicacy and rumored to be an aphrodisiac. Frankly, it just tastes like chicken soup to me.

Another major export from Long Bagun is incense. Tribesmen trek deep into the rain forest to gather it and are often gone for months at a time. It's a long and arduous process to find the particular kind of tree and then get at the core of the trunk, where the fragrant pockets of resin are located. Here is another locus for crime: the best incense can sell for $4,500 a pound, making it easy prey for thieves, who will hijack canoes loaded with these small, aromatic chips of wood as they glide downriver. It has gotten to the point where helicopters are chartered to pick up the precious cargo and bring it to Samarinda. There, it is sold to dealers who ship it to India and the Middle East, where it is used in religious ceremonies. From the prospectors upriver sifting gold out of gravel to the tribesmen who maneuver the rapids to bring a load of incense down to market, this is a place where a lot of people work very hard to produce large profits for a very few.

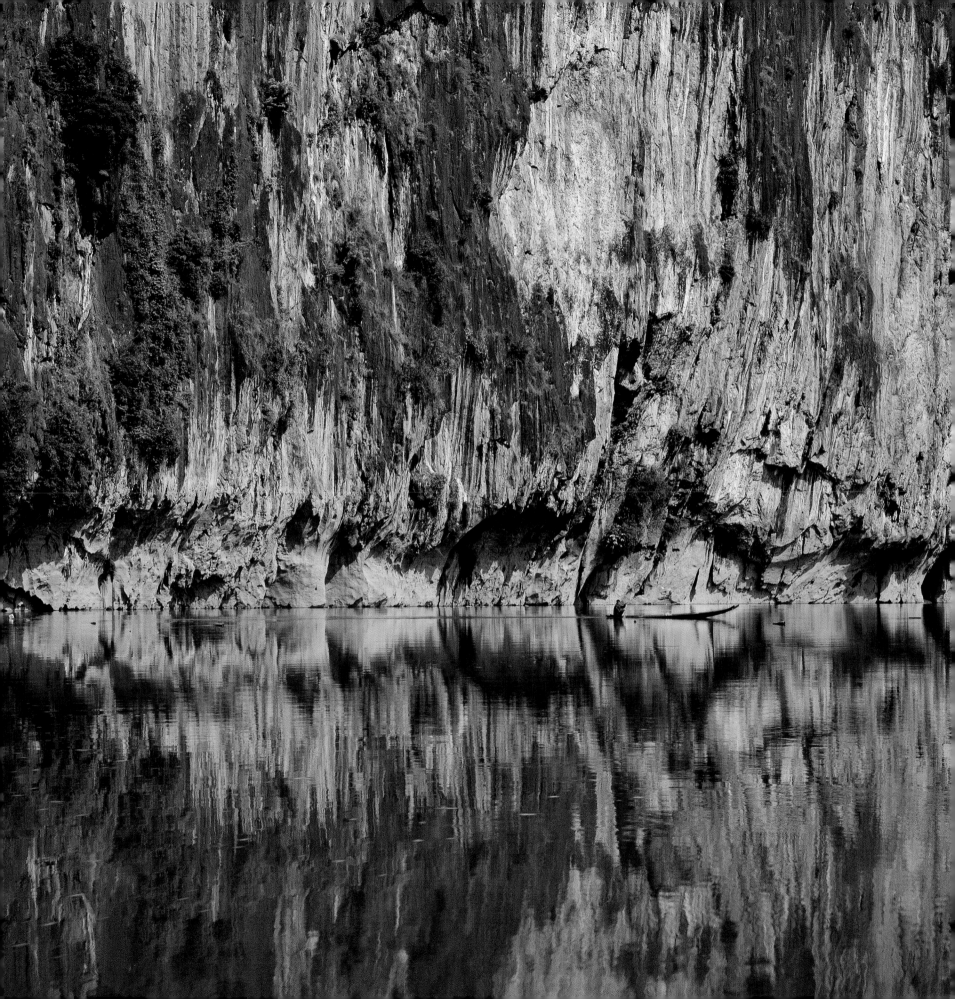

After a one-night stay, we headed back down the river to Melak, where I had been promised a glimpse of the rare black orchid. I grow my own orchids in New York, and it's always a thrill to see them in the wild. I had dinner and went to bed in order to be ready for the journey. We had crossed the equator six times in the last few days because the river snakes up and down. At this latitude, the sun is so strong that you can get burned in just half an hour.

At 7 A.M. I was sitting in a skeleton of a truck with an exposed motor, planks in the back for the floor, wooden benches tied to the planks, no glass in the windows of the cab, and about as much suspension as a New York City taxi. The driver, wearing thick glasses, sat hunched over the wheel. In the course of the one-hour drive, we ran over two chickens and one baby pig. Every so often I'd see something ricochet off to the side of the truck, but he just kept going.

As soon as I walked into the Kersik Luway Nature Reserve, a scent of perfume permeated the air from the hundreds and hundreds of orchids clinging to the trees. Each clump had numerous sprigs of flowers. They were extraordinarily fragrant, yet I could tell that these were not the famous black orchids. A closer look at the branches of the trees and at the ground revealed many other species,

one with stems five feet tall and buds the size of dinner plates. I was told it was called the sugar orchid because of the sweet nectar it produces. The ones with spiny greenery were called cactus orchids. Not every plant was in bloom. Nonetheless, it was an imposing show—but still no black orchid. The ranger who was taking me around kept pushing aside leaves, penetrating deeper into the forest, searching for the elusive Colony Pandurata. And suddenly there it was, just like Greta Garbo, all alone on a tree, its vibrant green flower set off with black spots and a black center. And when I say black, I mean black, with a very heady scent. Part of the rarity is the fact that it is only known to grow here, in the wild, and the flower lasts only one week.

After tearing myself away from this orchid, I took a walk with the ranger to see the giant mahogany trees, each trunk wide enough to require ten people holding hands to go around it. Carnivorous plants, looking like jack-in-the-pulpits, were everywhere, hanging off branches by the dozens, waiting for their next meal. There were all types of bamboo and ferns and huge termite colonies attached to trees. When I looked down at the ground, I realized it was in motion—red ants, centipedes, and leeches, all crawling and creating a moving tapestry on the forest floor.

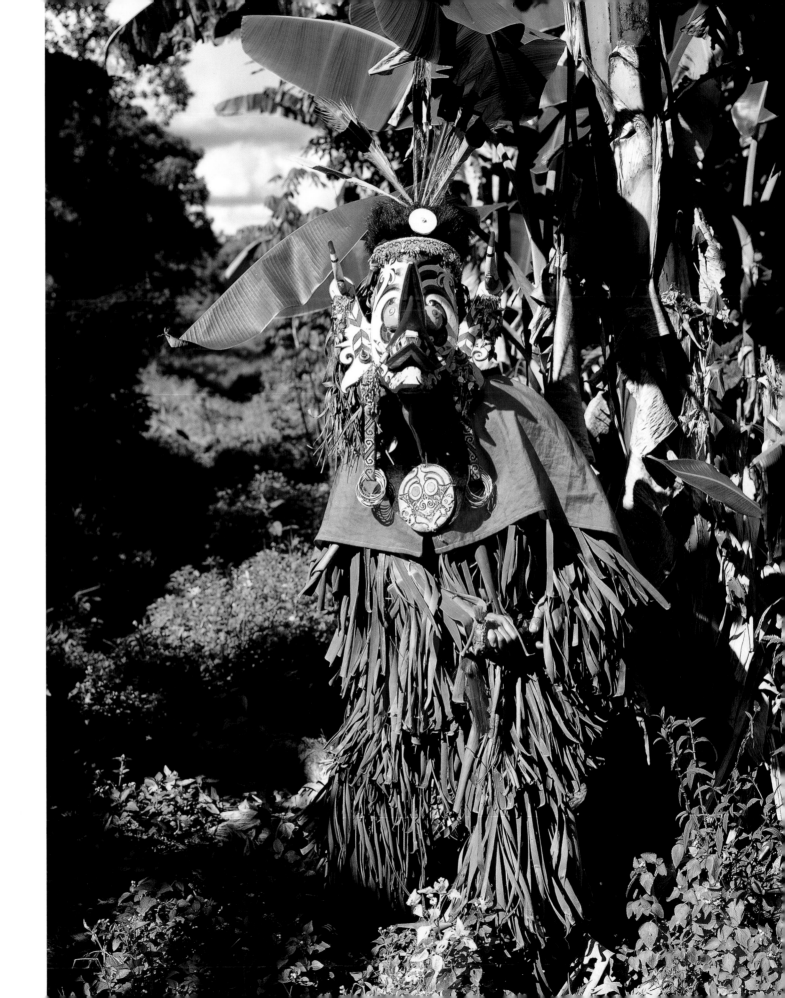

On the way back in the truck, we stopped
in a nearby village, looking for things
to buy. My guide asked to see the medicine
man, who's often a good source of
information, not to mention amulets and
talismans. We were told he was thirty
minutes away, trying to heal a woman
with a very high fever. I was curious
about the process and so we went off to
find him. The woman was lying on her
bed, at the edge of delirium. The ceremony
had started with the sacrifice of a small
pig, which would later be eaten by the
neighbors and the medicine man. He had
carved an effigy of the woman, which
he laid alongside a lit candle in the bottom
of a miniature boat. He hung the boat
from the ceiling and started swinging it
back and forth while he danced around,
praying. He was holding coconut sprigs in
both hands. Dangling from a leather
thong, strung across his chest were
more small, carved figures. On his arm,
he wore large metal bracelets that made a
clinking sound to help call the spirits.
Round and round he went, swinging the
small boat. I was told that sometimes
he falls to the ground in a trance, which
means he has communicated with the
spirits. This might go on for fourteen
hours. While it continues, the family
prepares the pig and other food for a feast.
The medicine man could stay for days,
costing millions of rupiahs (the equivalent
of hundreds of U.S. dollars). I left after
only an hour, wishing that modern
medicines were available. I was informed
that, after two weeks, if she was not better
(or dead), they would bring her to the
hospital.

By the time we arrived back on the houseboat for the final leg of our river odyssey, it was almost dark. We chugged off, but the fog was getting thicker and the captain opted to pull over to the riverbank and wait until it cleared. The crew and I were playing cards up front while the cook prepared dinner in the kitchen. All of a sudden, we heard a bloodcurdling scream. When we ran back to the kitchen, we saw a four-foot-long water snake climbing onto the boat with lightning speed. The captain ran to the engine room for his machete and sliced the snake in half.

Well! As far as I'm concerned, you could put needles under my nails, but don't show me a snake. They scare the hell out of me. I was told that these snakes are more poisonous than some cobras and that people get bitten all the time along the river. And as if that was not enough, in the villages sometimes pythons eat small dogs, cats, and even pigs. I vowed to be much more cautious from then on, and we quickly pulled away and drifted down the river. I checked my room that night before going to bed. It was my last night on the boat, and the motor lulled me to sleep—with no more excitement.

We arrived in Tenggarong at 6 A.M. after a cool and breezy night on the river. This city of sixty-five thousand people was once the capital of the sultanate of Kutai. We toured the royal palace, which was built in the 1930s with some good art deco detailing—much more interesting than the old costumes in dusty display cases. Then it was less than an hour back to Samarinda, where the voyage started. I left the boat regretfully, already missing that sense of freedom I had when I was lying on the deck watching the trees silhouetted against the sky. Going upriver in Borneo is like discovering a forgotten land. The jungle was just so raw, so lush, and so voluptuous.

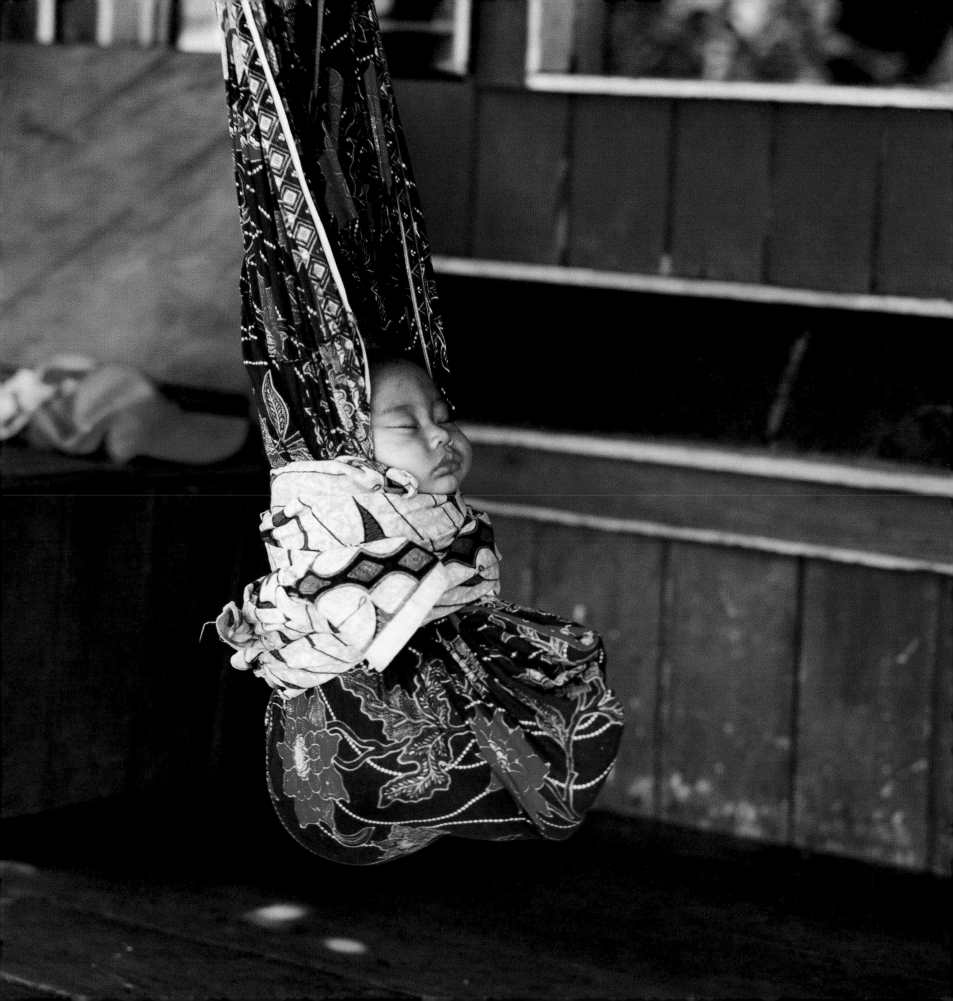

BORNEO CONTRAST

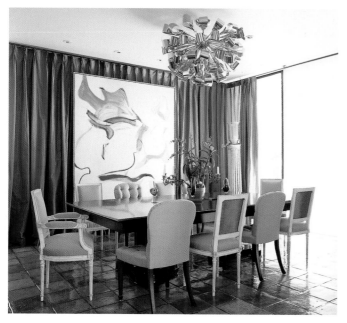

I DIDN'T GO TO DESIGN SCHOOL, WHICH TURNS OUT TO BE A GREAT ADVANTAGE WHEN IT COMES TO BREAKING RULES. I never had any to begin with. All I could operate on was my own instinct, honed over the years by touring great houses, going through museums, and looking at books. But when you have no formal education, it's easy to question yourself.

I try not to do that anymore. I think the most interesting rooms are very individual and a little unexpected, and that only happens when you're not afraid to express yourself. I've learned through experience that my first thought is usually the best (the second, third, and fourth often have more to do with insecurity than inspiration).

When I was asked to redo this dining room for clients who are serious art collectors, I knew the terra-cotta floor was a problem. It didn't quite fit the concept of an elegant, dramatic space—not to mention the fact that hard stone floors are not the best choice in a room that should encourage quiet conversation. Unfortunately, the clients did not want to rip it up. My only option was to neutralize it. I realized the floor would stand out less if the walls were the same shade. Normally I would just paint or upholster the walls, but I wanted to do something different so I wrapped the room with curtains of iridescent brown silk—which also improved the acoustics. Hanging art was a bit of a challenge. I ended up mounting paintings on pegs, so they seem to float right on top of the curtains.

Lighting offers another opportunity for drama. I found a pair of stylized wooden pedestals in France and topped them with hurricane lamps. The candlelight brings out the shimmer in the silk. Most people would have automatically hung a crystal chandelier, but I wanted something with a little more wit and chose a 1960s fixture salvaged from a Miami Beach hotel. It's hard to believe, but those pistachio green cabinets (bought at an antiques fair in Parma, Italy) once held priests' vestments. The whimsical urn-shaped sculptures by Allan McCollum add more candy colors—an unusual combination with the brown.

This newly built house in Connecticut was constructed on the principle of the open plan. There are no doors between the public rooms, which creates a sense of expansive, flowing space. But in this case, the effect was a little disconcerting because the plan had no inherent logic. Spaces meandered or abruptly terminated in dead ends. What the place needed was a point of view.

Since there were no distinctive architectural details, I had to give the eye something else to focus on. I decided to upholster the furniture in tobacco, black, and dark brown, relying on those deep, rich shades to ground the space and give a graphic punch of dark colors against white walls. Then I picked one accent color—an exuberant lemon yellow—to weave through the house, like a thread. It travels from pillows to slipcovers to brightly painted chairs.

This is a weekend house and the budget was modest, so I had to figure out how to get a lot of style for only a little money. Here's my method: just as I wove in that accent color, I wove in one-of-a-kind elements such as the inlaid Indian chair. That gives another dimension to a place where the majority of furniture is from Pottery Barn or Crate & Barrel.

In the dining room, I took the top from a traditional Crate & Barrel table and mounted it on two modernist white enamel tulip bases. The piece subverts expectations, just like the unconventional mix of chairs. I like to marry pieces that would normally not even be on speaking terms. I think this kind of mix creates a casual environment where strangers meet and instantly feel comfortable. The huge rectangular lampshade is like a luminous cloud floating above the table; it defines the dining area even though there are no walls.

In the foyer, a 1950s Italian table stands on a colorful rag rug. To complete the vignette, I composed a little still life with an early American tin candlestick, Ethiopian jewelry, a photograph, an African mask, and a wooden bowl bought at a flea market in Connecticut. The lamp hanging above is overscaled, almost a piece of sculpture in itself. These are the first things you see as you come in the front door, and I wanted the message to be: expect the unexpected.

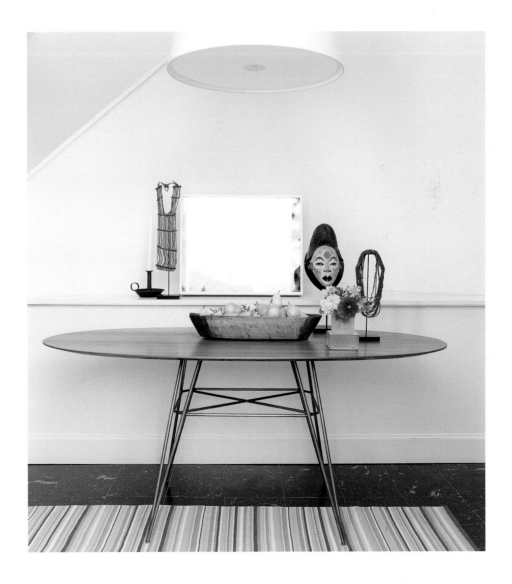

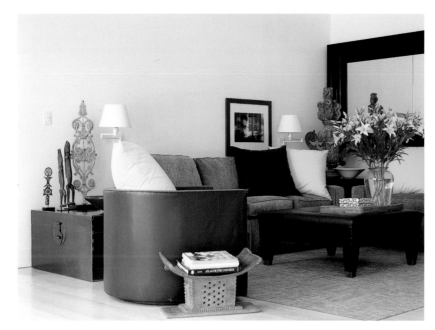

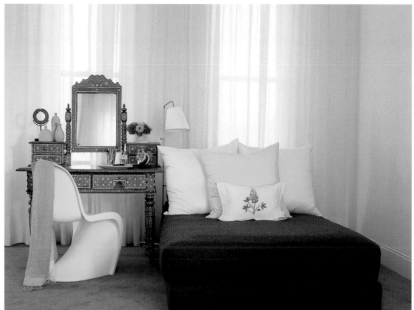

With grandchildren constantly visiting, the Connecticut house is subject to
a lot of wear and tear. Instead of a traditional carpet in the living room,
I chose an easy-maintenance rug made of woven plastic, which subtly picks
up the tones in the upholstery. This area dead-ended on a wall and
looked much more interesting once I hung a long rectangular mirror above
the sofa to create a virtual window. A swiveling barrel chair that I designed
for the client eighteen years ago is covered in its original black leather.
An African bench doubles as a side table.

In the bedroom, it is a space-age Verner Panton chair that carries
through on the yellow theme. It is not at all what you would expect to find in
front of an antique dressing table inlaid with bone and made in India.
But I like the juxtaposition of minimal against elaborate, molded plastic and
wood, sinuous curves and straight lines.

The eating area is a play on my predilection for unmatched chairs.
I thought it would be fun, and much more interesting, to do unmatched colors.
One of the Windsor chairs is painted yellow and the rest are lime.

BENJAMIN MOORE
ROXBURY CARAMEL
HC-42

BENJAMIN MOORE
STRAW
2154-50

BENJAMIN MOORE
AMBER WAVES
2159-40

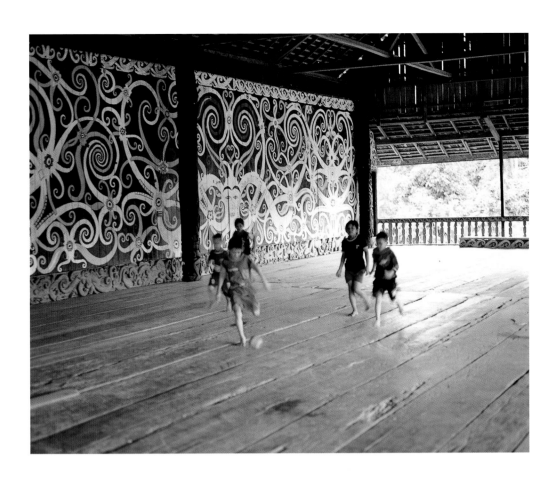

THE CEREMONIAL PAINTINGS ON THE WALLS OF THIS BORNEAN LONG-
HOUSE DEPICT MYTHOLOGICAL CREATURES that reappear in the carvings
and the columns.I love the unusual swirling patterns of yellow tones
interlaced with white, which give the whole design much more depth and
make the mural almost vibrate.

I used a similar palette in a guest room in Florida. The straw-
colored curtains, the banana cream–colored leather chair, and the natural
linen headboard are all set off by an earthy wool carpet, reminiscent of
those wide-plank teak floors. The band of white on the bedskirt accentuates
its shape, just as the white highlights the curves in the painting. Even the
artwork above the bed subliminally suggests the same motion and
reminds me of something every artist knows: if you want to give depth to
a painting (or a room), do it by subtly varying the tones.

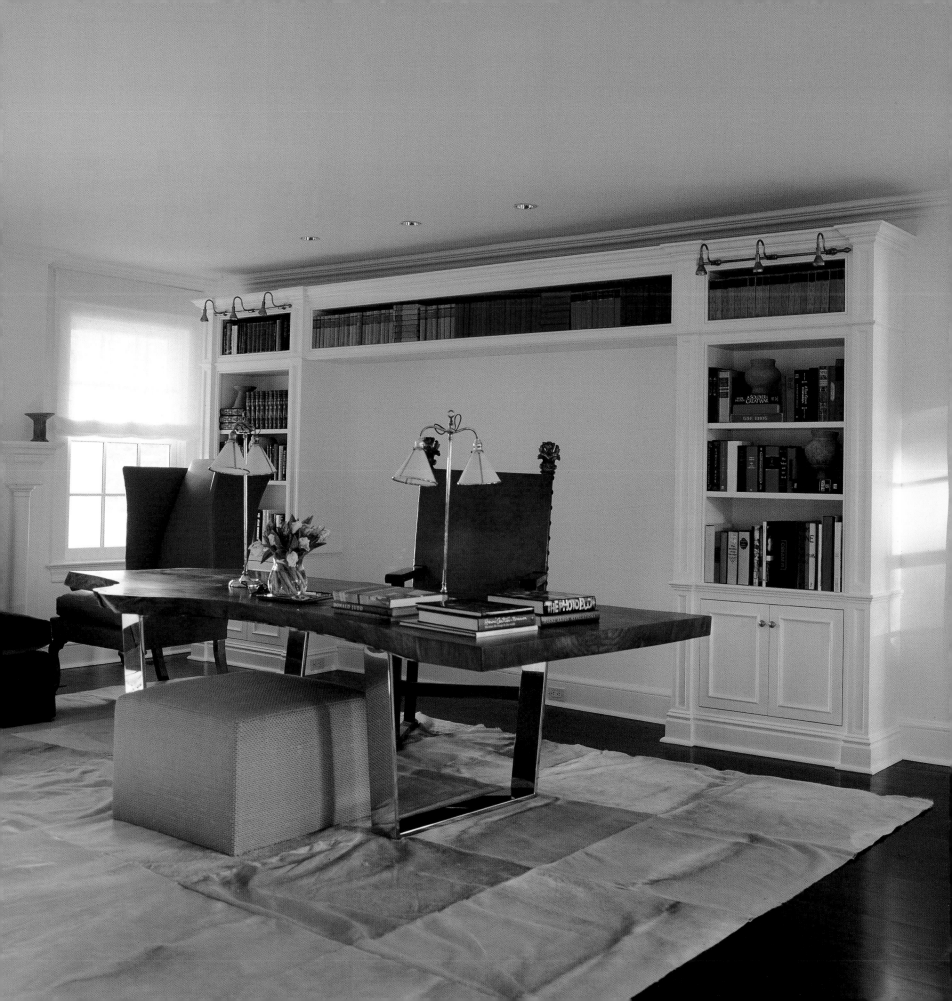

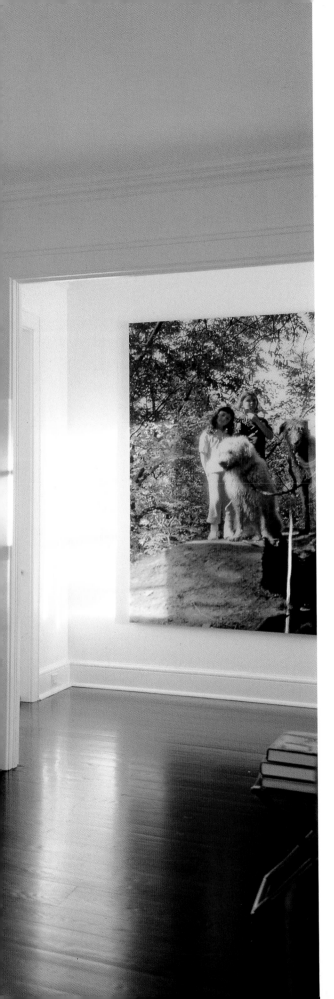

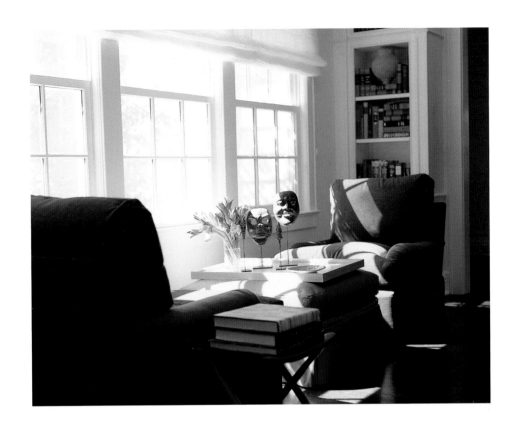

In Long Bagun I found myself staring at the limestone cliffs where the swallows nest—these are the nests so prized for bird's nest soup—and studying the range of tones: tans, taupes, dark shadowy water. In this library in Connecticut, I decided to work with a similar range of tones, made even richer by the variation in texture. As always, I wanted to bring in elements from many different cultures to convey the fact that this is the study of a cultured man. A seventeenth-century Tuscan leather chair is pulled up to a desk I designed, with an organically shaped slab of walnut resting on a steel base. A pair of old-fashioned French desk lamps, made of antique silver with glass shades, contrast neatly with a contemporary ottoman covered in woven linen and leather. Then there's the luxurious softness of the rug, made of squares of cowhide stitched together and set on the dark ebonized floor.

 A pair of leather wing chairs flank the fireplace, next to a mohair-covered ottoman. At the opposite end of the room, I used the same fabrics and just reversed the arrangement, putting leather on the ottoman and mohair on the chairs. A weaving pick from Borneo possesses its own sculptural integrity, standing beside the masks on the tray.

FUCHSIA AND APPLE GREEN ARE NOT FOR THE FAINT OF HEART, but it's a color combination that works on this porch in Borneo and looks just as delightful in this bedroom in Connecticut. Naturally, I had to select furniture that was equally high-spirited, such as the 1968 Bubble chair by Finnish designer Eero Aarnio. The gunmetal gray carpet is enlivened by a round insert of apple green under the 1994 Paper Clip table by Massimo and Lella Vignelli. Of course, no twenty-first-century teenager's room would be complete without a plasma TV.

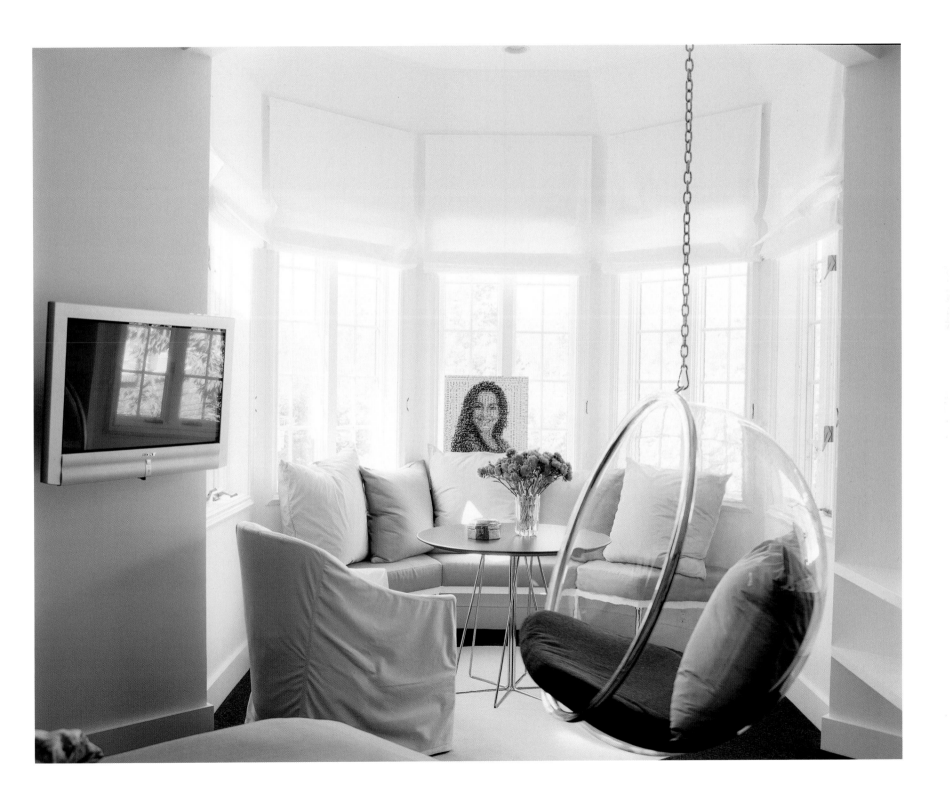

TALK ABOUT OPPOSITES. The kitchen on the boat I took up the Mahakam River was very basic—just two hot plates, a sink, no refrigerator, and a large plastic container holding purified water, all lit by one fluorescent bulb. This kitchen in upstate New York comes equipped with every possible convenience. Designed to float free in the center of the space, it is anchored by a steel I-beam that has been left exposed. A sheet of frosted glass, with two clear-glass inserts, separates the cooking area from the pantry. Slim steel tubes support the floating walnut countertop. The Paris bar stools are made of lime-rubbed oak and upholstered in perforated leather, resembling the seats of a sports car.

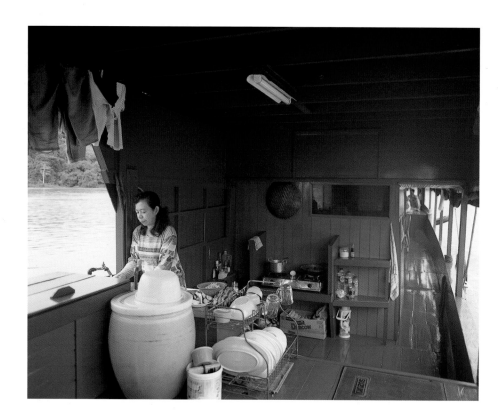

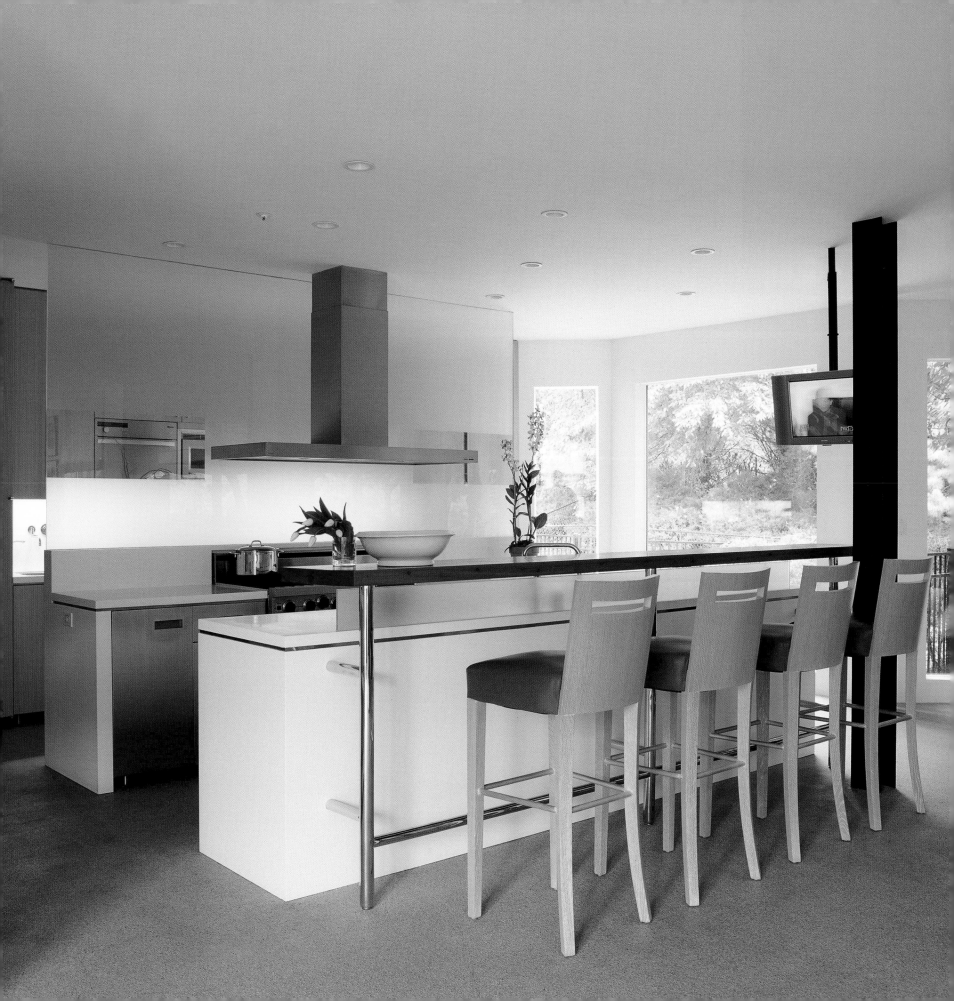

SYRIALIGHT

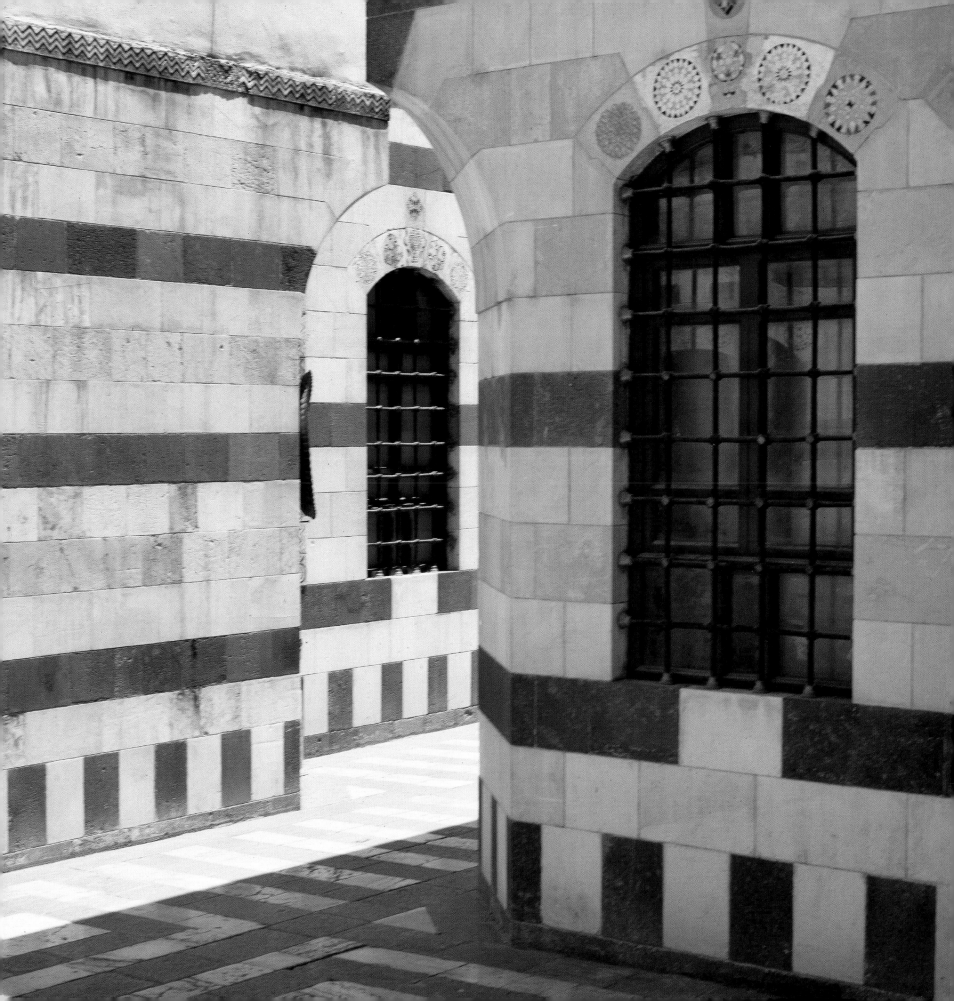

AS A DESIGNER, I'M KNOWN FOR COOL, LUMINOUS ROOMS IN PALE, ELUSIVE COLORS. YOU WON'T SEE SOFAS COVERED IN A FLAMBOYANT, FLOWERY CHINTZ. BUT WHEN I WANT TO BRING A HIT OF PATTERN AND TEXTURE INTO A ROOM, I'LL OFTEN CHOOSE DAMASK. I LOVE THE SWIRLING SHAPES AND THE SUBTLE CONTRAST OF MATTE AND SHEEN IN THE WEAVE. MY EYE GRAVITATES TO THE SHIMMER. INTRIGUED WITH THE FABRIC, I GOT THE IDEA OF GOING TO THE SOURCE, TO THE CITY THAT GAVE DAMASK ITS NAME.

DAMASCUS IS THE CAPITAL OF SYRIA, A MUSLIM COUNTRY WITH A DEEP AND INTACT CULTURAL TRADITION STRETCHING BACK MILLENNIA. ALL I KNEW ABOUT SYRIA WAS THAT ITS HISTORY PREDATES THE BIBLE AND THAT IT MAKES GREAT MOTHER-OF-PEARL INLAY. SYRIA IS ALSO FAMOUS FOR THE SOUKS IN DAMASCUS AND ALEPPO; FOR ITS ISLAMIC, MEDIEVAL, AND ROMAN ARCHITECTURE; AND FOR ITS POSITION IN HISTORY AS A CENTER OF WORLD TRADE GOING BACK TO THE SILK ROAD. EVEN THE WORD *DAMASCENE* (AS IN THE FINELY WROUGHT METALWORK ASSOCIATED WITH THE CAPITAL—AND MY LOVELY DAMASK) CONJURES IMAGES OF AN EXOTIC PLACE FABLED FOR ANCIENT AND ORIGINAL FORMS OF BEAUTY.

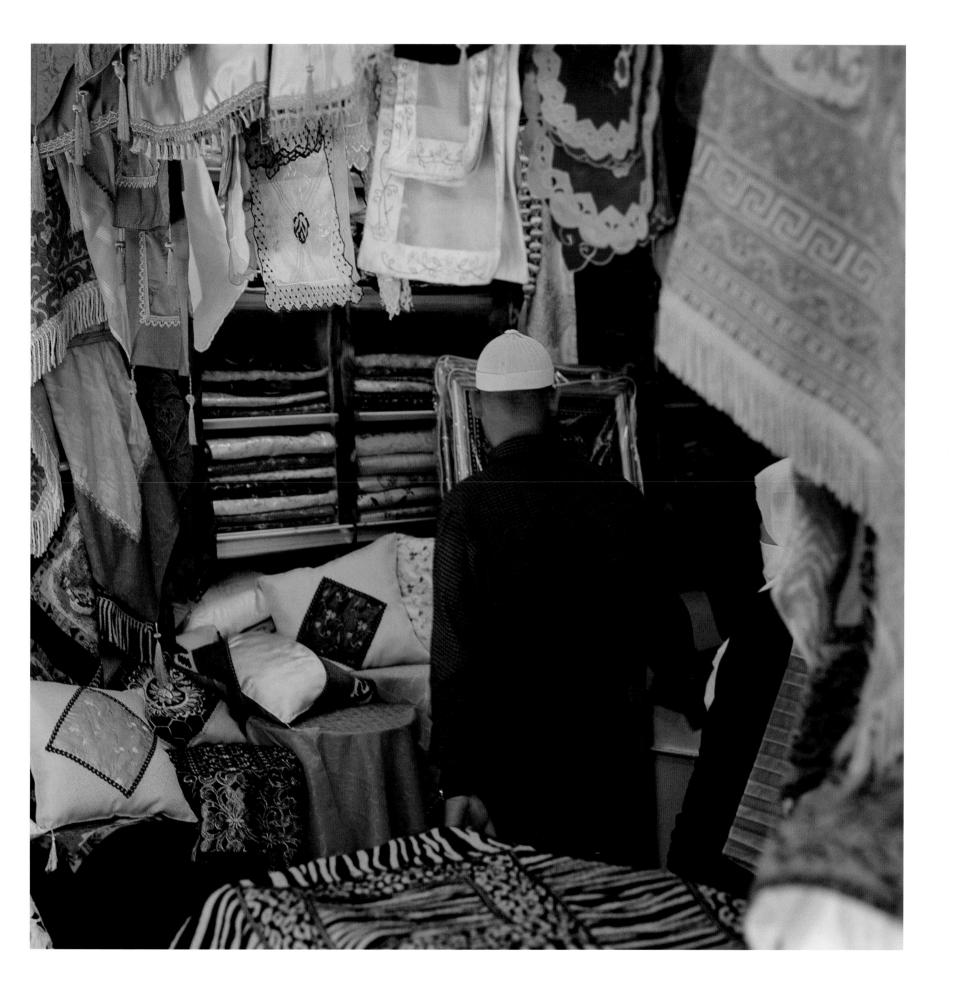

My understanding of a country usually starts with the view from the airplane, so I always try for a window seat. My first glimpse of Syria revealed a continuous, completely treeless plane of sand tinted pink by the setting sun. In the desert, light is the dominant element.

Even though it was 11 P.M. by the time I got to my hotel, the modern, well-equipped Cham Palace, my guide, Abdel, was there to meet me and asked if I was up for a walk through the souk. The light of the full moon filtered through the vine-covered alleyways of the old city. The shops are closed at this hour, but people were out and about, ordering scoops of pistachio or lime at Bekdach, the best ice-cream shop in Damascus, smoking hookahs (water pipes) in cafés, or just enjoying the fresh night air in each other's company. As a New Yorker, I expected that Syrians would be in bed by eight at night, but the souk sets the stage for a very gregarious town. In the shadow of the Umayyad Mosque and the Citadel, the old, narrow streets—some with many jogs and others quite straight—draw people together in a community that has been socializing in the same way for centuries.

The next morning when I returned to the bazaar, it was a very different experience, packed with vendors, shoppers, and everything imaginable to buy. Shopkeepers, singing the praises of their wares, entice you to come in and look. Wandering through this maze of alleyways, you see coins mounted as pendants, bracelets, and earrings hung in a window on strings, and row upon row of shimmering gold.

The souk is really the living heart and soul of the city, not just a historical leftover intended for tourists. It's still the main marketplace, where citizens make special purchases, such as wedding dresses, and also buy everyday items like cooking utensils and clothing. Neighborhoods in the souk are organized by the type of goods. In the silk section, you find hand-blocked scarves in incredible color combinations—turquoise and brown, apple green and pink, burgundy and fuchsia. Singing canaries, parrots, finches, and doves populate the bird market. In the candy market, the dried glazed fruits stuffed with nuts look tempting. The spice market sells all different types of teas, and I created my own mixture of rosebuds and mint leaves from the different sacks. It smells like potpourri and tastes like heaven.

The spice market is just opposite the famous Umayyad Mosque, at one time the largest in the world and still one of the most revered. The thriving street scene provides an improbable setting for this cultural monument, with merchants selling fresh blackberry juice, jellied candies, and underwear jockeying for position right up to the front door. Construction of the current mosque, begun in A.D. 705, kept one thousand stonemasons and artisans busy for ten years, and the glorious mosaics look just as radiant today. Saladin, the great Islamic warrior who fought the crusaders, is buried in the garden just outside the wall, and the head of John the Baptist, who is revered by Muslims as a prophet, is enshrined in the huge prayer hall.

The Umayyad Mosque is an epicenter of Arab and Islamic culture, but like Syria itself, it is multilayered. The Romans constructed a temple here, which Christians converted into a church, whose parts are now seamlessly integrated into the Islamic mosque. You can't quite tell where one architectural tradition (and religion) ends and the other begins. It has all been absorbed.

Walk into the huge sanctuary and you spot elements that you're used to seeing in more familiar, domestic environments: crystal chandeliers hang from ceilings, and the floors are lined with a profusion of Persian and even Savonnerie rugs, piled one atop the other, all given by devoted worshipers. The intense Middle Eastern sun projects reds and yellows and greens onto the carpets through multicolored glass windows, mixing more hues into the already colorful rugs. In large part, the mosque, which has survived invasions, earthquakes, and fires, remains an exquisite aesthetic whole, but then there are fluorescent fixtures just hanging haphazardly, blaring light. There's an unselfconsciousness here that you rarely see in the West in a monument of this stature, accompanied by the unscripted devotion of the faithful. Men group around imams, engrossed in teaching, and children recite verses from the Koran. In the background, you hear the murmuring in the huge prayer hall. The faith here is alive and ardent.

With its Christian towers, Persian rugs, European chandeliers, and abstract Arab geometries, the mosque in its entirety implies that Damascus has long been a city tied to the rest of the world. One of the rare Arab capitals that was not destroyed in one war or another, it was a hub for caravans from the Silk Road, receiving the spoils of India and China: in the old city there are still caravansaries from this period, the motels of their day (with a parking lot for camels). To the west, Damascus was the last stop on the Orient Express. Agatha Christie lived in Syria with her husband, an archaeologist, and often took the train that inspired her murder mystery. Damascus was a critical link in a trade chain that crossed continents, and all the influences are woven into the fabric of the country.

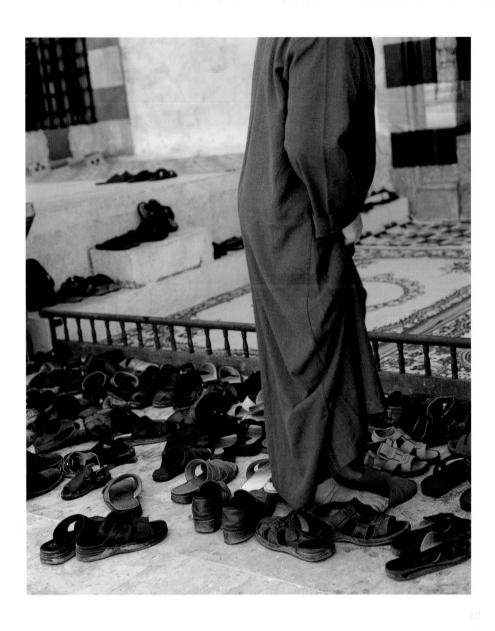

From the Umayyad Mosque, we headed
for the Azem Palace. We walked through the
same streets I had roamed the night
before, but now I could glimpse the inner
courtyards of private homes through
half-open doors. The palace, built in the
eighteenth century for a governor of
the Ottoman Empire, offered a hint of what
daily life was like in one of these private
enclaves, even if it presented a rarefied case.

The traditional Arab home centers
on a garden, much like the Roman town-
houses and villas that are its forebears.
But the privacy so cherished in Arab
households (because of the need to shelter
women) makes the Damascene home all
the more introverted and self-contained:
women spend most of their time here.
The gardens aren't just gardens; they're
the heart of the home.

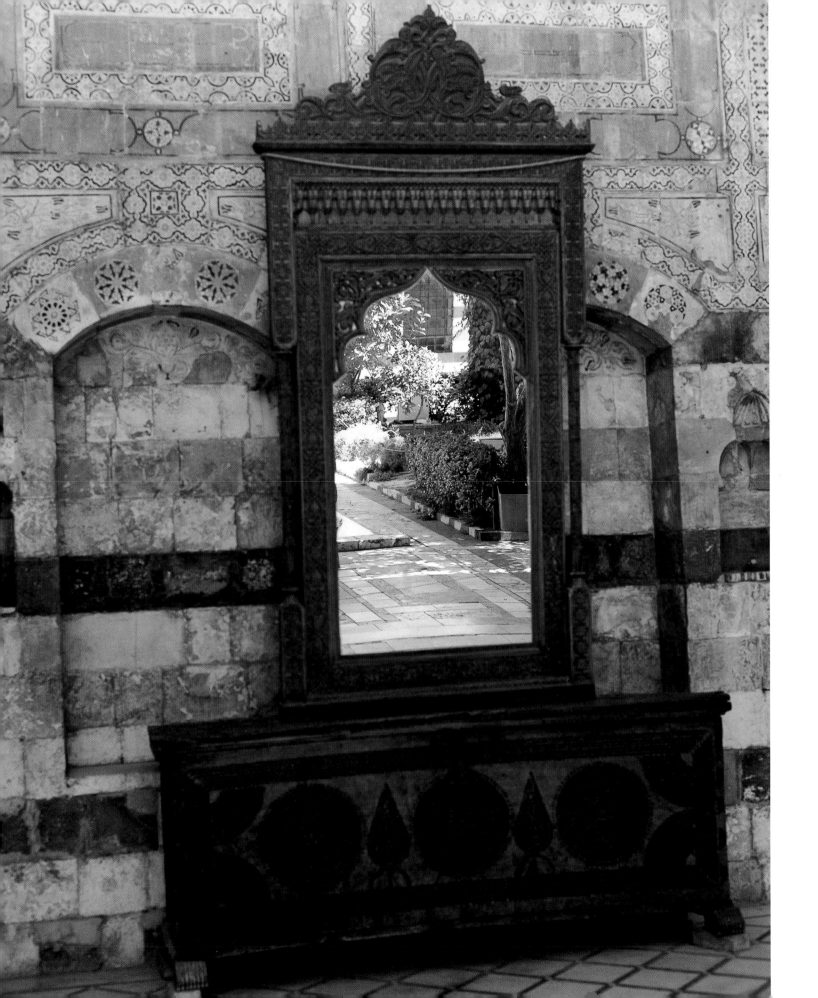

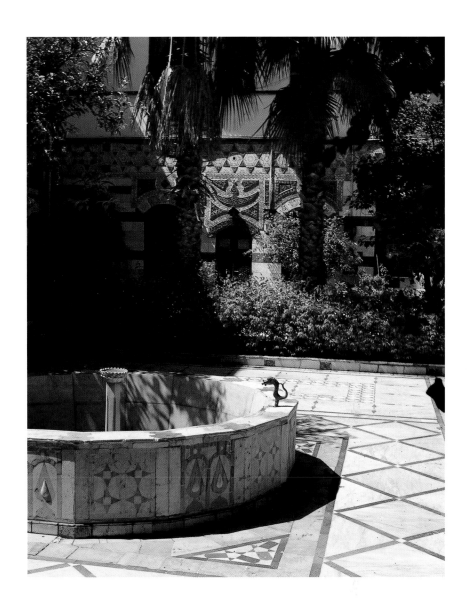

The garden at Azem Palace seduces your senses. Fragrant jasmine vines climb all over the courtyard. The house, especially the women's quarters, is sybaritic—elaborately decorated and sensuous in the indolence it implies. The women in this aristocratic household had their own *hammam*, or bathhouse. Ceilings are elaborately carved and painted in gilded geometrics and ethereal shades of blue and pale green, which evoke coolness and act as a form of visual air conditioning. Summer and winter loggias are oriented to the shade or sun. Fountains splash and mosaics decorate the niches. I began to notice that if you take one color and repeat it over and over, it neutralizes itself. The same thing occurs with the repetition of geometries. Strong in themselves, they never advance into the foreground but rather remain in the background. In its delicate excess, the mosaic dissolves within itself.

It's not far from the palace to the National Museum, with its inviting garden full of sculptures and architectural fragments going back to the pre-Christian Roman era. Great oleander trees flourish next to rows and rows of building artifacts. Sometimes I'll drop into a museum like this for the same reason I do in New York—to better understand the culture I'm about to see but also to glimpse the trip in advance. It's a good way to get a big picture, quickly, of the history of the country.

But in the museum, the thing that strikes me most is the striped stone wall, with black, cream, and beige marble set into repetitive bands that run around the courtyard. It's a motif I see here frequently, and it looks so modern. I'm reminded of the striped window patterns in high-rise buildings. In the continuum of time, certain details repeat themselves.

As we leave the city the next morning, Abdel and I pass large housing developments and take wide, new causeways: it's not my image of a primitive country. I wish the Long Island Expressway were in such good condition. The occasional Mercedes or BMW whizzes by. Along this desert road you start to see the importance of greenery. It represents shade, life, even luxuriance, like a gift from Allah. That is why every house has a tree or plant at its center, with the water that gives it life. No wonder the tiles in Syrian homes and mosques feature green and blue.

Our first stop is Maaloula, forty-five miles north of Damascus, a small town known for its unusual pastel blue and yellow houses that climb a cliff and splash the desert in color. In this enclave of Christianity, Aramaic—the language spoken by Christ—can still be heard. This charming little village, one of the earliest centers of Christianity, is famous for the convent of St. Thecla. A shrine contains the relics of this Christian martyr, who is said to have been a pupil of St. Paul. Pick up some pita bread at Hubs and eat it like the locals do—dipped into olive oil mixed with oregano, sesame seeds, ground almonds, salt, pepper, and lemon rind. Just outside of town, the elaborate monastery of St. Sergius, with parts recycled from Roman temples, dates back to the fourth century A.D. Inside are incredible wood carvings and wonderful painted icons and frescoes.

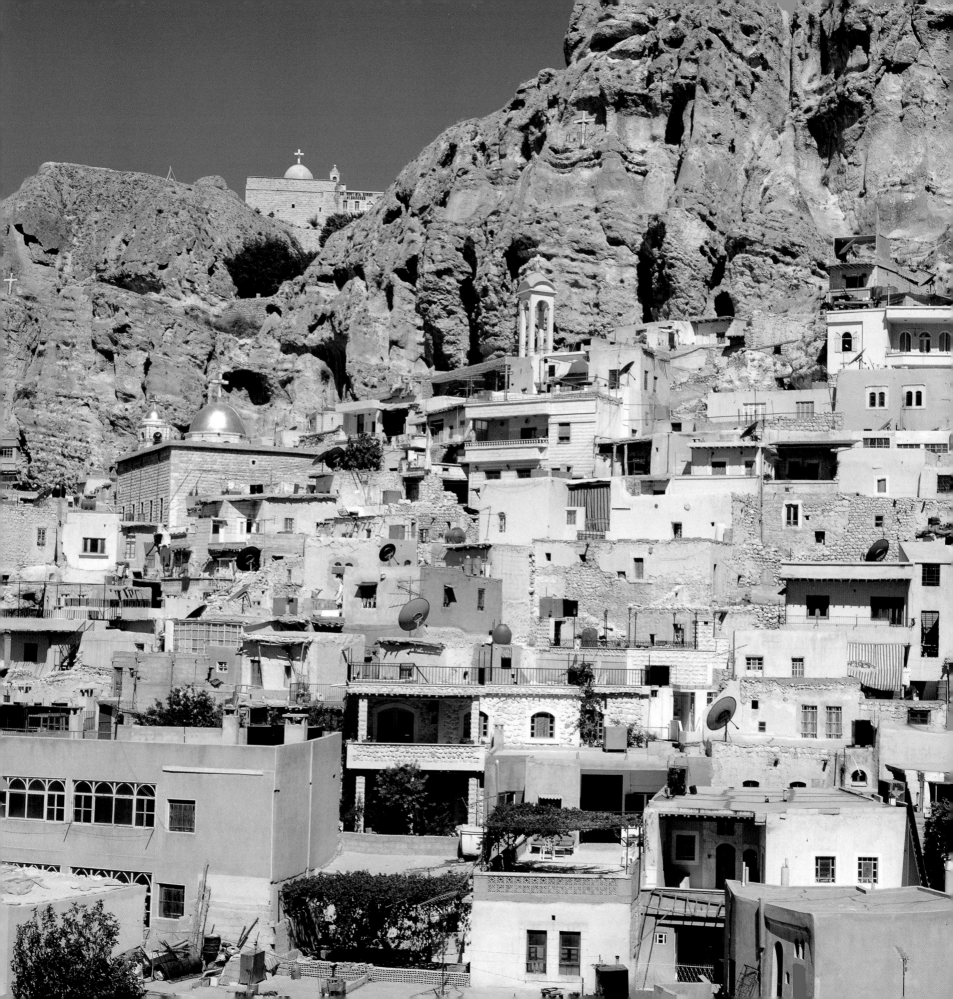

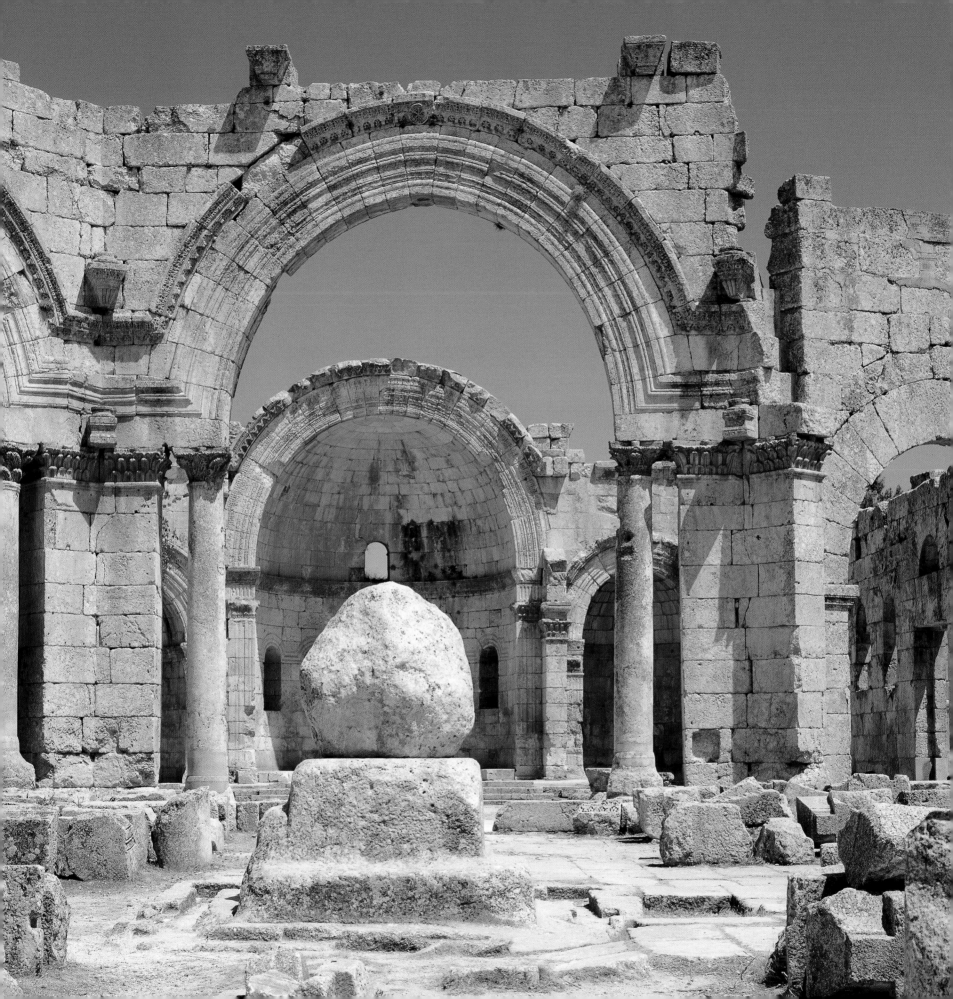

A modern highway leads north to Aleppo, roughly following an ancient pilgrimage route, and as you drive you see romantic hilltop castles appearing and disappearing into the landscape. The castles were stop-overs for pilgrims heading to Jerusalem (T. E. Lawrence, better known as Lawrence of Arabia, visited fifty during a summer vacation from Oxford), and when you take them together, you begin to understand how embattled this piece of land was.

The mighty Krak des Chevaliers is the most elaborate and best preserved of these fortresses. Sitting atop a mountain spur (sometimes the wind is so strong you can't stand up), it protected the strategic Homs Gap, which controlled the flow of armies and commerce for centuries. In the twelfth and thirteenth centuries the knightly order of the Hospitallers expanded an eleventh-century castle, so that inner and outer ramparts (outfitted for boiling oil and other medieval delights of war) protected the castle inside. Rooms could house up to two thousand soldiers, and the huge stables took in six hundred horses. The sheer scale of the crusading business was huge, and the stone structure remains very impressive, one of those rare monuments that has survived wars and sieges intact. Despite its size, the fortress has delicate moments, such as thin pencils of light piercing through high, tiny windows into large, gloomy rooms.

We followed up the visit with lunch at the Al Kala'a Castle Restaurant, which according to Abdel has the best roasted chicken in Syria. He was right: chicken just split down the middle, flattened out, marinated in olive oil, vinegar, and lemon with a little garlic, salt, and pepper, then barbecued for two hours and forty-five minutes over a coal fire. Before the meal, a plate of tomatoes, cucumbers, carrots, onion, and peppers is put in front of you—so fresh you would swear the garden is right out back.

Syrians say that Damascus and Aleppo are the oldest continuously occupied cities in the world. I'm willing to believe them. In both cities, as in all of Syria for that matter, there's a sense of time layered in strata reaching deep into antiquity. But if the histories of the capital and Aleppo parallel each other, today the pace is slower in Aleppo, where you can relax as the city telescopes you into the past.

I checked into the hotel Beit al-Wakil, a 450-year-old converted mansion that was deftly restored in 1998. Since we arrived on a Friday, when everything was closed, I didn't venture far from the hotel on the first day. I just strolled through the old city, taking in the atmosphere and charm. Many doors sported intriguing nineteenth-century knockers portraying a hand holding a pomegranate, and when I chanced on a Christian-owned antique shop that happened to be open, I was delighted to find a nice selection. Following my rule that you always need to buy at least three, I got six—in a range of sizes. Of course, in Syria, bargaining is expected, and I was able to walk out paying a third less than the asking price, leaving both the merchant and me happy.

I returned to the hotel with my new collection and finally had a chance to sink into the kind of courtyard I'd been glimpsing. The hotel has two, both with fountains and greenery. One is an enclosed restaurant, and the other, with walls and floor surfaced in apricot travertine, opens to the sky.

The temperature is a pleasant surprise: the courtyard felt ten degrees cooler than the street. Seated under the jasmine vines, I listened to the murmur of the fountain mingle with the faint voice of the muezzin calling the faithful to prayer. Cooing doves fluttered against a peerless blue sky. Who would have thought that paradise could exist in such a small space? With this experience, I realize that this is the lesson I will take from Syria: it is inside, not outside, our walls that we find the gifts of serenity and peace.

Shafts of light accent the dark and narrow walkways of the Aleppo souk. A heady blend of olives, soap, spices, perfume, and fruit scents the air. Men pushing donkeys loaded with merchandise bump into ladies draped in black head to toe. Children squeal and run. Some of the old caravan hotels are now open-air warehouses, filled with carpets or bolts of damask, each more beautiful than the next.

I had been looking forward to going to a *hammam*, and I chose the Yalbougha an-Nasry—very old and opulent, with vaulted ceilings, chandeliers, divans, and marble baths. You enter the main room where the attendant collects the fee, then undress and wrap yourself in a towel and proceed to the first space, where you stay for a while to acclimate your body to the heat. Then you're escorted to a room with a large slab in the center where you are massaged and scrubbed with a loofah until you look like a tomato. After being washed down with hot water, you relax in this hottest room for fifteen or twenty minutes, then reverse the process, moving from hot to cooler rooms as you lounge. I crawled back to my hotel and slept like a rock.

Abdel kindly invited me to spend a day and a half at his house, where he promised his wife would cook all sorts of Syrian specialties. As we drove north from Aleppo, we started to see olive groves and orchards of pomegranates, peaches, and plums. We visited the ruins of St. Simeon, a mighty Byzantine basilica erected around the column on which the good but strange hermit saint sat. He became a fifth-century celebrity, preaching to people who gathered below. We were nearing the Turkish border, and before heading east into the deep desert that stretches to the Euphrates, we stopped briefly at Ain Dara, where a temple dedicated to the Hittite goddess Ishtar stood a thousand years before Christ.

When we got to Abdel's house, we went out to the garden, where jasmine-vine carpets were set with cushions. It truly felt like paradise in the desert. Abdel's wife had been cooking all day, helped by two of her daughters-in-law. What I thought was going to be a party of three quickly grew into dinner for twenty people. The family had roasted a goat, and the feast was arrayed on the porch. Men, women, and children sat around low tables with large copper trays laden with roasted goat, chicken, lamb, broiled eggplant, stuffed zucchini, stewed tomatoes, string beans, cucumbers in yogurt, hummus, baba ganoush, olives, and Allah knows what else. As the sun went down, the electricity went out and candles and lanterns appeared. This Muslim family drank no liquor, but there was arrack for me, as well as melon, orange, and cantaloupe juice. Everyone ate with their hands. It was a lively evening with children singing. One of the guests brought a lute, and we all clapped along as he played under the stars.

After a breakfast of homemade yogurt flavored with apricots from the garden and fresh pita bread, we were off to the east on an ambitious six-hour loop across expanses of desert to Palmyra, the famous Roman city. Along the way, we saw market towns catering largely to Bedouins.

I was acquiring an appreciation for the desert. There is such tranquillity about it—the flat one-color quality, the neutral tones against the blue sky, the lack of anything but sand to capture the eye, the utter silence broken only by an occasional brush of wind. When you see structures, they're built from the earth around them and blend into the sand and rock. The sun, especially when it's low, makes everything look warm and soft, as though filtered through amber. At its most intense, the sun casts shadows that seem as deep as black holes. I realized that I could try to get that same effect inside a house, with contrasts of light and shadow to give a space depth and perspective.

I gather that most Bedouins have been co-opted by towns, but we did pass goatherders' tents sprinkled across the desert, where sheep were being moved from one grazing area to another. It seemed almost biblical. We stopped where a herd was being milked, all tied together in a staggered pattern so they can be approached from both sides. I was welcomed and one little girl milked a sheep right into a glass and offered it to me, still warm: this is as fresh as it comes. Water and greenery are so important to life in the desert, and I noticed that in front of the Bedouin tents, plants were kept in portable cans.

We pushed on to the rim of the Euphrates, where farming creates a wide green band on either side of the river. This is the river that bred one of the oldest civilizations in the world, and I was thrilled just being there.

At the northwest edge of the great Syrian desert that stretches toward Jordan and Iraq, Palmyra was a port of call as far back as two millennia B.C. for caravans traveling between Mesopotamia and the Mediterranean, and later the Silk Road. Today it is a provincial town of forty-thousand people that has been built right around the Roman ruins, as though they were a natural feature.

The best time to see the ruins is very early in the morning, from 5:30 on, when the sun is low and the shadows sculpt every line and curve of the fluted columns and leafy capitals (and before the tour buses come). But beyond the detail, there's the grandeur: I came completely unprepared for the scale of the ruins, which is staggering. For an oasis, Palmyra was a large city—at the height of its power, the capital of an empire—and some three hundred immense marble columns have been re-erected to line the main avenues where they originally stood. When you walk through the site, between the colonnades, you feel elevated, as though on a civic stage: the setting throws you back to the second century and the Empire. Unlike the Appian Way and other important roads of antiquity, these boulevards were not paved, in deference to the padded feet of camels. The original city that once lay on the far side of the columns is just sketchily etched on the ground.

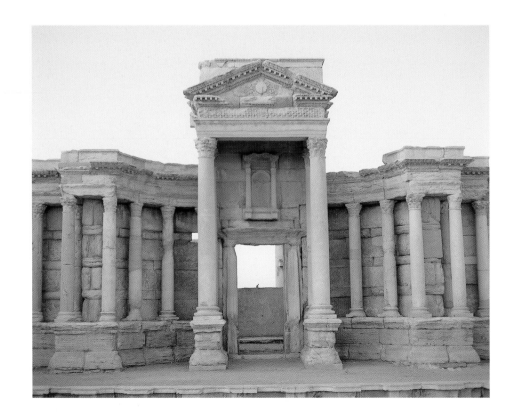

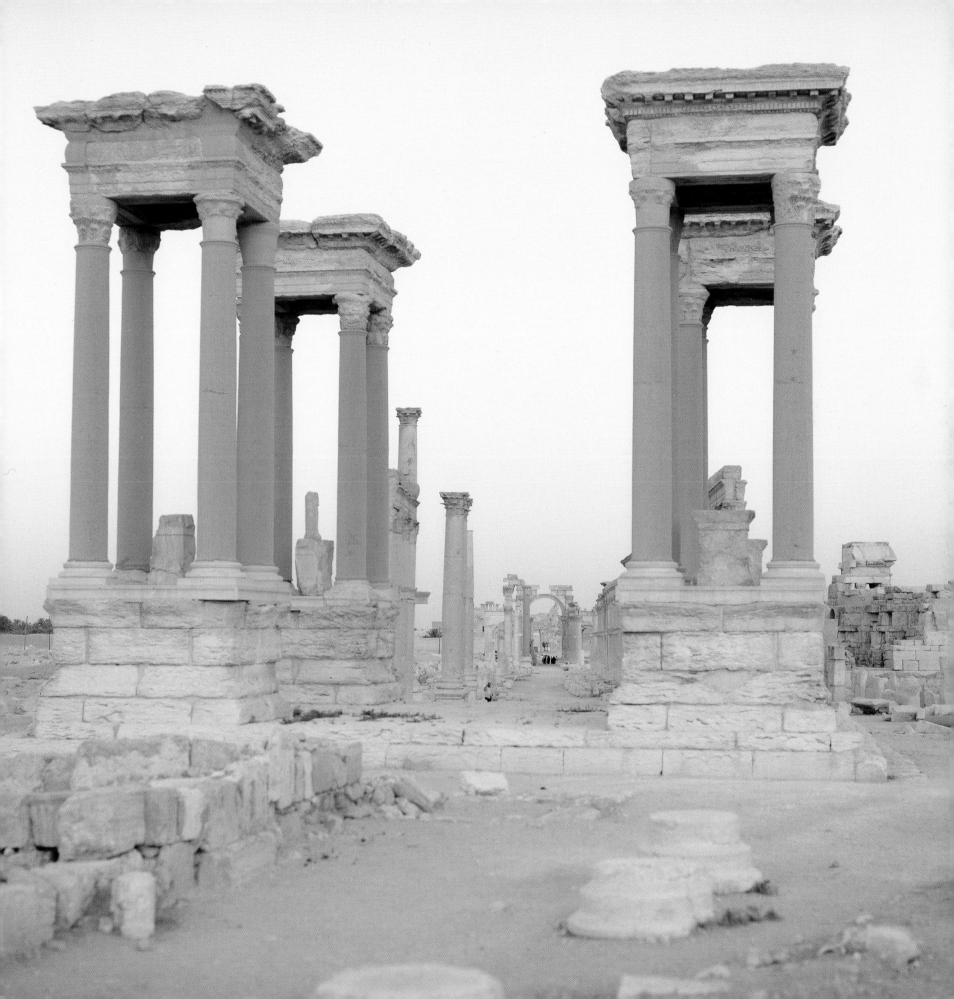

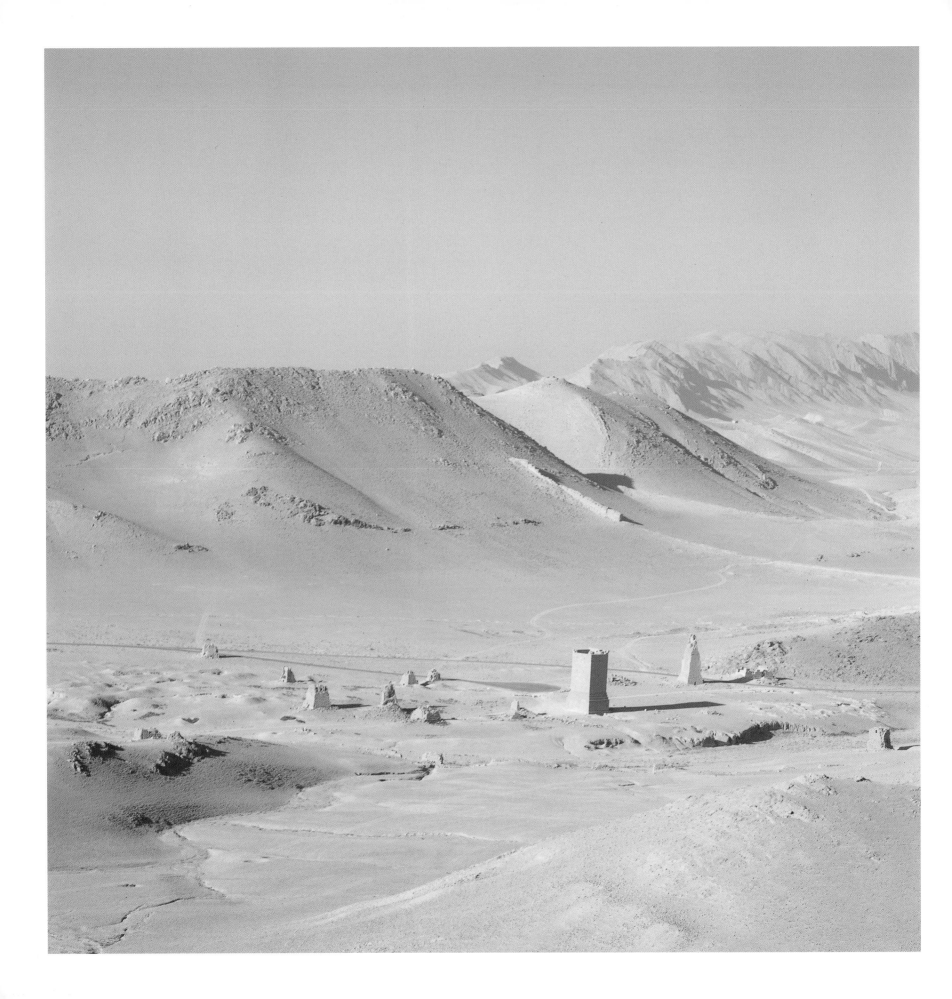

When the sun was not so hot, we visited some Roman grave sites in the Valley of the Tombs. International teams have restored them, and you get a very clear vision of the burial ritual. Faces carved on the tombs portray the deceased not as they looked when they died, but as they looked when young. Presumably the dead went off to paradise in top shape.

Palmyra offered some tempting treasures—antique Roman glass in very good condition, but at a very high price. I love ancient glass for its pearlescent quality and the delicacy of the forms. I also came across nice Bedouin silver pieces— necklaces and pendants—and a good selection of embroidered costumes.

On my return to Damascus, I rushed back to the souk to complete my shopping and found the workshop of Ezat Al Ilarastani, an artisan who makes new versions of the classic wooden boxes, inlaid with great sculptural shapes of steel instead of the typical mother-of-pearl. Each box is signed and stamped with the date it was completed. They are true works of art, and for me, they embody this rich culture— built on tradition yet committed to the modern world.

SYRIA LIGHT

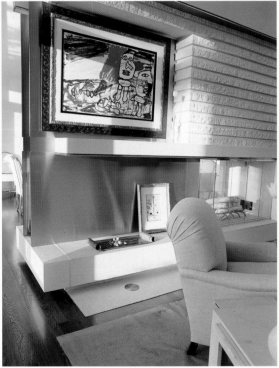

THE BRILLIANT DESERT SUN WARMS THE CRUMBLING WALLS OF THE ANCIENT CITY OF PALMYRA, bringing out every ridge and indentation in the stone. Light is something I've really started focusing on since I began doing my own photography. If I had to make a choice between great antiques and great light in a room, there's no contest. Even an empty room bathed in light is full. Light can bring drama and romance as it plays up the architecture and highlights details of the furnishings.

Lighting is one of the most important elements in a room, and it can determine whether a space feels warm or cool. Recessed lights in the ceiling create a different effect than a table lamp with a silk shade. But even more special is the light that comes through the windows, bringing a sense of life as it changes constantly throughout the day. I'm particularly fond of the mellow, late-afternoon light that rakes a room, casting long shadows. Then there are the last rays of light that precede the darkness, one flash of beauty before the sun is gone.

Before I start work on a room, I study how the light comes in. I want to know whether I'm dealing with cool, even light from the north or a warm, sunny southern exposure. Then I decide how to cultivate it. In this Palm Beach living room, with windows two stories high, I hung creamy white wool curtains to filter the hot midday sun. But in the afternoon, the curtains can be pulled back, allowing the light to carve out the shadows in each block of the limestone fireplace and burnish the Russian oak floors.

Originally, my client wanted me to upholster all the furniture in white, but I thought that might look too clinical. In order to give the neutral palette more warmth, I picked up the tonalities of the limestone and put natural linen on the club chairs and driftwood-colored suede on the sofa. The ottoman in the center of the room is upholstered in tree-bark brown leather. A white parchment table by Jean-Michel Frank adds another note of pale color and intriguing texture.

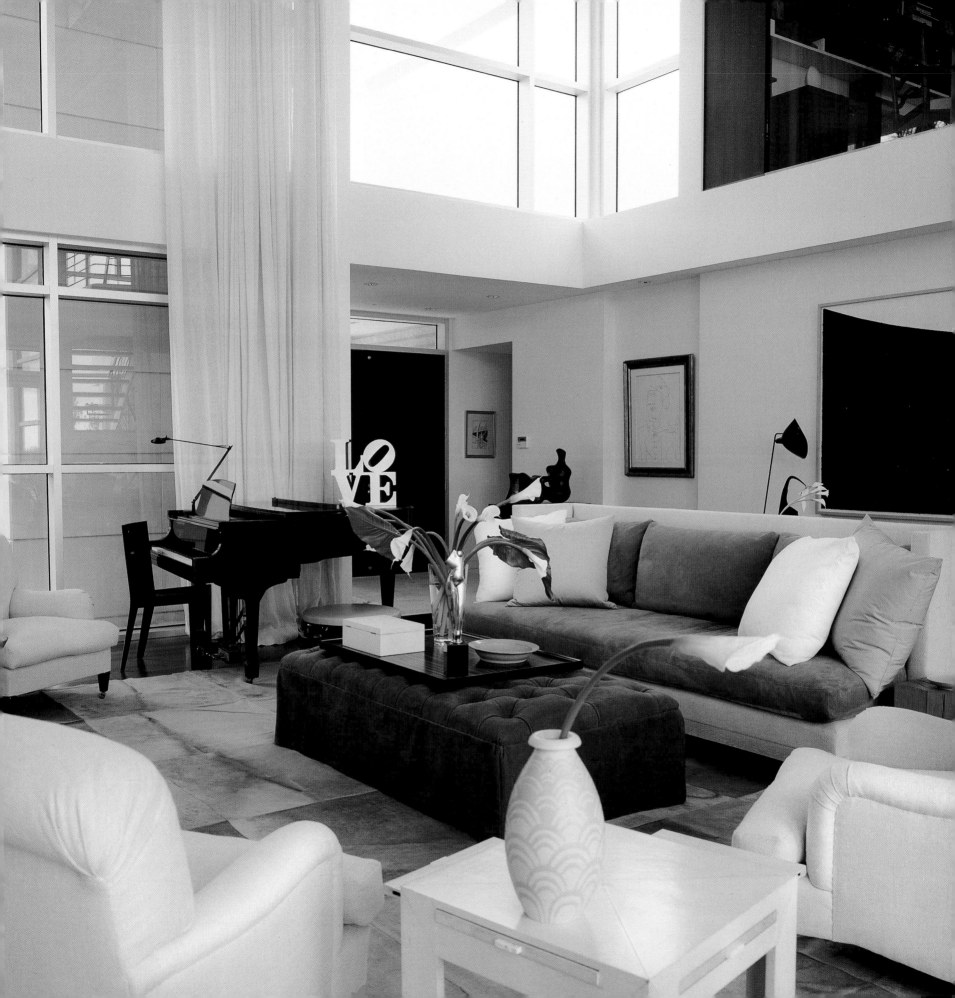

THE SUN SHINES THROUGH APERTURES IN THE RUINED BASILICA OF THE
KRAK DES CHEVALIERS and turns a stone wall into an abstract composition.
In the same way, a fretted Chinese screen creates a compelling design
of darkness and light. Screens are one of the most useful decorating tools
around. I used one in this Manhattan apartment to create a foyer where
there was none. Now you no longer walk straight into the living room. Instead,
a gilded iron table topped with a 1940s French bust creates a reception
area near the front door. Then, as you come around the screen, you're
welcomed by a large curved sofa in pale blue, with iridescent silk pillows.
I wanted to maximize seating but I was bored with the idea of an L-shaped
sofa, so I solved the quandary with a curve. Four people can actually
sit on it at once and look at one another without having to lean forward.
A round table made of lime-rubbed oak, with steel details, is topped with
frosted glass.

BENJAMIN MOORE
SUMMER PEACH
2167-70

BENJAMIN MOORE
DEER FIELD
1159

BENJAMIN MOORE
IN YOUR EYES
715

BENJAMIN MOORE
AMBER WAVES
2159-40

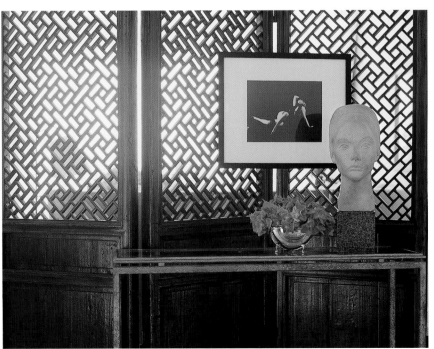

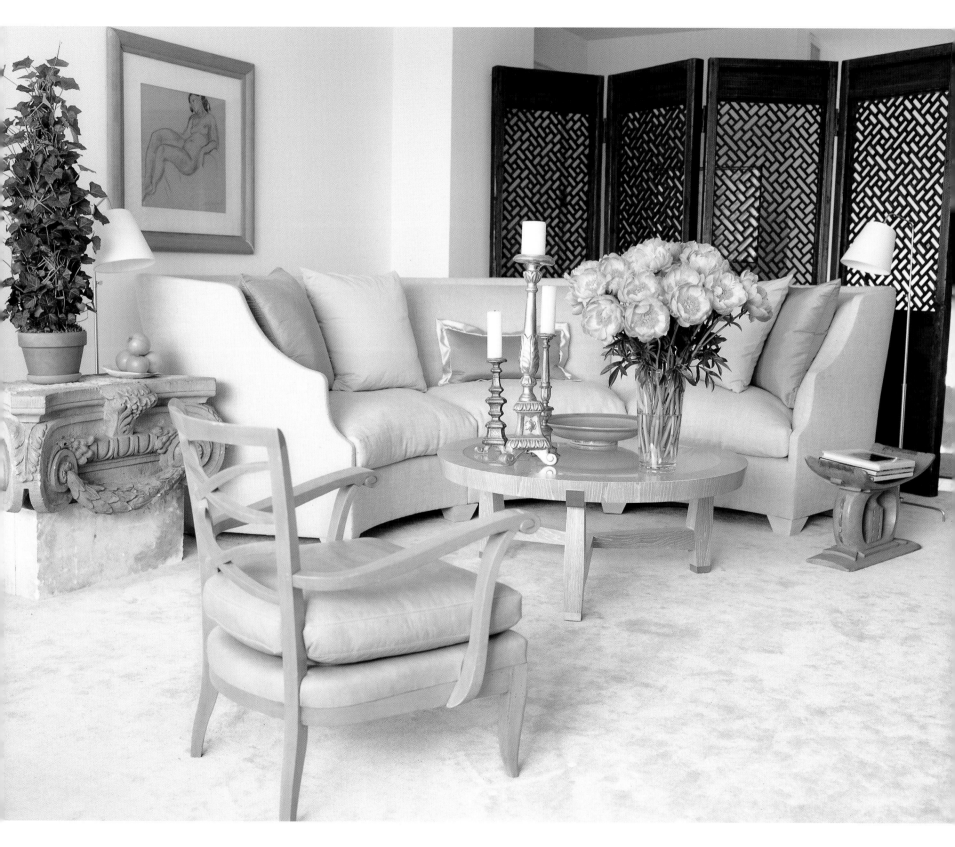

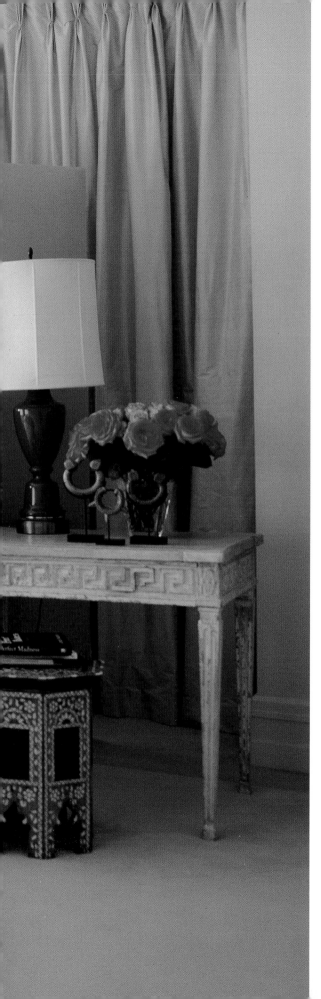

BENJAMIN MOORE
PIRATES
COVE BEACH
OC-80

BENJAMIN MOORE
APRICOT BEIGE
1205

BENJAMIN MOORE
ODESSA PINK
HC-59

In this Park Avenue bedroom, the screen behind the bed gives me
another surface, and therefore another texture, for the peachy, dusty rose
used throughout the room. It has still one more purpose—it blocks a
window that faces a neighbor yet still lets in the natural light that glows,
almost like a halo, around the head of the bed. An enameled mirror
and an octagonal table inlaid with mother-of-pearl (both from Syria) also
catch the light. The two notes of intense blue in the lamps cut the
sweetness and add a little edge.

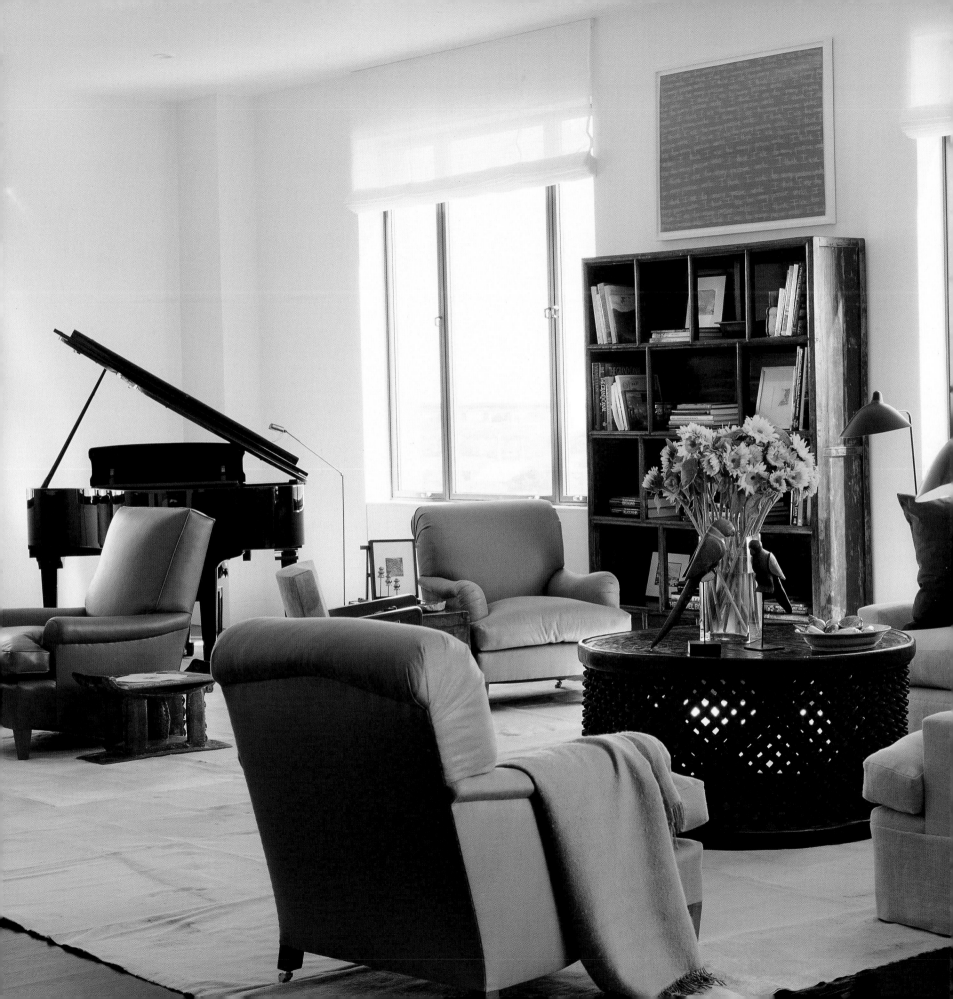

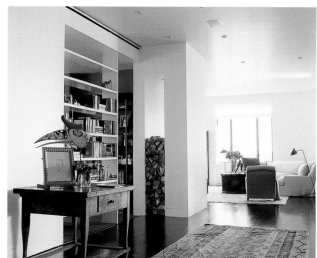

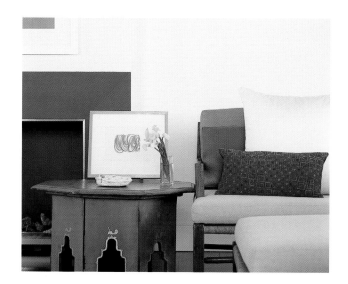

I opened up the space of this Manhattan apartment with a view of the East River by taking down unnecessary walls; now the river light penetrates as far as possible. A wall that once separated the foyer from the library has been replaced by open bookshelves. (When a guest comes to stay, a large sliding partition closes it off for privacy.) The area between a structural column and the chimney flue has become another slot of light, and also a storage area for logs. The wall between the living room and dining room came down, too. Now the kids roller-skate through the space.

The aesthetic became even more minimal when we changed the fireplace, removing the mantel and replacing it with simple slabs of slate. The little teal blue table in front of it used to belong to the Thai royal family; it folds up for travel. A country French chair and ottoman are upholstered in the same natural linen as the sofa and layered with pillows in leather and suede. I found a bright red Berber wedding costume in Syria and had it made into a pillow.

Another seating group is clustered around a coffee table from Cameroon, made from a hollowed and carved tree trunk. A cowhide rug adds a little softness underfoot. I like to bring in something with a hint of age, like the Chinese bookcase between the windows. The standing lamps, made in the style of the French designer Serge Mouille, have an appealing inquisitive stance. It all becomes part of the global mix of furnishings, which gives the apartment a uniquely contemporary point of view.

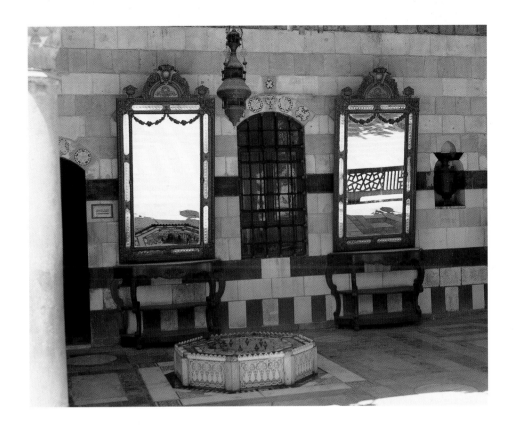

THIS U-SHAPED HOUSE, BUILT AROUND A LUXURIANTLY LANDSCAPED
COURTYARD, WAS ONCE A PASHA'S DOMAIN. Traditionally, the heart of a
Syrian house was the private garden, where the family would escape the
bustle of the city and gather to relax or entertain visitors. My eye was caught
by the boldly striped stone walls in this loggia, on the perimeter of the
garden. A window is flanked by a pair of mirrors (with matching consoles)
that reflect the sun and capture a glimpse of the garden as you walk by.

 I followed the same principles of symmetry in this Long Island
bathroom, but I upped the ante with seafoam-green glass walls that reflect
even more light into the space. I hung an English eighteenth-century
mirror in the middle and flanked it with a pair of Baccarat sconces. It's a
formal arrangement in an informal setting, which is always intriguing. I also
like the contrast of the modern stainless-steel towel bar with the antique
mirror. The fact that the bathtub itself looks almost like a ceremonial
fountain helps the effect. The glass walls give the room an aqueous quality,
which diffuses the boundaries of the space and makes you feel as though
you're underwater.

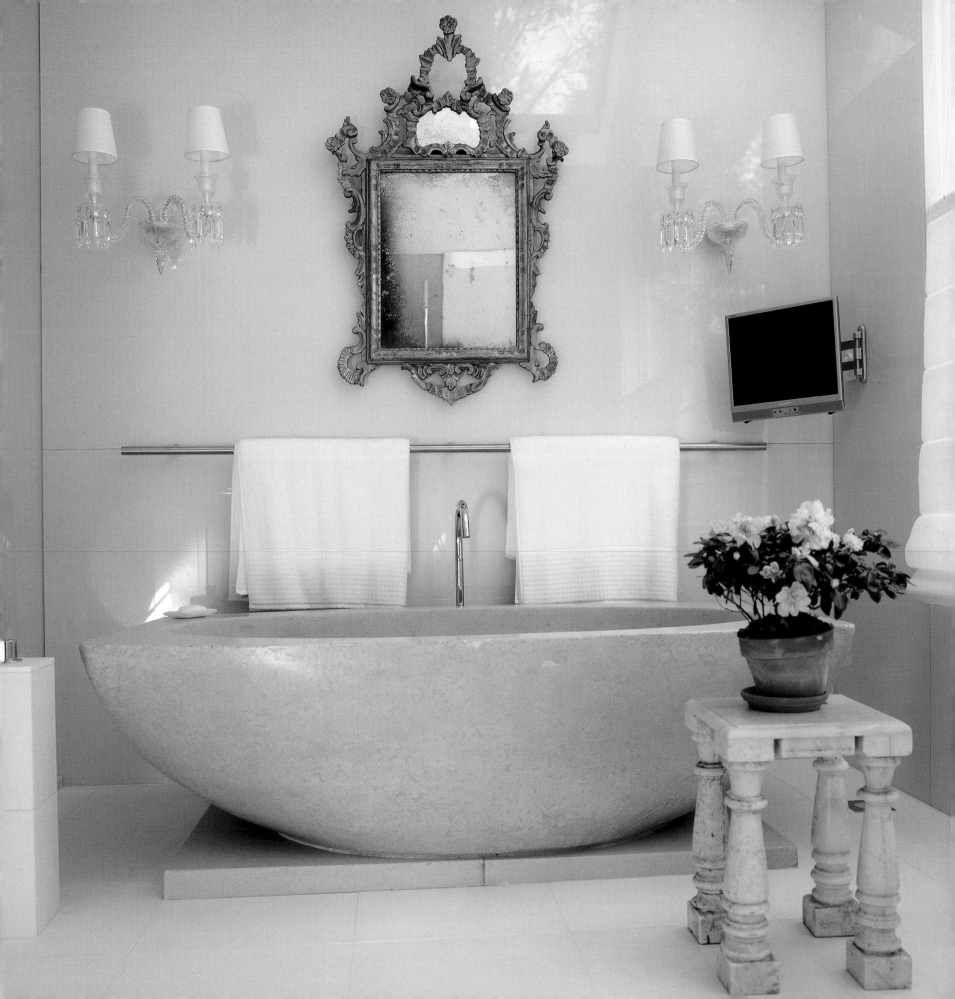

SOME DESIGNERS ARE FAMOUS FOR ELABORATE CURTAINS WITH SWAGS AND TASSELS; I'M FAMOUS FOR LEANING MIRRORS. It all started twenty-five years ago, when my client Willi Smith, a fashion designer, needed a full-length mirror for fitting models at home. Just hanging a mirror on the wall wouldn't suffice because it didn't show the feet. Fortunately, the ceilings in his apartment were very high, which gave me the opportunity to do a perfect rectangle, four by eight feet. I propped it up and stood back, astonished. Leaning it against the wall dramatically altered not only the reflection, but also the whole perspective of the room. In this position, the mirror made the floor look continuous, as if we had opened a doorway. It seemed to extend the space.

The scale is so huge—I've done mirrors fourteen feet tall and ten feet wide, framed with a nice, thick bolection molding—that it becomes an architectural element in the space. It's not always easy to get the idea across to clients. People still walk in and ask, when are you going to hang the mirror? But I like the casual effect. It's a bold gesture, a way of altering your perception of the space—and much better than a mediocre piece of art on the wall. Now I see leaning mirrors in the Pottery Barn catalog—how ironic.

The mirrors often arrive in parts and are assembled on site. I usually keep them an inch or an inch and a half lower than the ceiling. When you lean the mirror against the wall, try different angles because each one will change what you see reflected. If children are present, anchor it to the wall on top to be safe.

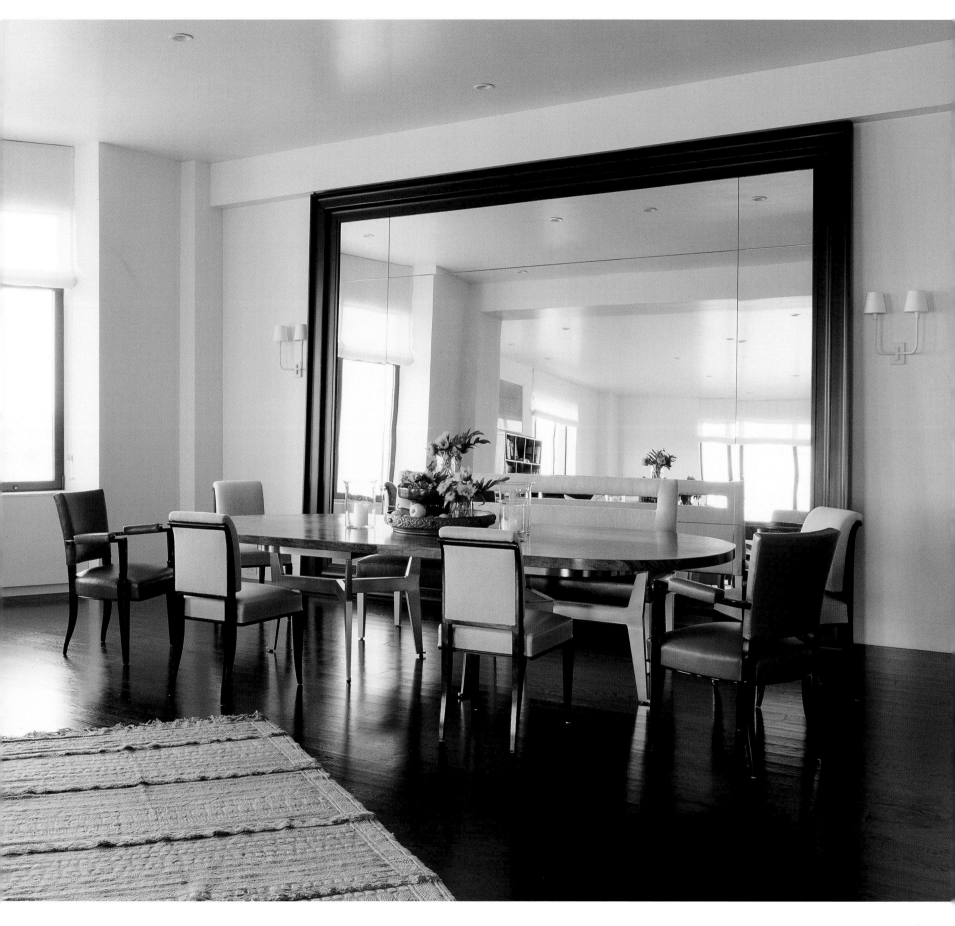

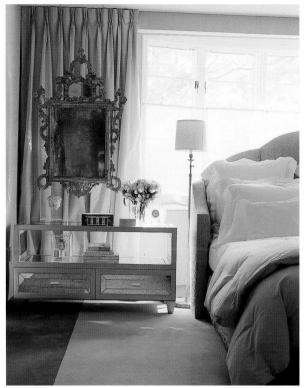

SOMETIMES THE BIGGEST DRAMA IN A ROOM IS THE FRAME OF THE MIRROR. I once walked into an antiques shop and was bowled over by a magnificent nineteenth-century concoction (which probably held a royal portrait at one time, since there's a crown on top). I immediately thought, where can I use it? Unfortunately, I had no commission that could accommodate it. So when I went to visit a prospective client and saw her tall ceilings, I had to take the job.

Oddly enough, the thirteen-foot ceiling in the bedroom was higher than the room was wide or long. I changed that perception by putting horizontal bands of textured silk on the walls, which broadened the room visually. To break the tunnel quality, I pulled the bed away from the wall and cocked it slightly. The few furnishings are understated to keep the eye focused on that extravagant mirror, haloed in an arc of light (thanks to a few strategically placed fixtures).

In another bedroom, this one on Long Island, an English Adam-style mirror is actually suspended from the ceiling and floating in midair, hovering over a night table, which is also mirrored. Like a feat of prestidigitation, it gives the whole room a fairy-tale quality.

I don't always hang mirrors vertically. In a California dining room, I mounted a four-by-eight-foot mirror horizontally above the banquette to expand the sensation of space without including the dishes in the reflection.

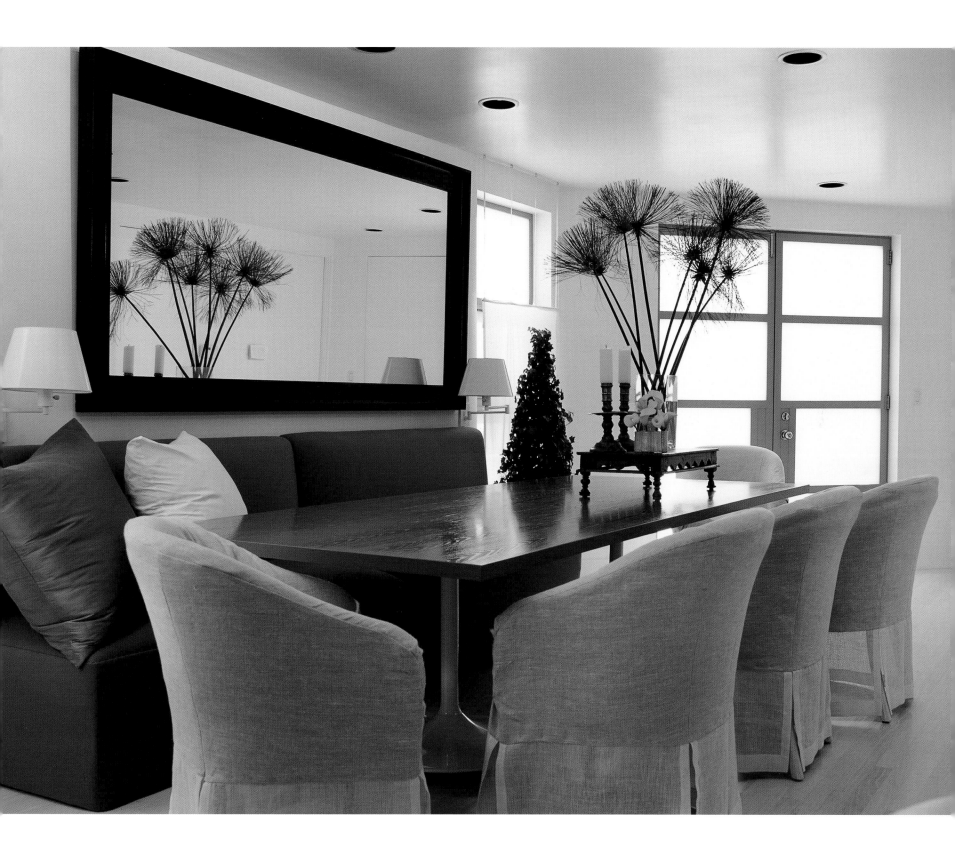

When I saw this column in the ruins of Palmyra, it gave me an idea. I composed a grouping of nineteenth-century Chinese perfume vials, an Andy Warhol piece, and a 1960s Murano glass vase and set it on top of an eighteenth-century limestone capital. Then, to give it a twist and some flexibility (it took four people to carry that column), I had a fancy version of a skid custom-made in lime-rubbed oak.

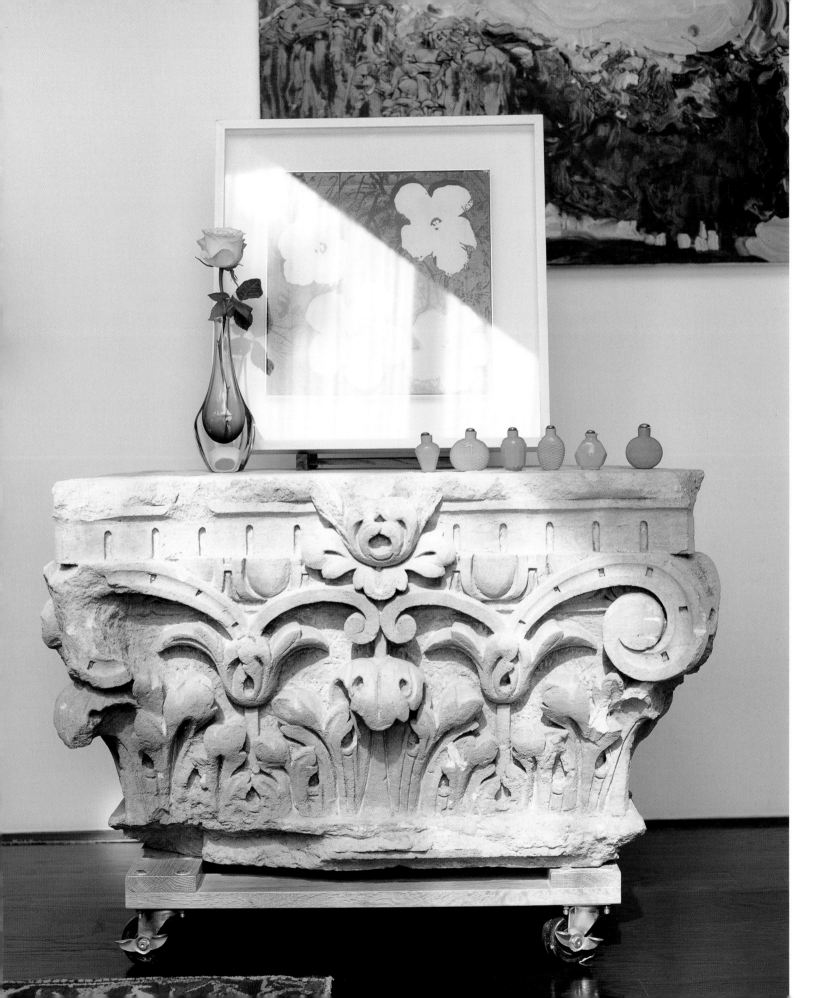

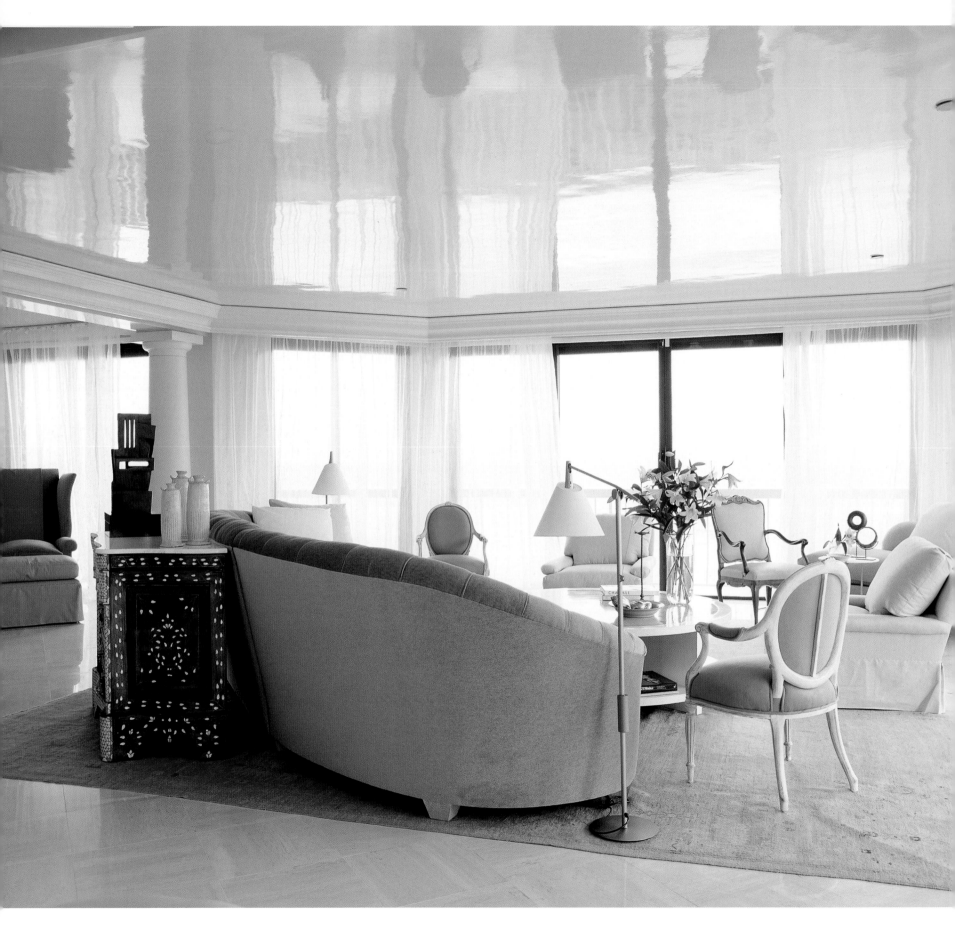

BENJAMIN MOORE
TEMPEST
AF-590

BENJAMIN MOORE
NUGGET
AC-9

BENJAMIN MOORE
AIRWAY
828

BENJAMIN MOORE
MARRY ME
1289

BENJAMIN MOORE
SILVERY BLUE
1647

REFLECTIONS ARE NOT ALWAYS LITERAL. In this apartment in Palm Beach, they enter in a different way—off the lacquered ceiling in the living room or the slab of polished steel mounted above the dining banquette. They're wavy and slightly distorted, like objects reflected in the sea. The upholstery in the room also reflects the colors of the ocean, with its watery blues, grays, and greens.

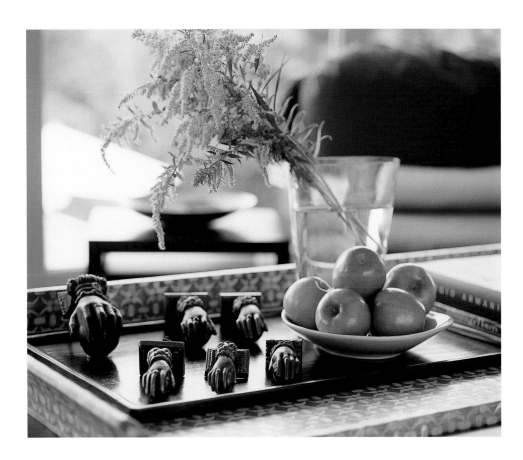

WHAT YOU CHOOSE TO COLLECT DOESN'T HAVE TO BE PRECIOUS. I've made collections out of snow shovels, pulleys, watering cans, keys. I found this assortment of Victorian door knockers at a shop in Aleppo and had them all polished to a sheen, which augments the detailing. There must be some sort of significance to the fact that every hand is wearing a ring.

FOR A WHILE NOW, I'VE BEEN THINKING ABOUT HOW TO BRING PATTERN INTO MY WORK without resorting to something like floral chintz. I tend to do it with objects—like this inlaid cabinet, found in a Damascus antiques shop—where the pattern is integral to the design. The mother-of-pearl fretwork on the drawers is backed by a mirror, and the intricacy of the pattern brings to mind the tilework, the lacy stonework, the calligraphy, the carpets, and the damasks I'd seen throughout the Middle East.

 After this trip, I've realized that all these motifs are rooted in the garden. When you walk through one of those private courtyards in Syria, all the patterns are there—in the geometric parterres and in the plant life. The swirling patterns of a Persian rug are just a reinterpretation of the fruits and flowers. It all starts in the garden.

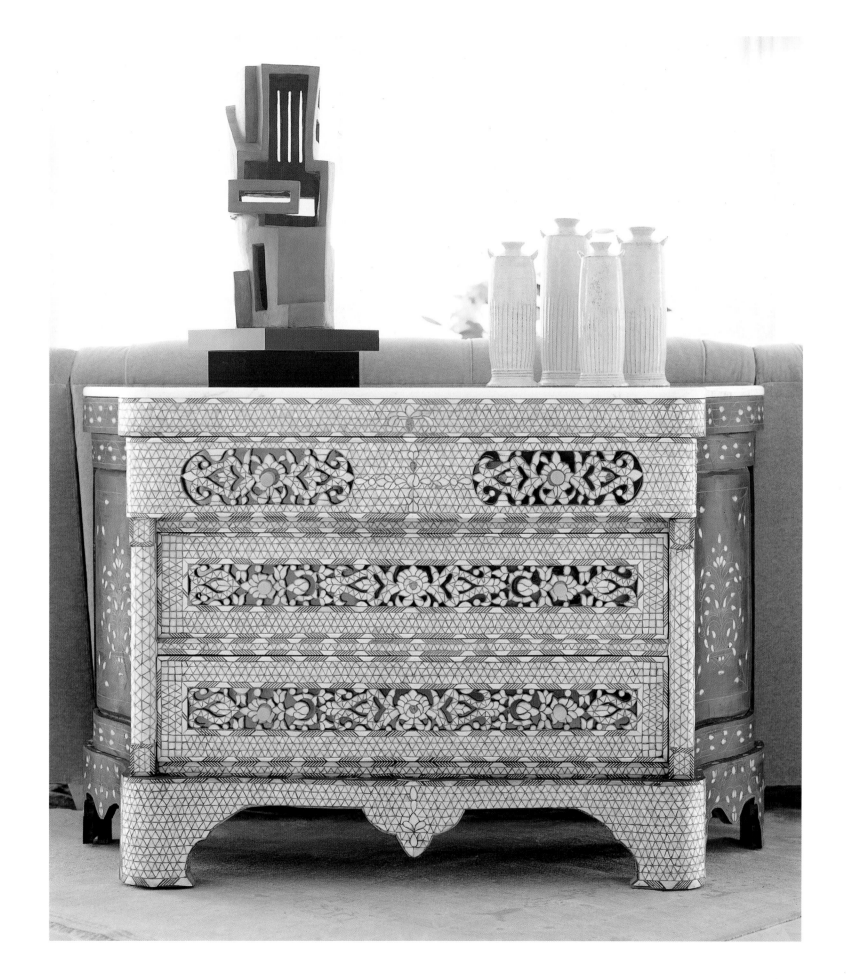

I WOULD LIKE TO ACKNOWLEDGE THE FOLLOWING FOR THEIR SUPPORT:

Christine Pittel, who put my thoughts into words so vividly

Andrea Monfried and everyone at The Monacelli Press

Joseph Montebello, who got me started in publishing

Benjamin Moore, for letting me use their colors to express my thoughts

TO THE MAGAZINES AND EDITORS-IN-CHIEF WHO HAVE ENCOURAGED MY WORK:

Carol Sheehan, *Country Home*; Margaret Russell, *Elle Décor*; Stephen Drucker, *House Beautiful*; Dominique Browning, *House & Garden*; Donna Warner, *Metropolitan Home*; Pilar Viladas, *The New York Times Magazine*; and Lisa Newsom, *Veranda*

TO MY WONDERFUL CLIENTS AND FRIENDS WITHOUT WHOSE ENDORSEMENT AND TRUST THIS WOULD NOT BE POSSIBLE, AND ESPECIALLY TO THE CLIENTS WHOSE HOMES APPEAR IN THE BOOK:

Mr. and Mrs. Steven Arnold, Preston Bailey, Mr. and Mrs. Harvey Bernstein, Adam Brown, Marie Douglas-David and George David, Mr. and Mrs. Raymond Epstein, Nely Galan, Karen Gantz Zahler, Jyll Holzman and John Geddes, Mr. and Mrs. Lawrence Kown, Mr. and Mrs. Norman Leben, Mr. and Mrs. Michael Lynne, Mr. and Mrs. Andrew Madoff, Mr. and Mrs. Robert Meyrowitz, MGM Grand, Mr. and Mrs. Gene Moscowitz, Mr. and Mrs. Richard Novick, Mr. and Mrs. Ronald Ostrow, Mr. and Mrs. Marvin Schur, Mr. and Mrs. Stephen Tobias, and Mr. and Mrs. David Wingate

AND TO MY TEAM FOR THEIR HELP:

Alison Uljee, who was my right hand in putting the book together

David Rogal, the associate designer for the projects on pages 45–47, 130, 218, 219, and 223

Maureen Martin, Mary Catherine McGarvey, Ximena Rodriguez, and Stephanie Travis

Feb